ONE MIND'S EYE

18-43

ONE MIND'S EYE

THE PORTRAITS AND OTHER PHOTOGRAPHS OF

ARNOLD NEWMAN

Foreword By Beaumont Newhall

Introduction by Robert Sobieszek

A NEW YORK GRAPHIC SOCIETY BOOK

Little, Brown and Company, Boston

To Augusta, Eric, and David with love.

Second paperback printing

FOREWORD

by Beaumont Newhall

ARNOLD NEWMAN is one of the few of today's photographers who makes portraits that are at once likenesses and compelling images. As Robert Sobieszek points out in his introduction to this fine collection of Newman's photographs, portraiture, once the very stronghold of photography, has almost become a lost art. We know our leaders, statesmen, artists, writers, musicians, and other public figures largely by the journalistic record, the hastily posed 'grab shot,' the overly theatrical magazine cover, the routinely lighted TV image. We remember our friends and our family by the casual snapshot or the grotesquely retouched product of the local studio. Rare indeed is the sympathetically seen portrait, product of the eye of a sensitive photographer and the active cooperation of a sitter. I think this is because few photographers possess the needed abilities.

Full mastery of photography is, of course, essential. The camera is a deceptive tool. With today's technology mediocre results can be achieved automatically. Unfortunately, mediocrity is all too often confused with success; we are too easily pleased. To push photography beyond the acceptable demands self-discipline and self-criticism on the part of the artist. I am reminded of that passage in Edward Weston's *Mexican Daybook* when, contemplating a photograph he had just made, he wrote:

> Just the trunk of a palm tree towering up to the sky; not even a real one – a palm on a piece of paper, a reproduction of nature: I wonder why it should affect one emotionally – and I wonder what prompted me to record it. Many photographs might have been done of this palm, and they would be just a photograph of a palm – Yet this is but a photograph of a palm, plus something – something – and I cannot quite say what that something is – and who is there to tell me?

No critic could have answered Weston's question. Only he himself could do so — and he did, not in words, but in photographs.

Avoidance of the trite, the banal, the obvious demands visual imagination. Newman's insistence upon the inclusion in his portraits of some vital aspect of the sitter's environment goes far beyond obvious symbolism. Subtly, yet powerfully, he recreates the very world of the sitter. Somehow the cigarette smoke in his portrait of Max Ernst is a palpable, three-dimensional form, akin to those the artist himself enjoys and creates; somehow Piet Mondrian becomes a part of his own photographed painting; somehow that fragment of wall which Newman integrated with the noble head of Jean Dubuffet could be a detail of one of that painter's canvases. In a strange sense many of Newman's most effective portraits seem to me almost self-portraits, as if the sitter himself had conceived the image. There is in them a sense of play, of excitement, of experiment. One can imagine the sitter saying, 'Let's try this!' and Newman answering, 'Great — just hold it!' This I consider the mark of yet one more ability, and the hardest to define: modesty, understanding, sympathetic (or perhaps rather empathetic) rapport with the subject, even self-effacement. There are photographers who impose their personalities upon the images they create to such an extent that the sitter becomes a model and not a person. Not so Newman, which may be the reason he dislikes fashion photography; it is interesting to observe that the one photograph in this collection identified simply as 'Model' is very much a person.

Over the years, since the day when he brought some of his early photographs to the Museum of Modern Art and I recommended that a few be purchased for the permanent collection, I have followed Arnold Newman's career, rejoicing in each step forward. To look back over his work as presented in this collection is rewarding. For he shows us clearly that photography, pure and simple, need not borrow from other media. The image, *his* image, was there when the shutter clicked.

INTRODUCTION

by Robert Sobieszek

THERE IS A DISTINCTIVE STYLE to the photographic portraiture of Arnold Newman, a style which evolved from a partly trained and partly intuitive sensibility to both pictures and people. A professional photographer working in New York for over the past quarter century, Newman's credit line is printed beneath a staggering number of famous and seminal portraits. His images of Stravinsky, to begin with his best-known work, as well as those of Max Ernst, Dwight D. Eisenhower, Pablo Picasso, Carl Sandburg, Lyndon B. Johnson, and Alfried Krupp, are not only photographic likenesses at their most accomplished but possibly more recognizable than the personality himself. Often, as in the cases of Stravinsky, Picasso, and Johnson, his portraits are the symbolic distillation of the sitter's appearance for the public consciousness. That certain of Newman's portraits are in many ways the single likeness immediately equated with the personality owes as much to the photographer's ability and refined sense of design as to the distributive powers of such publications as *Harper's Bazaar* and *Life*. However, even if his images had not been as well marketed as they were, Newman's portraits would still exemplify a very real artistic achievement in photographic portraiture. His pictures have already been included in many of the histories of photography and are comfortably maintained within the context of the medium's portrait tradition.

The engaging and lucrative property of rendering the human face has been the single most dominant role of photography since its advent. This visual perquisite could not fail but command such an accessible medium. Within months of the 1839 publication of the daguerreotype process, the first successful photographic technique, New York witnessed the establishment of this country's first photographic portrait gallery. The ensuing portrait 'industry' expanded at a phenomenal rate; while there were only three portrait galleries in London in 1841 and about a dozen by 1851, by 1861 there were in excess of two hundred.[1]

The demand for likenesses that were at once easy and inexpensive to obtain was satisfied by the photograph. The credibility of the camera image and the potential for unquestioning faith in its similitude to the person represented further added to the growth of the industry.

The primary function of the photographic portrait has been to record the faces and figures of kin, acquaintances, and the famous. As a document the portrait becomes a form of visual biography utilized for both immediate recognition and historical recollection. This function was accepted by the early pioneers of the medium and is still professed today. William Henry Fox Talbot, the inventor of the modern negative/positive printing process, inquired in his book *The Pencil of Nature:* 'What could not be the value to our English Nobility of such a record of their ancestors who lived a century ago?'[2] The significance of this role was made apparent by the thousands of commercial portraitists whose work filled albums and scrapbooks since the 1840's. With little art or expression in the portrayal of the sitter, with no charm or picturesqueness in the visage, countless photographs of barely identifiable individuals have been manufactured solely to record a face for another to consider.

A small percentage of portraitists obviously exercised varying degrees of artistic control in order to transcend the ubiquitous and uninteresting. These photographers have through time defined the limitations and possibilities of the camera portrait as a work of art. Some were amateurs like Degas and Lewis Carroll who had no intention of marketing their work. Others worked mainly as individual artists who also found some commercial outlets for their work: these included D. O. Hill and Robert Adamson, Julia Margaret Cameron, August Sander, Edward Weston, Alfred Stieglitz, and Diane Arbus. More were professionals such as Southworth and Hawes, Nadar, Cecil Beaton, Richard Avedon, and Edward Steichen who had to balance their own criteria of

aesthetic judgment with the exigencies of a client and a business. What-ever art they managed to apply to the finished picture, it was the basic need to document a likeness that remained paramount.

Essentially a professional photographer, Arnold Newman has accepted this fundamental requirement of the portrait: 'The portrait is a form of biography. Its purpose is to inform now and to record for history. We must record facts, not fiction or idealized images. The vital visual facts in today's magazine make up tomorrow's history textbook.'[3] Although Newman firmly believes the basis of the portrait is to record a likeness, he does not allow that any likeness will suffice nor that the content is most important. Before any portrait can be a good portrait, he has repeatedly claimed, it has to be a good photograph, which is why the best portraits are achieved by the most sensitive photographers.

As a factor in immediate recognition or as a mode of historical recol-lection, the portrait can range from a simple countenance to a complex array of material and symbolic data. These data can consist of gestures, facial expressions, physical accessories, emotive lighting, and environ-mental contexts. Most common commercially has been the accessory: the book on a table, the antique statue or column, the tools of the sitter's trade, and the superbly elegant fashion the sitter wears. Each of these artifacts denotes a quality of the sitter and inspires the viewer to an understanding of the subject's social situation, degree of intelli-gence, and other implied biographical details.

More predictably, especially so with amateur snapshots, the biograph-ical data external to the figure are contained within the backgrounds of the portrait. The environment in which the sitter exists, the archi-tecture or landscape with which he cohabits, informs the viewer with an understanding of the sitter's life and situation without recourse to a symbolic language. It is precisely the working out of the relationships that exist between a person and his environment that was the basis of Newman's early portraiture.

A preoccupation with abstraction, combined with an interest in the documentation of people in their natural surroundings, was the basis upon which I built my approach to portraiture. The portrait of a personality must be as complete as we can make it. The physical image of the subject and the personality traits that image reflects are the most important aspects, but alone they are not enough. . . . We must also show the subject's relationship to his world either by fact or by graphic symbolism. The photographer's visual approach must weld these ideas into an organic whole, and the photographic image produced must create an atmosphere which reflects our impressions of the whole.[4]

While this statement is valid for Newman's portraiture in general, he has since enlarged his conceptual framework by experimenting with graphics, abstractions, and more refined symbolism.

Around 1941, when Newman began to make portraits, there were few photographers attempting to integrate the sitter with his natural sur-roundings. It was with this goal in mind that Newman commenced his career as portraitist, an idea, as he often mentions, basic to the fun-damental structure of the ubiquitous snapshot. At their best, these inte-grative portraits function for Newman on a somewhat symbolic level, and he is convinced that the isolation of these people in their surround-ings is almost in itself a symbol. The symbolism is not a factor that is constructed out of the particular details and data of the portrait. Rather, the complex interrelationships of figure and environment act as a picto-rial code to the personality of the subject and as a demarcation of his character.

Much of the psychological trust in photographic likenesses has been culturally combined with the assumption that the human face is a vehi-cle for the individual's character. In 1850 the German philosopher Scho-penhauer could write:

That the outer man is a picture of the inner, and the face an expres-sion and revelation of the whole character, is a presumption likely enough in itself, and therefore a safe one to go by; borne out as it is by the fact that people are always anxious to see anyone who has made himself famous . . . photography . . . affords the most com-plete satisfaction of our curiosity.[5]

The camera's image was even allowed in extreme cases the facility of actually eliciting and capturing the sitter's inner personality. Holgrave, Hawthorne's photographer in *The House of the Seven Gables*, contin-ued at length about the penetrating insight of the daguerreotype por-trait and claimed simply that 'while we give it credit only for depicting the merest surface, it actually brings out the secret character with a truth that no painter would ever venture upon, even could he detect it.'[6]

Most photographers have not placed so much faith in any auton-omous, semi-magical quality of the camera, yet the majority of the more accomplished portraitists have admitted that one of the most necessary requirements for a good portrait was their ability to interpret the sitter and render not only a likeness but one which contained a cue to the sitter's inner character. The first attempt at an aesthetics of photogra-phic portraiture was written by the French critic Francis Wey in 1851. In his essay, 'The Theory of the Portrait,' Wey categorically declares that 'resemblance is not a mechanical reproduction but an interpretation that translates for the eyes the image of an object so that the spirit imagines it with the aid of the memory.'[7] Indeed, it was the strength of the picture's interpretation that made the image more a likeness of the subject than the subject himself. 'Let us not be afraid to affirm that, materially speaking, the copy of a figure is susceptible of seizing a

spectator by the power of the interpretation more vividly than even the reality could under certain circumstances.'[8]

The concept of the interpretative portrait, the portrait that captures something of the inner personality of the sitter, has been central to the photographic tradition. Since the 1840's and 1850's, most photographers and critics who have discussed their ideas of portraiture have stressed this concept. The French photographer Nadar stated simply that 'the portrait I do best is that of the man I know the best.'[9] The American critic A. J. Anderson wrote in 1910: 'The gift of character reading is essential in the portrait photographer; and once the sitter's character is discovered, it is no bad plan to try and photograph some predominant quality in the abstract.'[10] It depended to a great degree on the particular photographer whether or not he felt that his interpretation of the sitter was just or complete. While some picture makers of the last century strongly believed that they could discern the true inner personality of the individual portrayed, most photographers have admitted that theirs is but a single and incomplete analysis.

At the heart of Newman's portraiture is the idea of the interpretative rendering of the personality. Not only is this concept quite obvious in the images themselves, but Newman has also discussed at length his beliefs on the subject:

I'm convinced that any photographic attempt to show the complete man is nonsense, to an extent. We can only show, as best we can, what the outer man reveals; the inner man is seldom revealed to anyone, sometimes not even to the man himself. We have to interpret, but our interpretation can be false, of course. We can impose our own feelings upon a man, and these feelings can do him a great injustice – we cannot always be one hundred percent correct. I think one of the greatest tests of the portrait photographer is his intuitiveness, his ability to judge a person, his ability to get along with all kinds of people, from a street-car conductor to a prime minister of a world power, his ability to have sympathy for each man and to understand the man he is photographing, to show tact and understanding of the problem the man obviously faces being before the camera. . . . But, to continue with the concept of interpretation, let's contrast photography to painting. A painting is a matter of creative distortion, and photography is a matter of creative selection. A portrait photographer, or any photographer for that matter, must be selective because he [is] limited [by the] material in front of him. . . . Inevitably there is a great deal of the photographer in his finished product. . . . If there isn't much of him, then there isn't much of a portrait. In other words, the photographer must be a part of the picture. It's a matter of joining forces with the sitter, in a sense.[11]

Interpretation must always be a combination of knowledge and intuition, and the most effective intuitiveness is largely based on well-integrated pre-knowledge. Nadar had to know the sitter well in order to do a portrait that pleased him. The most dramatic Southworth and Hawes daguerreotype portrait is that of Massachusetts Chief Justice Lemuel Shaw bathed in an almost theatrical overhead light and taken in a moment of aesthetic inspiration while the Chief Justice was entering the studio. Southworth himself later stated that

what is to be done is obliged to be done quickly. The whole character of the sitter is to be read at first sight; the whole likeness, as it shall appear when finished, is to be seen at first, in each and all its details, and in their unity and combinations . . . in the result there is to be no departure from truth in the delineation and representation of beauty and expression, and character.[12]

Newman admits that intuition plays an important part in his photographic technique:

Strictly speaking, we should know as much as possible about the person from many sources; if he's well known, we may get the information from the printed page; if he's not well known, we may find it by visiting him and talking to friends and associates and going out to lunch or dinner beforehand, and so forth. This naturally helps, but sometimes – and every professional has this problem once in a while – the man walks in on you cold, or you must walk in on the man and his environment cold. In that case, you have only your intuition and the background of experience you have amassed over the years to help you make the judgements.[13]

The personality of a sitter is never static, and Newman believes that there is no such phenomenon as a complete portrait of an individual. Each portrait is nothing more than a rendering of a person's image at a given point in time. It may perhaps be inspired and revelatory, but it reveals a temporally changing character at a precise location and at a specific moment.

It seems to me that no one picture can ever be a final summation of a personality. There are so many facets in every human being that it is impossible to present them all in one photograph. When I make a portrait, I don't take a photograph. I build it, seeking all those graphic elements that will express the most typical common denominator of the subject as I see him within the obvious limitations of a single image.[14]

Stieglitz appreciated this problem when he embarked on his twelve-year multiple and composite portrait of Georgia O'Keeffe, and Newman somewhat more modestly achieved this sort of 'serial portrait' with Igor Stravinsky when he photographed the musician first in 1946 and then over a period of several months in 1965 for his book *Bravo, Stravinsky.*

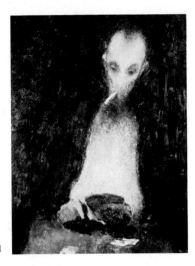 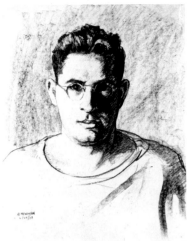 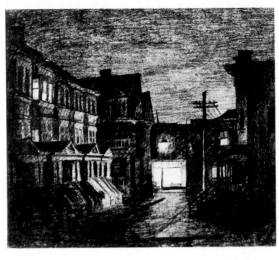 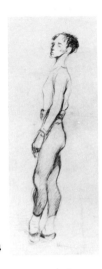

1 2 3 4

Arnold Newman's early art work. These were done by Newman outside of class or after leaving the University of Miami. **1.** *Gambler,* oil on board, 1937.

2. *Self-Portrait,* grease pencil drawing, 1938. **3.** *Street at Dusk,* grease pencil drawing, Atlantic City, 1938. **4.** *Dancer,* Conte crayon, 1938

Nevertheless, what is important to the formulation of a portrait, whether it is a portrait over a length of time or a single portrait at a given instance, is the distillation of what exactly connotes and denotes the person portrayed. Newman calls it the 'common denominator of the subject'; few have phrased it more aptly. His portraits, like all refined and accomplished portraits in any medium, have seldom, one senses, failed to achieve this distillation.

ARNOLD NEWMAN was born in New York City on March 3, 1918, the second of three sons of Freda and Isidor Newman.[15] Isidor had been in the clothing manufacturing business, but after this concern failed in the early 1920's, the family moved to Atlantic City, where Isidor started a dry-goods business. Like many other small family businesses, the Newmans went under because of the 1929 stock market crash. As a result, the father turned to leasing small hotels serving the tourist trade of Atlantic City and Miami Beach. The family divided their residence between Atlantic City in the summer and Miami Beach during the winter. To this day Arnold Newman attributes much of his compatibility and fascination with people to his early experiences in and around the hotel environment.

At about the age of twelve, he began displaying a marked aptitude for art which his parents encouraged, an encouragement, it should be stressed, entirely unusual during the Depression era. Graduating from Miami Beach High School in 1936, he was offered an art scholarship and matriculated at the University of Miami, then a relatively small institution of about 750 students. Newman received what amounted to a work-study scholarship which included the duties of hiring models, organizing classes, painting scenery for the University's theater, and executing a patio design for the school.

Newman continued his art studies from 1936 to 1938, during which time he met as a fellow member of his etching class David Douglas Duncan, later to be a renowned Magnum photojournalist. He studied under the 'realist' artists Denman Fink and Richard Merrick. His art work during this period took on certain distinct qualities of twentieth-century American realist painting, such as the rustic urban scenes of John Sloan or the forlorn, nocturnal urban images of Everett Shinn and Charles Burchfield, the latter's work having had a direct influence on Newman. The few pieces remaining are good examples of 1930's student realism, but what is more pertinent is that they show at the start of his career as a visual artist that Newman gravitated to the elements of realism and the data of everyday life – elements crucial to his photography later.

Economic imperatives forced Newman to quit school in 1938, and he moved to Philadelphia to accept his first real job possibility. The offer

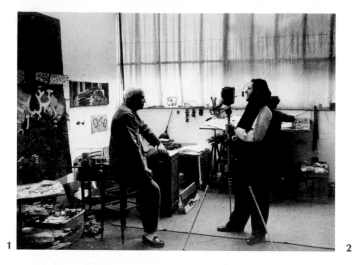

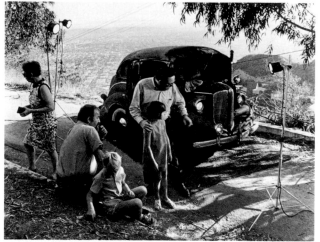

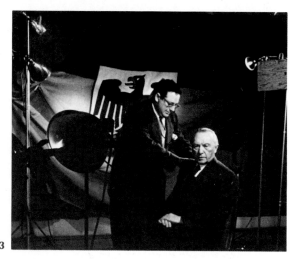

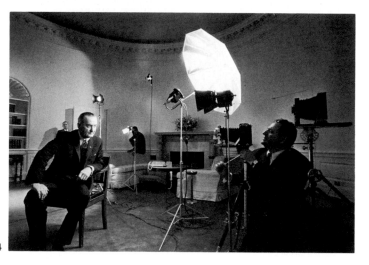

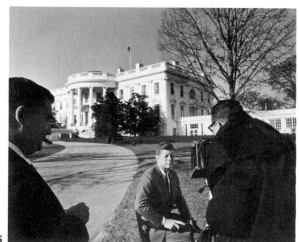

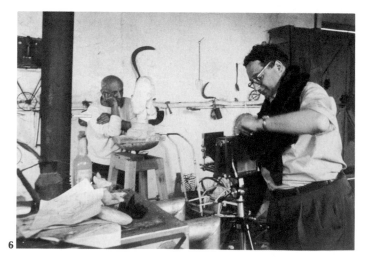

Arnold Newman on location:

1. *Georges Braque's atelier,* Normandy, France, for *Holiday* magazine, 1956. Portrait from this sitting on page 89.

2. *Edward Kienholz.* Los Angeles, on assignment for *Look* magazine, 1967. Portrait from this sitting on page 178.

3. *Chancellor Konrad Adenauer.* In the Chancellery, Bonn, Germany, on assignment for *Life* magazine, 1954. Portrait from this sitting on page 81.

4. *President Lyndon B. Johnson.* Photography for Johnson's Official Portrait, the White House, 1963. Portrait from this sitting on page 133.

5. *President John F. Kennedy.* The White House lawn, on assignment for *Holiday* magazine. (Pierre Salinger on left.) Portrait from this sitting on page 132.

6. *Picasso's atelier,* Vallauris, France, 1954. Portrait from this sitting on page 73.

came from Leon A. Perskie, a professional photographer and friend of the family. In a letter to Newman's father, Perskie wrote:

Relative to our conversation, I would like your son Arnold to report to work in Lit Brothers, Philadelphia, Pa. at the Photo Dept. on the 3rd floor, Monday, Sept. 19th. . . . You understand that in as much as he will be working as an apprentice, I cannot give you or him any assurance as to how steady the job will be. If his work is satisfactory and he takes to photography, I will keep him on, but if he does not interest himself and learn what has to be learned he will be of no use to me.[16]

Newman took the job and proved himself capable of both learning the trade and interesting himself in the craft. Newman had thought that he would be able to continue his art studies at night in Philadelphia but his concern for them began to suffer as he had developed a marked interest in photography as well as in contemporary art. His new interests were aided by his involvement and friendship with a group of student artists at the Philadelphia School of Industrial Arts. These were students of Alexey Brodovitch, art director of *Harper's Bazaar,* and included Ben Rose, whom Newman had already met in Atlantic City as his Boy Scout patrol leader and with whom he was staying in Philadelphia, and Sol Mednick; both have prominently figured in editorial and commercial photography since.

At Perskie's studio, Newman had to photograph up to seventy subjects a day and was paid sixteen dollars a week. But he photographed independently on his time off and found that his painting was soon supplanted by this new medium. Describing his early days, Newman states:

During lunch hours and weekends, I carried my borrowed camera (a 2¼ x 3¼ Contessa Nettle that belonged to my uncle) and tripod into the streets of Philadelphia, mostly around the area of the Lit Brothers Department Store, where I worked. At nights, having been granted special permission, I would work on my own photographs in the studio darkroom until midnight or later.

I began to experiment in photographic abstractions as well as social realism. I became fascinated with the control of the camera and the ability to make it see as I saw. The examination of one pack of film was enough to make me realize that I had to stop looking as a painter and try to examine in terms of the camera's eye. I read and looked up everything I could find on photography, going back to its beginnings as well as studying the work of contemporary photographers. My friends produced material from their libraries and gave freely of their advice and time. I went to museums and bought and clipped [used] magazines like Vanity Fair, a strong influence on me. However, the biggest impression was made by the photographs of the Farm Security Administration, principally those of Walker Evans, whose book was my most constant reference source during this period.

My job was a blessing in disguise. I had to make forty-nine-cent portraits, but before I was allowed behind the camera, I had to know every phase of the darkroom and know the use and meaning of every chemical that lined its shelves. A chemical mixture did not merely do something – I had to understand why and how.

I worked for over a year for this commercial chain in Philadelphia . . . in Baltimore and for a while in Allentown, Pennsylvania, exploring the cities and photographing on my own as I traveled.[17]

Perskie owned and operated several studios or concessions in department stores and drugstores in Allentown, Philadelphia, and Baltimore. Between 1938 and the autumn of 1939 Newman was moved at various times among these locations. Dissatisfied with the somewhat transient nature of the job, Newman quit and accepted a job offer to manage a Tooley-Myron Studio in West Palm Beach, Florida, in December of 1939. The studio was one of a chain of coupon portrait studios and Newman remained with it until his move to New York in 1941.

Nearly all of Newman's photographs from 1938 and 1939 exhibit those elements of pictorial concern he incorporated in his student art work: realism, genre subjects, and the depressing face of the urban landscape. Much of this sensibility came from his academic training, more out of the physical demands of the Depression. It is little wonder that the photographs of the Farm Security Administration, headed by Roy Stryker, attracted him and caused such an impression on him. 'Two Men on Front Porch' (West Palm Beach 1940), page 4, may well have been printed for Stryker's historical group; it has the same formalism and immediacy as an Evans picture and the same demand for humanistic sympathy as one by Dorothea Lange. Newman later met Stryker in the winter of 1941 with the idea of joining Stryker's group only to be told that it was breaking up. (Newman eventually did work with Stryker in 1952 for the Jones and Laughlin Steel Company of Pittsburgh.) Comparisons might also be made between these early images of the late 1930's and the works of Aaron Siskind, Morris Engel, and the other New York photographers who worked on 'The Harlem Document' during the same period, although Newman was unaware of these pictures.

Newman visited New York in the summer of 1939 and met for the first time the photographer and gallery dealer Alfred Stieglitz. Newman's diary gives an account of that encounter:

I walked into Stieglitz' gallery, 'An American Place,' at 509 Madison Avenue, with only a few months of photographic experience behind me and no photographs under my arm. Confronting me was the man himself, wearing a woman's apron as he was doing some

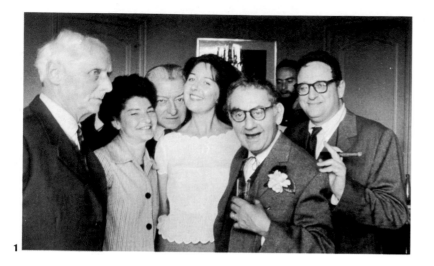

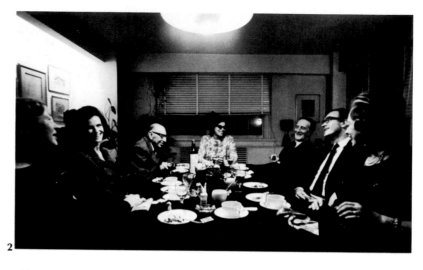

Personal photographs. 1. *Paris, 1960,* (left to right) Max Ernst, Juliet Ray (Mrs. Man Ray), François Baron, Dorothea Tanning (Mrs. Ernst), Man Ray, Arnold

Newman. 2. *Dinner at Newman home, 1966,* (left to right) Mrs. Marcel Duchamp, Jean Stein Vanden Heuvel, Igor Stravinsky, Augusta Newman, Marcel Duchamp,

printing of his work. I asked to see some prints, none of which were on the walls, and he allowed an assistant to show them to me. I will never forget my first impression of Stieglitz – it was dominated by the vision of a tremendous amount of hair growing out of his ears. Such is one's first thought when meeting, face to face, one of his idols.

Later, Stieglitz himself came in to see what I was taking so much time for, and remained to talk about photography with me. We decried the overemphasis on lab technique, though its importance we did not deny. The grand old man then mentioned something I have heard him repeat on later meetings – 'I don't care what you did or how you did it, I'm only interested in the finished picture.' Then he took me into his little dark room. I shall never forget it. Three trays with the shelves stocked with what he said could be bought in any drug store. No tricks. Imagine my excitement as I recognized prints in the hypo that were familiar to me. One was of O'Keeffe's hands, another of a girl sitting at a table near a window with a striped pattern of light on the wall behind her made by the shadows of the blinds. He explained that the Museum of Modern Art wanted him to give a one-man show but that he was doubtful as his health was failing. When I left, I asked him if he would look at my work sometime. I said that I thought my work was of sufficient interest to

deserve his criticism. He said he would and I floated out the door.[18]

Newman continued to support himself in commercial, 'small-studio' portraiture while maintaining an output of his personal photography. The increased salary of thirty dollars a week he earned at the Tooley-Myron Studio allowed him to buy a four-by-five-inch press camera, and in his spare time he devoted himself to shooting and printing his own pictures. Though many of the images from this period reflect a continuation of his pictorial themes and subjects from those of the late 1930's, the use of a larger format camera infuses them with a much greater resolution, clarity, and refinement of composition. A clear example of this would be a comparison between 'Convict Sign' (Philadelphia 1938) and 'Billboards' (West Palm Beach 1940). It is also during this period that Newman began his cut-out images and shaped photographic assemblages, a private concern of his that he revived some twenty-five years later, as seen in his 1966 portrait of Yaacov Agam (p. 183). With at once an almost Dada irreverence for the concept of the straight print and a constructivist's penchant for classicizing design formulations, Newman produced a series of completely modernist and entirely unexpected images.

On another trip to New York in June 1941, Newman met Beaumont Newhall, Curator of Photography at the Museum of Modern Art. On the same trip, and at Newhall's instigation, Newman paid another visit to

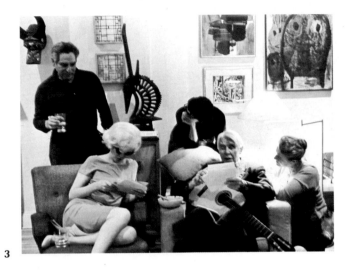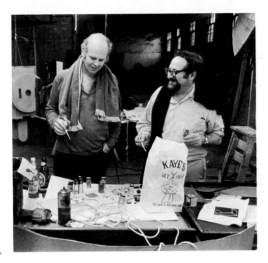

3 4 5

Robert Craft, Madame Stravinsky. **3.** *Newman home, 1962,* (left to right) Chaim Gross, Marilyn Monroe, Augusta Newman, Carl Sandburg, Renee Gross.

4. *Claes Oldenburg's New Haven studio, 1969,* Claes Oldenburg and Arnold Newman. **5.** *Paris, 1954,* Marc Chagall, Arnold, Eric, Augusta, and David Newman.

Stieglitz, who in turn viewed Newman's photographs and this time encouraged him. He also met Dr. Robert Leslie of *A–D* magazine and the A–D Gallery, then the only significant gallery outlet for editorial or photographic art work in New York. Leslie offered Newman a joint exhibition with Ben Rose, which opened in September of the same year. The printing and preparation for the show took place in West Palm Beach, while Newman terminated his employ with the Tooley-Myron Studio after having decided to move to New York. The A–D Gallery exhibition was well received by the press and was visited by many critics, art directors, and photographers, including Ansel Adams. Soon afterward, Newhall and Adams purchased one of the Newman photographs from the show for the Museum's permanent collection, the first of many museum acquisitions.[19] It was principally this exhibition, then, that launched Newman's career as a professional photographer.

Newman had moved to New York at the time of the opening of this exhibition. Between that winter and the spring of 1942 he utilized his commercial photographic training by taking portraits and advertising still lifes to comprise what amounted to a portfolio. But it was the portraiture that involved him the most and now he had greater personal control over the picture. The idea that he conceptualized at this time, the idea that was to be the basic nucleus of his future work, was

to take pictures of people in their natural surroundings with a little

stronger feeling about not just setting it up. . . . There wasn't any kind of conscious effort to put this thing together graphically . . . or any experiment in portraiture.[20]

Newman applied this concept to those he knew or got to know, and in the winter of 1941 he became acquainted with New York painters and sculptors.

I had been thinking for more than a year in terms of visual ideas, and it was comparatively easy for me to conceive of various visual themes related to the individual painters. The work of many of these men had influenced my own thinking and way of seeing, and it was a marvelous opportunity to meet them.[21]

A few days after the opening of his exhibition, Newman went to photograph the painter Reginald Marsh. Marsh was not in his studio but Raphael Soyer's was on the same floor and Soyer became the first of what Newman calls his 'experimental subjects.' Soyer introduced him to other painters in New York and Newman has been photographing artists ever since.

In the autumn of 1942, Newman returned to Miami Beach for induction into the United States Army. Receiving a temporary deferment, he remained in Florida and opened a portrait studio that expanded so rapidly that by the end of the war he was employing more than nine photographers and assistants. He now found himself debating between

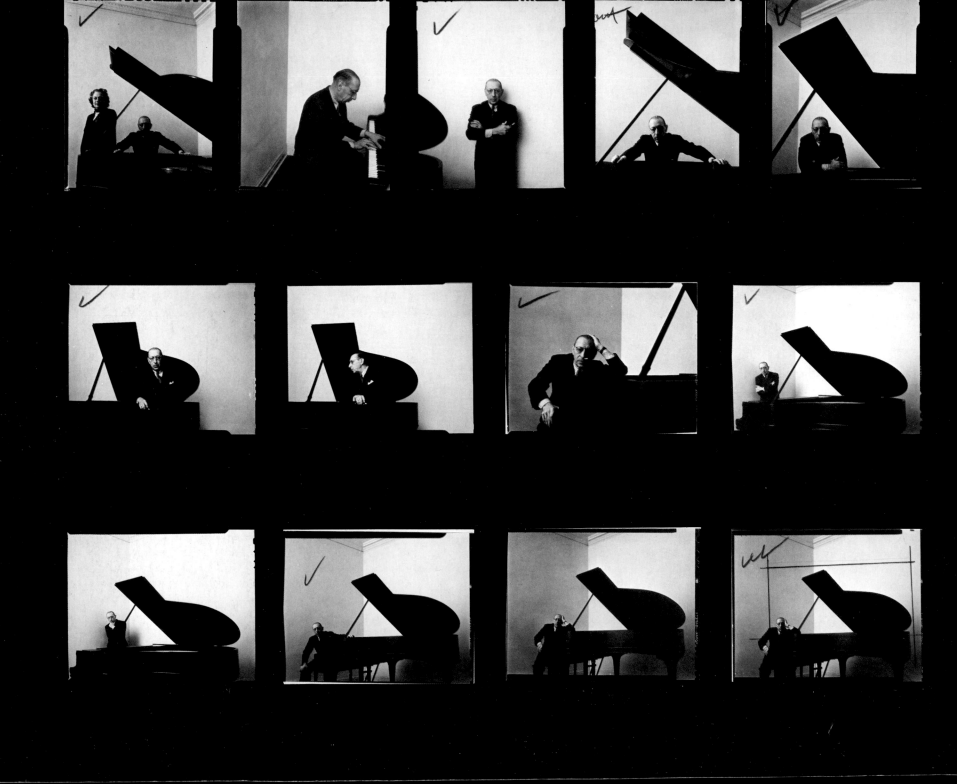

continuing with this potentially lucrative business, and risking his career in the uncertainties of New York. That he did finally choose to move back north was in part predicated by the success of his second, this time one-man, exhibition, 'Artists Look Like This,' which was held at the end of 1945 at the Philadelphia Museum of Art. The exhibition, consisting of portraits of artists living mostly in the New York area that Newman had made during the war years on various visits, was received extremely well. The Philadelphia Museum of Art purchased the show and transported it to other locations; it was also reviewed in *Life* and the *New York Times,* among other publications.

Moving to New York in 1946, his first, although temporary, studio was on Fifty-seventh Street. It was here that he worked on assignments for Alexey Brodovitch. Newman feels, and correctly so, that it was at this point that his professional career firmly began; it is likewise true that his opportunities also increased. Late in 1946, at the age of twenty-eight, he received his first assignment from *Life*, a portrait of the American playwright Eugene O'Neill, which for a youthful photographer was not exactly beginning at the lowest rung of the commercial ladder.

Life and *Harper's Bazaar* were Newman's major clients for his first two years in New York. Brodovitch, whom Newman considers an influence and teacher by osmosis, even entertained the idea of developing him into a fashion photographer for the magazine, an idea Newman did not receive very enthusiastically. The same year that he met O'Neill, Newman also achieved what is perhaps his most famous portrait: Igor Stravinsky at his piano. The picture was shot on assignment for *Harper's Bazaar* but was rejected by Brodovitch; one of the most noted photographic rejections.

Throughout the late 1940's Newman's pace of life grew more hectic and complex. He continued working on editorial assignments, principally for *Life*, remained financially modest, moved to West Sixty-seventh Street where he still lives and works, was exhibited at the Museum of Modern Art, and married Augusta Rubenstein. He had met Augusta in 1948 while she was working for the Haganah in Teddy Kollek's New York office smuggling arms to Israel. Since their marriage the following year she has remained one of his principal supports, acting as a combination studio assistant, secretary, business manager, and general companion as well as a wife and mother to their two sons, Eric and David. Their life-style together has been one of almost constant contact with artists and the city's cultural milieu. As a large number of the painters

Stravinsky sitting, New York City, 1946. Madame Stravinsky is in the top left print. There were twenty-six 4x5 inch exposures in the sitting, mostly variations of the thirteen prints on the facing page. Edge notchings were used to identify the negative holders. Portraits from this sitting on pages 39 and 40.

and sculptors Newman has photographed have exchanged pieces of their work with him, the Newmans have informally amassed a quite sizable collection. Their residence is a concise outline of mid-twentieth-century art, including among other items Mondrian's two preparatory charcoal sketches for *Broadway Boogie-Woogie*, a small bronze by Henry Moore, a de Kooning, an Oldenburg, a Rickey, an Indiana. At least in one respect, the medium Newman chose to devote his career to in the late 1930's has allowed him to surround himself with fine examples of his first visual love, painting.

Since the 1940's his career has not slackened in the least. From the 1951 one-man exhibition at the Camera Club of New York, an organization that had had as members both Stieglitz and Edward Steichen, to his large retrospective at the George Eastman House in 1972, Newman's schedule of exhibitions has stayed filled. His professional portraiture has consistently remained before the public view; from his series of portraits of the executives, columnists, feature writers, and critics of the *New York Times*, which was started in 1951 and spanned a number of years, to his cover portraits of artists for *Art in America* begun in 1973, he has been one of America's most visible portraitists. In 1968 he started teaching an advanced photography course at the Cooper Union in New York, and in 1972 he signed with the Light Gallery. Newman's vitality and energies have never failed him; he is as prolific at fifty-six as he was when he began his professional life.

The visibility and prolificacy Newman has enjoyed over the last quarter century are not the products of formula and repetition. His portraits are nearly always custom-formulated with the subject as an active foil. Each individual he photographs dictates more or less what the structure of the picture will be. There is a rather distinct difference of style between his portrait of Piet Mondrian of 1942 and that of Marcel Duchamp in 1966. Where one is stark, formal, and rigidly hierarchical in its depiction, the other is seemingly casual, humorously angled, and eccentric. It is apparent that the psychological makeup of the various subjects affected the photographer and his way of visualizing the finished portrait. Similarly, the black, introspective, and withdrawn aspect of Georges Rouault, 1956, is in marked contrast to the hard, aggressive appearance of David Smith in 1957. Each picture reflects an interpretation of the individual artist's way of seeing and, of course, presenting himself. The temptation even exists to read out pictorial statements of differing political philosophies in the three portraits (and environments as symbols) of Presidents Truman in 1960, Kennedy in 1961, and Johnson in 1963.

The capability of the sitter actively to affect the photographer's approach to his portrait has been a commonly understood psychological relationship. The 'facile' portraitist will allow the subject to com-

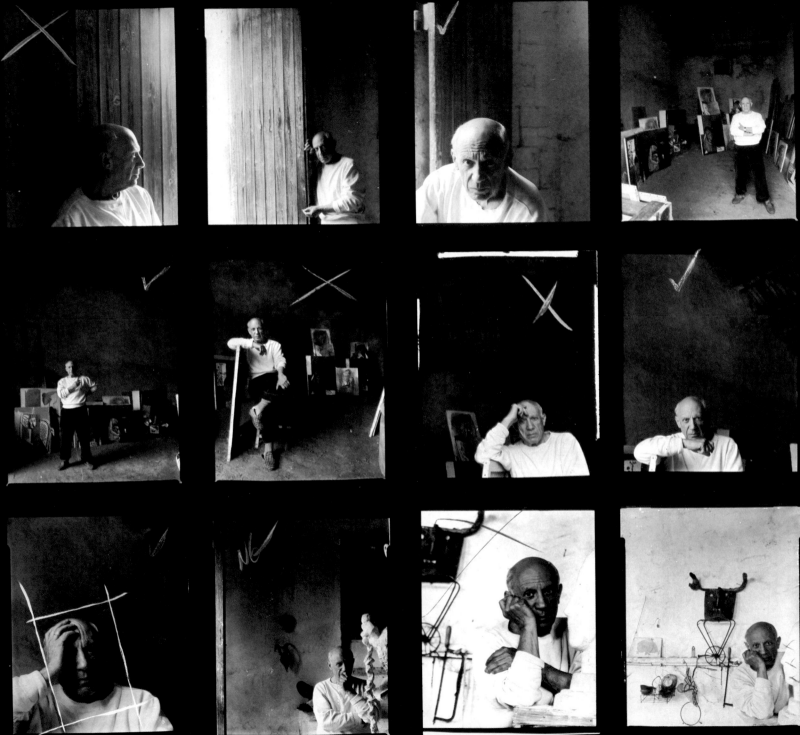

mand the entire picture from conception to retouched print. The more artistically exceptional photographer will use this potential as a catalyst to energize his own concerns and sensibilities. The more conscientious he is, the more the finished print will be a product of his overriding yet receptive control. Newman's complete control over the photograph is a prerequisite to his art, yet this control is not one of force or affect. He allows the subject to place himself and to relax into characteristic postures with a minimum of direction and choreography; often he will spend preliminary sessions conversing with the subject so that his self-consciousness will be diminished. Newman's role as portraitist is simply to select the appropriate surroundings and details and to lead the sitter gently toward a potentially significant relationship with his environment as witnessed through Newman's interpretation.

He leaves little to chance, infrequently allowing for a post-visualized accident. As much a product of his design and art training as his temperament, Newman's exquisite control is deliberately obvious at times. The geometric precision of his 1953 portrait of Harry Schwartz, the sensuous and enigmatic rendering of Jean Arp, 1949, and the mechanical emptiness of the Trova portrait of 1971 are all products of a constructivist and intellectual control of the image. Even the so-called 'accidental,' surreal shape of the smoke from Max Ernst's cigarette in his 1942 portrait appears almost as a pre-planned product of design. Newman constantly maintains a visual domination of every aspect of his picture: the setup, lighting, cropping, and printing values. In his own manner he is as meticulous about the overall design and the details of his pictures as one of his favorite painters, Mondrian, was about his compositions.

Arnold Newman has practically defined and established the twentieth-century environmental portrait in America. When he began portraiture there was no major photography being done in this mode. He recalls having been excited by the portraits of Stieglitz, Steichen, and Man Ray, all of whose work he saw at the Museum of Modern Art, but none of them emphasized a primary concern for situating the subject within an environmental framework. Walker Evans' work, as well as that of other FSA photographers, influenced his ideas but almost solely in terms of their power of pictorial interpretation and sensitivity to their subjects. Newman learned most of his craft in a rather ordinary portrait studio and applied his training in art and his aesthetic sense to the creation of his portraits.

Picasso sitting, Vallauris, France, 1954. This is a selection from about eighty 4x5 inch exposures, an exceptionally long series for Newman. In the early days he normally made eight to twelve exposures. Later an average sitting would consist of twenty to forty photographs. Portrait from this sitting on page 73.

Newman's work is decidedly within the tradition of photographic portraiture as it has developed for over a century. In many ways there are similarities between Newman's 'common denominator of the subject' and the sense of personality inherent in an early daguerreotype portrait. Forced to remain posed, usually clamped to a head rest for indeterminable lengths of time, the sitters for these simple portraits could not affect a deliberate expression or extreme gesture; their principal imperative was to not move. The result was an often blank, sometimes grave countenance that gave the image representational honesty and a fundamental, basic likeness. Newman has commented on this effect on more than one occasion, and perhaps it was precisely this effect that led Hawthorne's Holgrave to his exaggerated conclusion.[22] But whereas the nineteenth-century photographer, when he thought about the art of his medium, based his aesthetics largely on those of the allied pictorial arts, Newman is entirely in line with twentieth-century photographic art theory.

> We must see our subjects through the camera and not through the eyes of one who thinks in terms of another medium. . . . The subject of a photographic portrait must be envisioned in terms of sharp lenses, fast emulsions, textures, light and realism. He must be thought of in terms of the twentieth century, of houses he lives in and places he works, in terms of the kind of light the windows in these places let through and by which we see him every day. We must think of him in the way he sits and the way he stands in everyday life, not just when he is before the camera. This is thinking in terms of photography. We are perhaps not consciously producing an art form, but in clear thinking, at least we are creating, not imitating.[23]

This line of thought is thoroughly bound to the modernist stance that the craft's intrinsic imperatives are paramount to the fabrication of the complete work. It is this stance, fervently championed by Stieglitz earlier in the century, that has determined the framature of most twentieth-century creative photography. Throughout his career as a photographer, Newman has rigidly adhered to this line of thought. He has adhered to it, but he has not just produced a number of artistically glamorous photographic portraits. He has also, and this must be stressed, compiled a veritable compendium of significant *iconographies* that at once both counters and compliments his achievement as an artist. His portraits are excellent portraits whatever one's criteria of aesthetic judgment; they are at the same time an encyclopaedic index to the likenesses of important personalities. It would be moot to question whether one or the other role will take precedence in any future consideration of Newman's work to date. Both factors have worked in mutual dependence toward the realization of his art, and both will

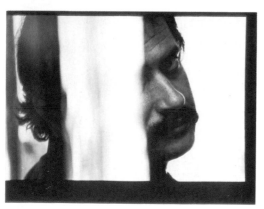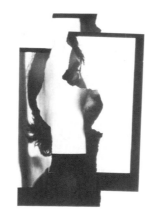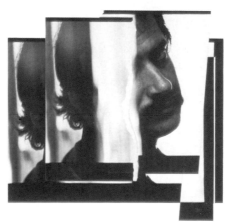

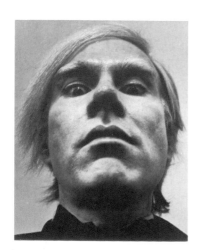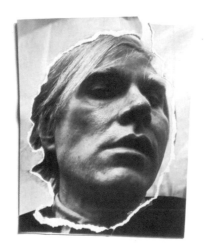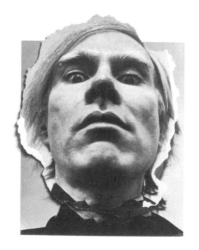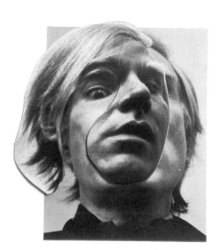

continue to be seriously entertained as comments on the history of the period.

Newman sees his photography in the metaphoric guise of graffiti on the walls of time signifying that he was here, as personalized verifications of existence. Like every sensitive and accomplished photographer, especially portrait photographer, Newman has formulated a series of signatured notational marks recording the ephemeral quality of expression and distilling, in his fashion, a formalized view of a single facet of a period through the appearances of its participants. That he has recorded is because he is a photographer; that his pictures are constructed so eloquently and mean so much aesthetically is because he is an artist.

Yaacov Agam sitting, New York City, 1966. The first four prints have been selected from the 35mm variations made by Newman. The fourth print was used to make the two following collages in 1972. The final collage is reproduced again on page 183.

Warhol sitting, New York City, 1973. These collages were made from two 2¼x2¼ negatives in 1974. The final portrait is on page 189.

NOTES

1. Helmut and Alison Gernsheim, *The History of Photography from the Camera Obscura to the Beginning of the Modern Era*, New York, 1969, p. 234.

2. William Henry Fox Talbot, *The Pencil of Nature*, London, 1844–1846, text adjoining plate XIV.

3. Cited in Charles Reynolds, unpublished ms. on Arnold Newman, collection of Arnold Newman.

4. Ibid., p. 40.

5. Arthur Schopenhauer, 'Physiognomy,' in *Religion: A Dialogue and Other Essays*, edited and translated by T. Bailey Saunders, London, n.d., p. 75.

6. Nathaniel Hawthorne, *The House of the Seven Gables*, Boston, 1964, p. 81.

7. Francis Wey, 'Théorie du portrait,' *La Lumière*, 1 année, no. 12 (27 April 1851), p. 46, col. 3.

8. Ibid., p. 46, col. 2.

9. Cited by André Jammes and Robert Sobieszek, *French Primitive Photography*, New York, 1970.

10. A. J. Anderson, *The Artistic Side of Photography in Theory and Practice*, London, 1910, p. 319.

11. Arnold Newman and Arthur Goldsmith, 'A Popular Photography Tape Interview: Arnold Newman on Portraiture,' *Popular Photography*, vol. 40, no. 5 (May 1957), pp. 125–126. Additions in [. . .] signify *post hoc* emendations by Newman.

12. Cited in Beaumont Newhall, *The Daguerreotype in America*, New York, 1961, p. 44.

13. Newman and Goldsmith, op. cit., p. 126.

14. Reynolds, op. cit., pp. 9–10.

15. Much of the biographical information has been obtained from Reynolds, op. cit., and from conversations with Newman.

16. Letter from Leon A. Perskie to Isidor Newman, September 13, 1938, collection of Arnold Newman.

17. Cited in Reynolds, op. cit., p. 18. Addition in [. . .] signifies a *post hoc* emendation by Newman.

18. Ibid., pp. 20–21.

19. In a letter from Adams to Newman dated September 25, 1941, collection of Arnold Newman, Adams states: 'I was vastly pleased with your exhibit. Mr. Newhall and I agreed that the Museum should purchase one of your prints. . . . My personal opinions, not concerned with the Museum at all, are *most* favorable to your work. I feel you have something very real and refreshing to say, and your print quality is gratifying.'

20. From conversations with Newman, autumn 1973.

21. Cited in Reynolds, op. cit., p. 23.

22. Newman notes: 'Ben Shahn and I once had a long conversation about a theory of his. He thought that during the long exposures required for the daguerreotype, the sitter would have many and different thoughts and these gradually settled the expression "most typically" [sic] of the sitter.' Letter to David R. Godine, undated (winter 1974).

23. Cited in Reynolds, op. cit., pp. 37–38.

PORTRAITS AND OTHER PHOTOGRAPHS

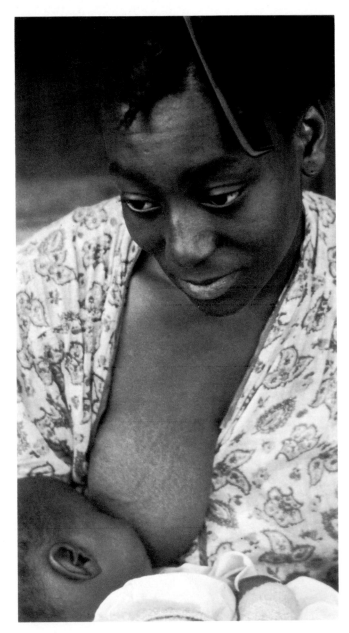

1. *Mother and child*, Philadelphia, 1938

2. *Convict sign*, Philadelphia, 1938

3. *Brick abstract*, Baltimore, 1939

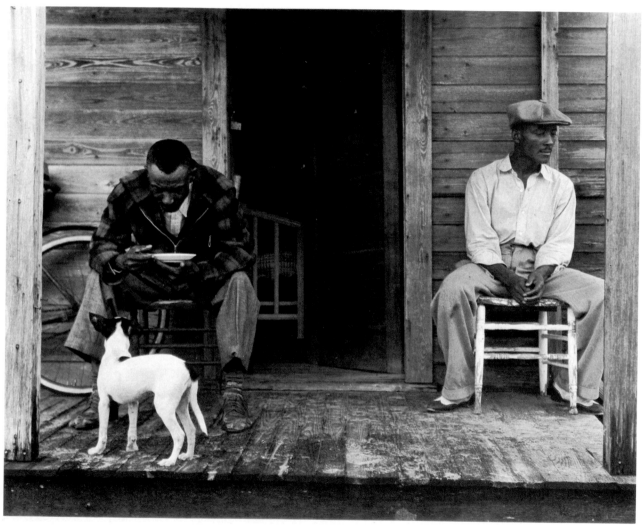

4. *Two men on front porch*, West Palm Beach, 1940

5. *Wall and ladders*, Allentown, Pennsylvania, 1939

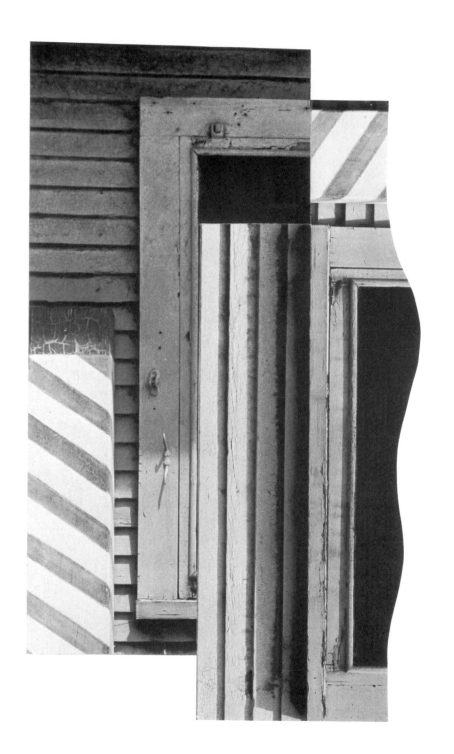

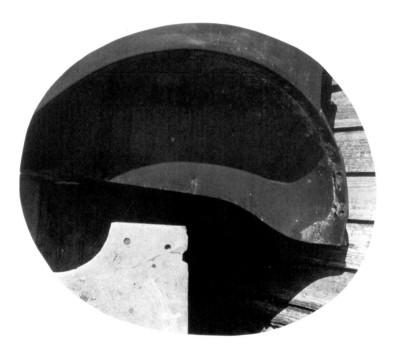

6A. *Barber shop cutout no. 1,* West Palm Beach, 1940

6B. *Circle,* West Palm Beach, 1940

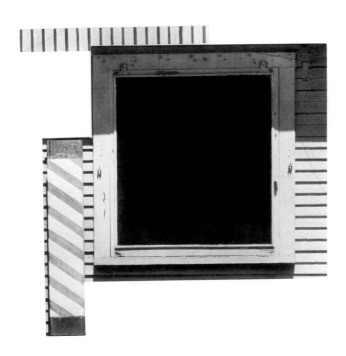

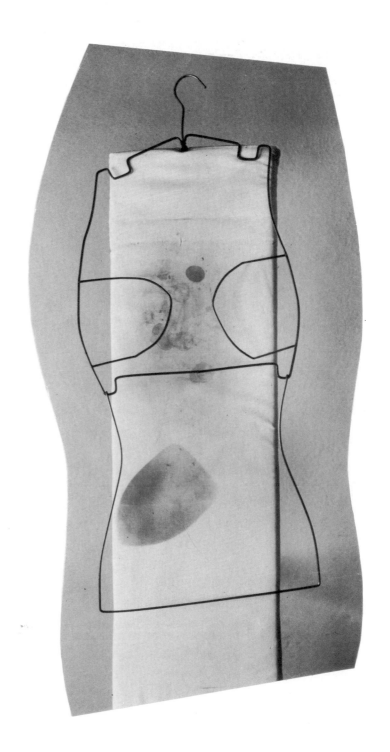

7A. *Barber shop cutout no. 2*, West Palm Beach, 1940

7B. *Ironing board cutout*, Miami Beach, 1940

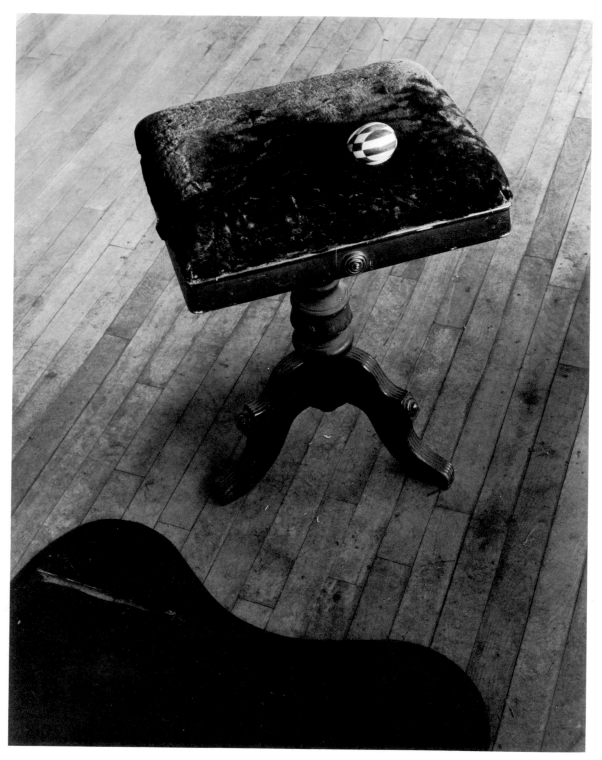

8. *Posing bench*, West Palm Beach, 1941

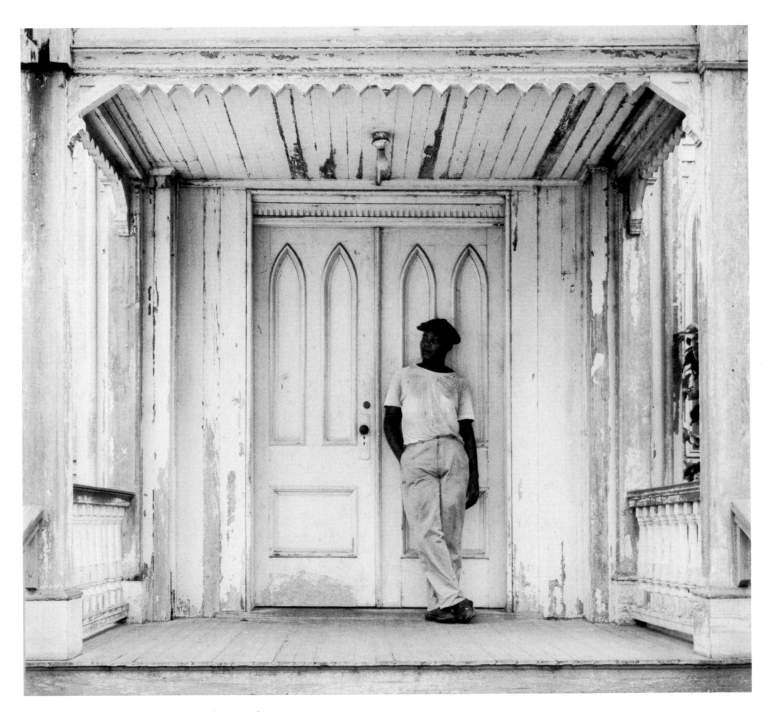

9. *Man on a church porch*, West Palm Beach, 1941

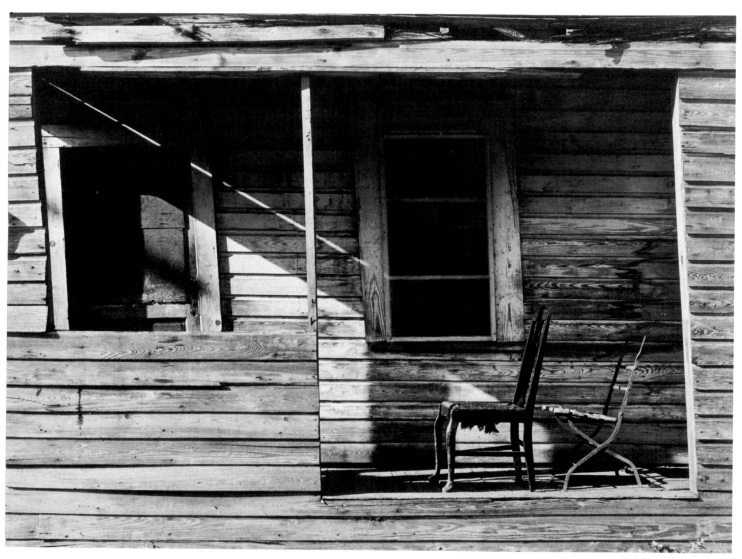

10. *Porch and chairs,* West Palm Beach, 1940

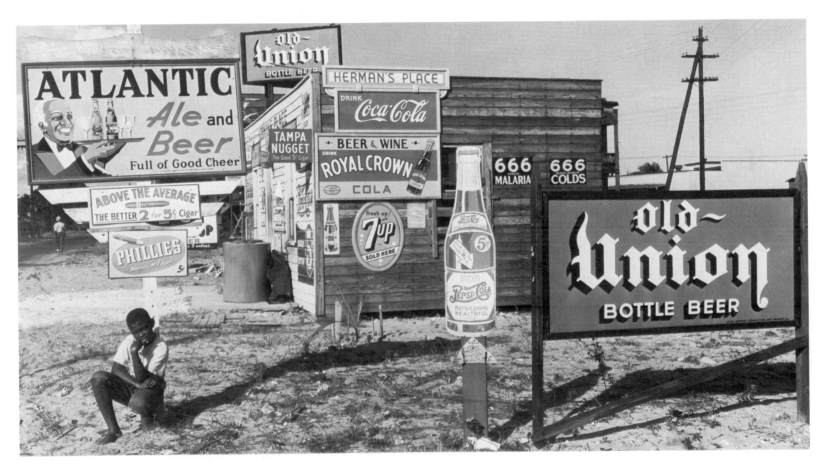

11. *Billboards,* West Palm Beach, 1940

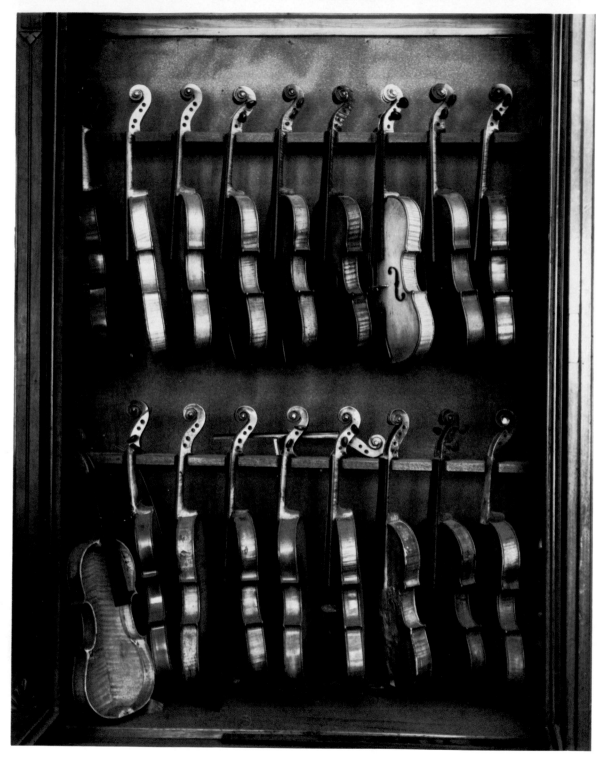

12. *Violins*, Philadelphia, 1941

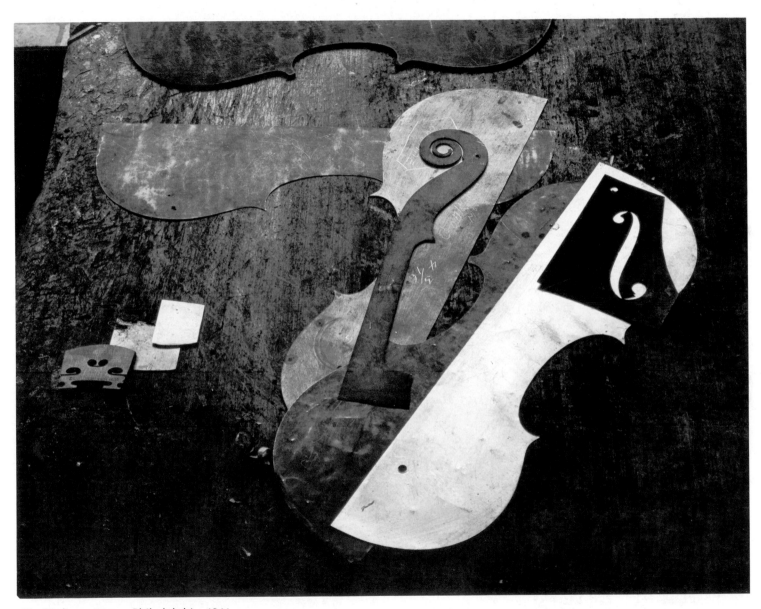

13. *Violin patterns*, Philadelphia, 1941

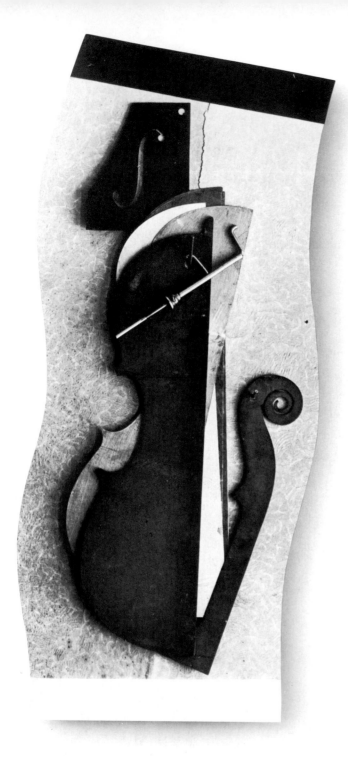

14. *Violin patterns cutout,* Philadelphia, 1941

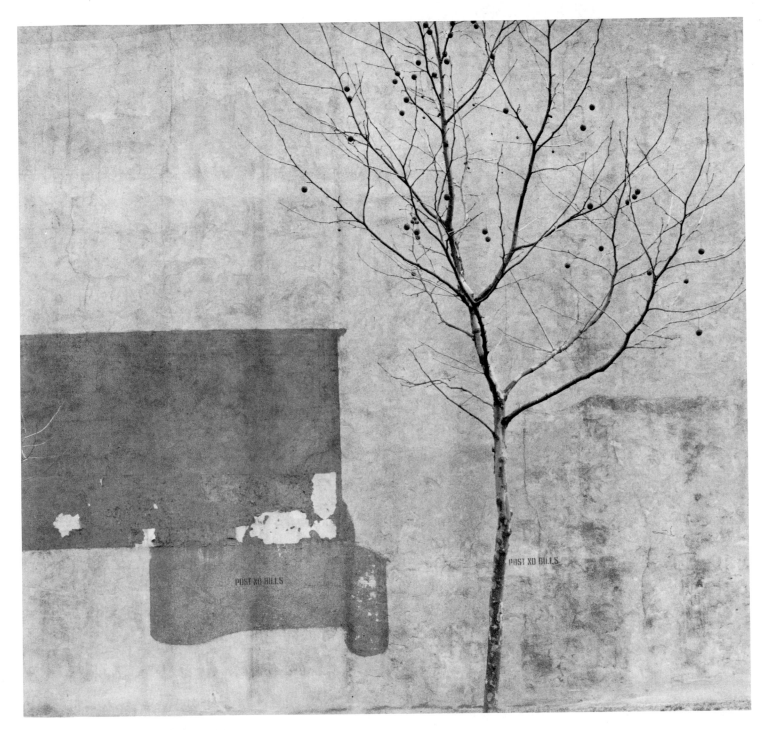

15. *Tree and wall,* Philadelphia, 1941

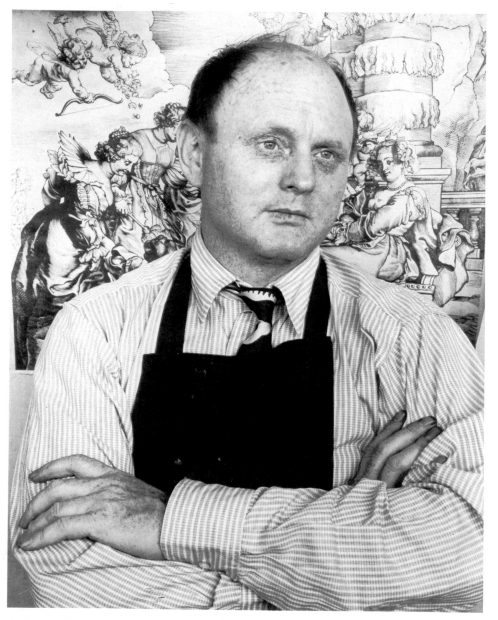

16. *Reginald Marsh,* One Union Square Studio, New York City, 1941

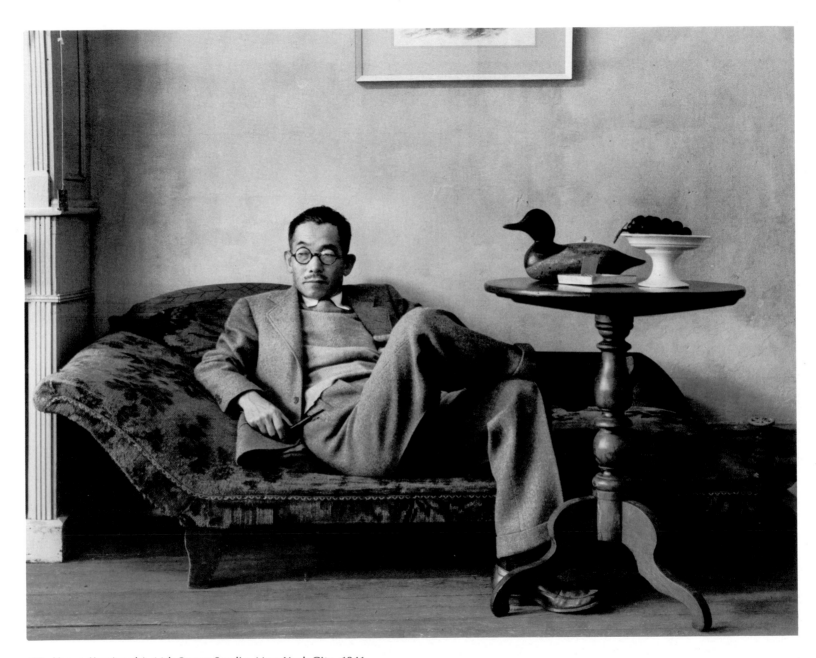

17. *Yasuo Kuniyoshi,* 14th Street Studio, New York City, 1941

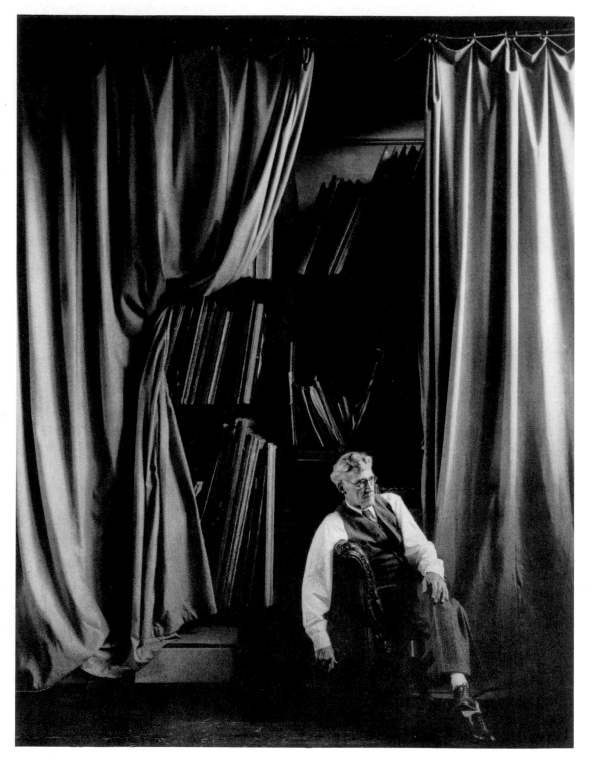

18. *John Sloan,* Chelsea Hotel Studio, New York City, 1941

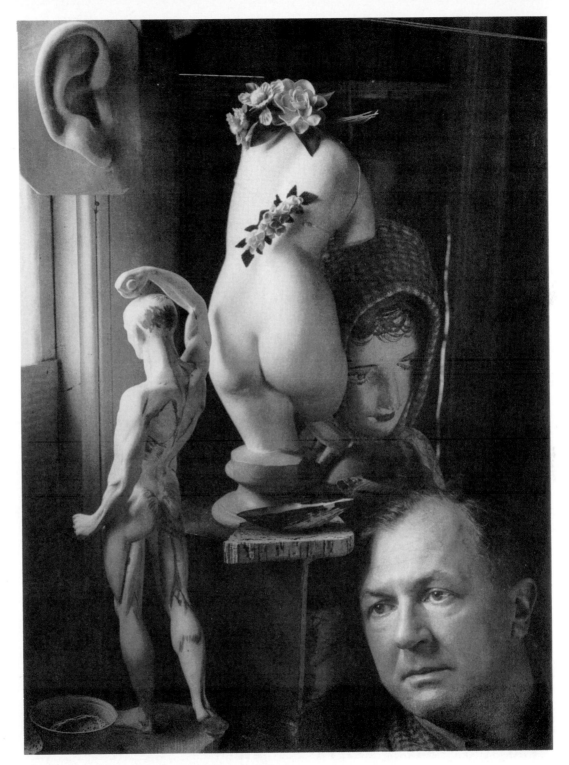

19. *George Grosz*, Bayside, Long Island, 1942

20. *Joseph Stella*, New York City, 1943

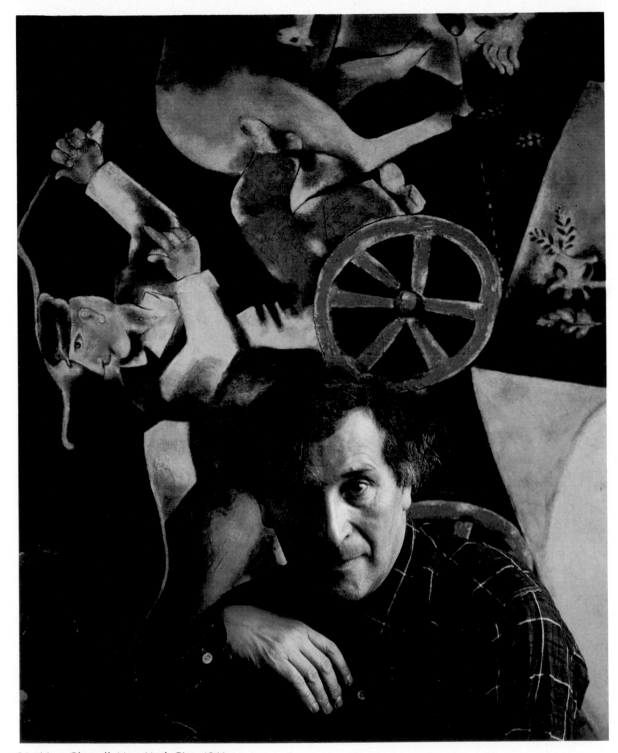

21. *Marc Chagall*, New York City, 1941

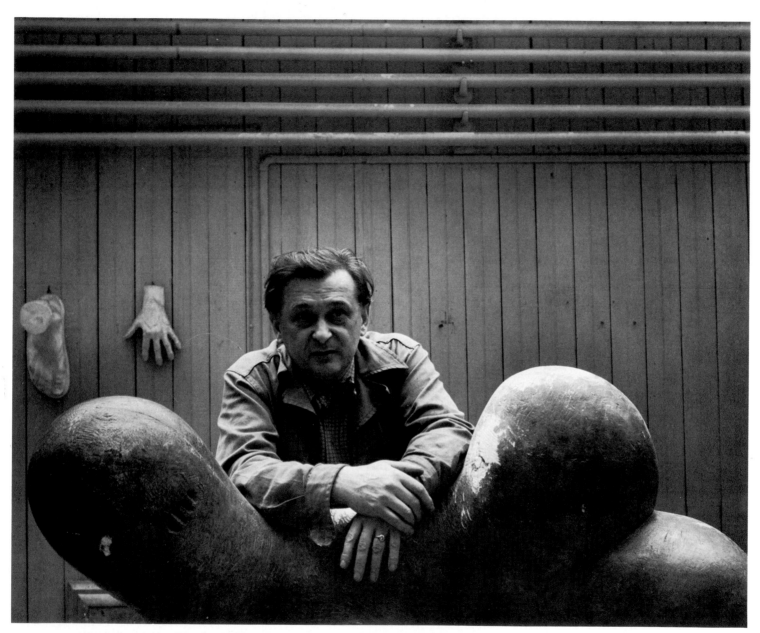

22. *Jacques Lipchitz*, New York City, 1946

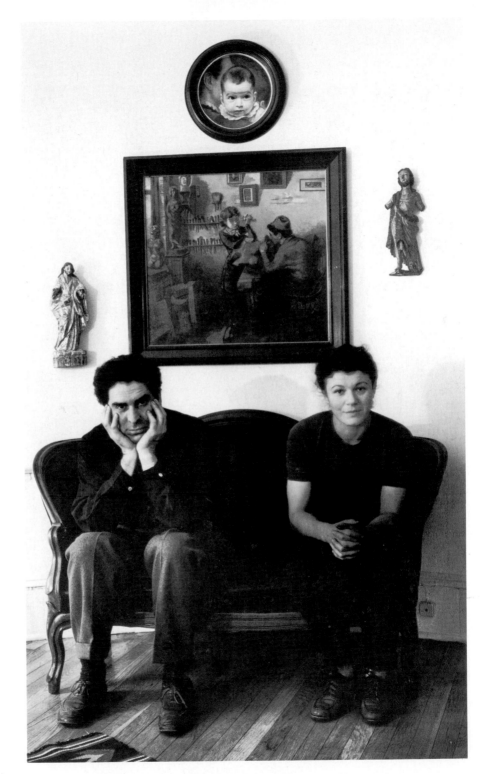

23. *Chaim and Renee Gross*, New York City, 1942

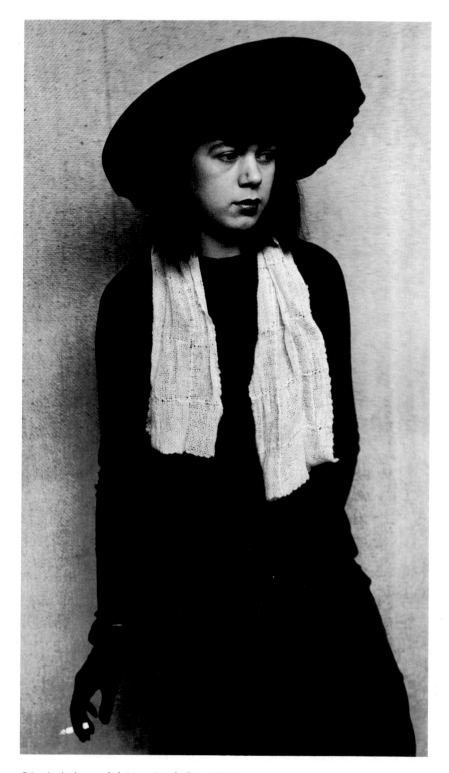

24. *Artist's model,* New York City, 1942

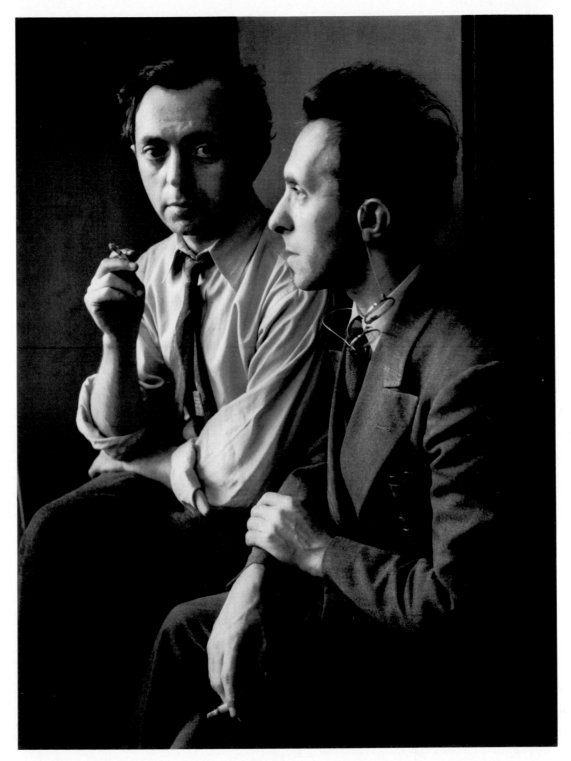

25. *Moses and Raphael Soyer*, New York City, 1942

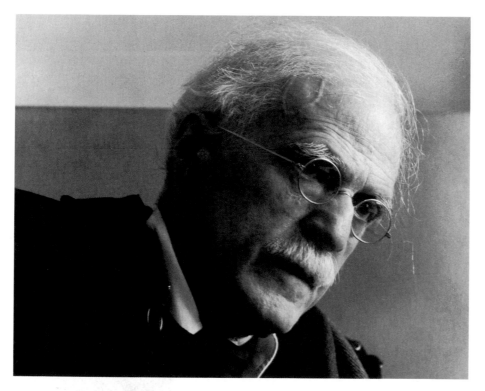

26. *Alfred Stieglitz,* at 'An American Place,' New York City, 1942

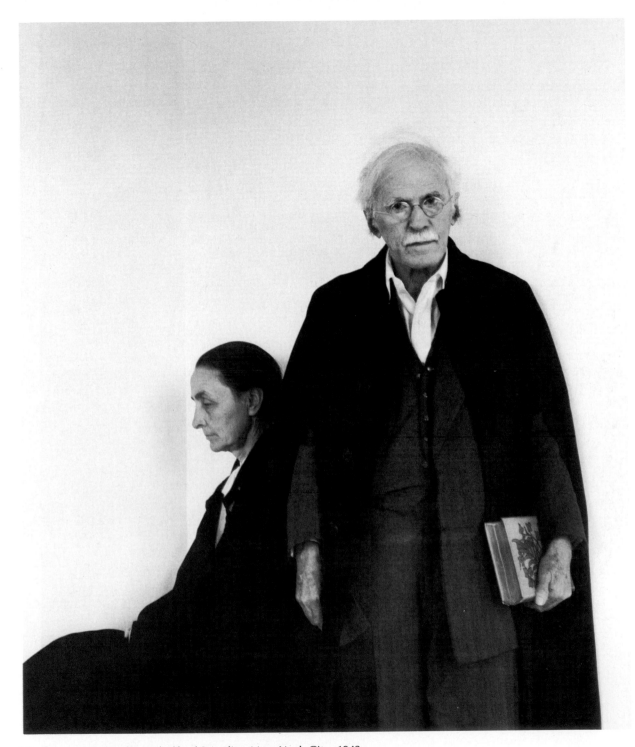

27. *Georgia O'Keeffe and Alfred Stieglitz*, New York City, 1942

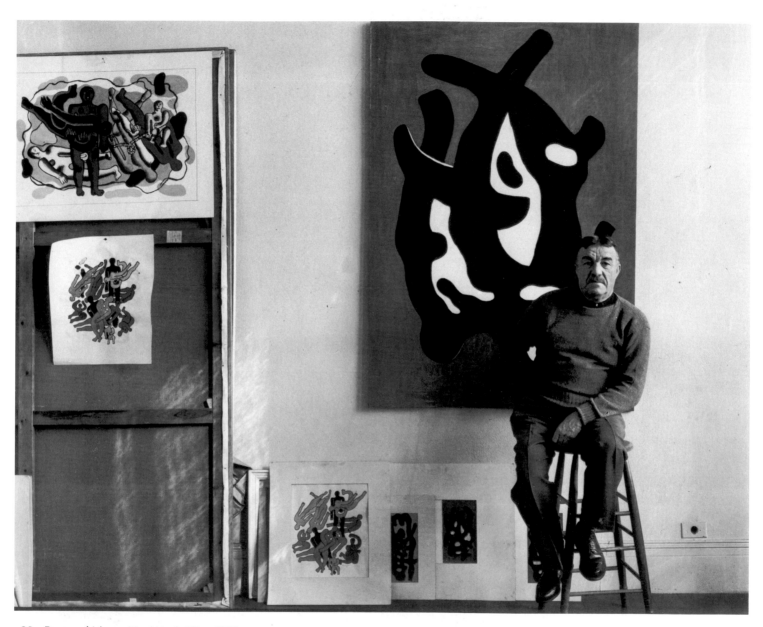

28. *Fernand Léger,* New York City, 1941

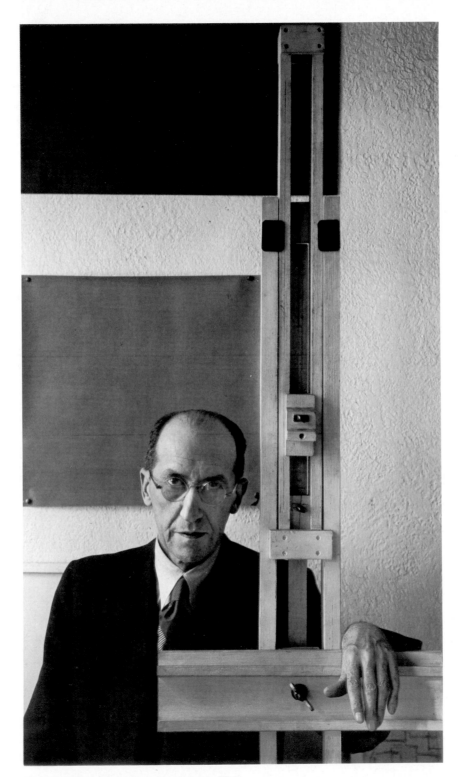

29. *Piet Mondrian*, New York City, 1942

30. *Marc Blitzstein*, New York City, 1945

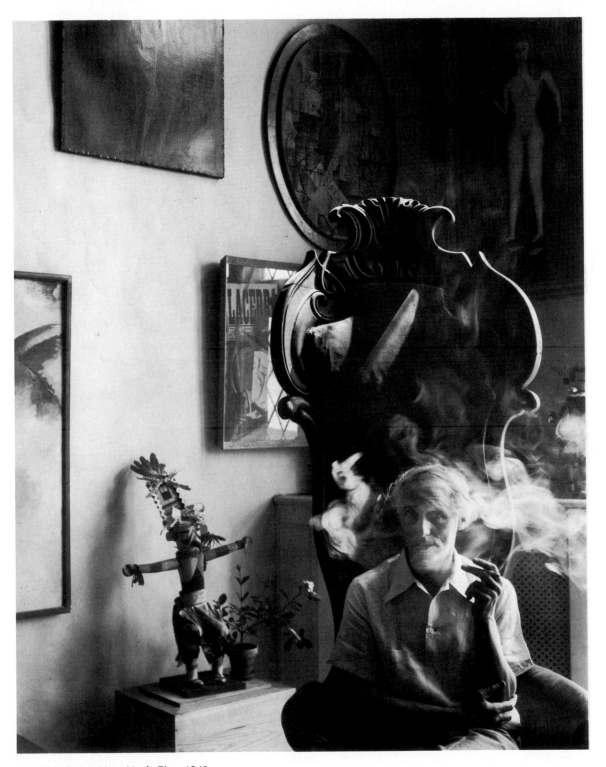

31. *Max Ernst*, New York City, 1942

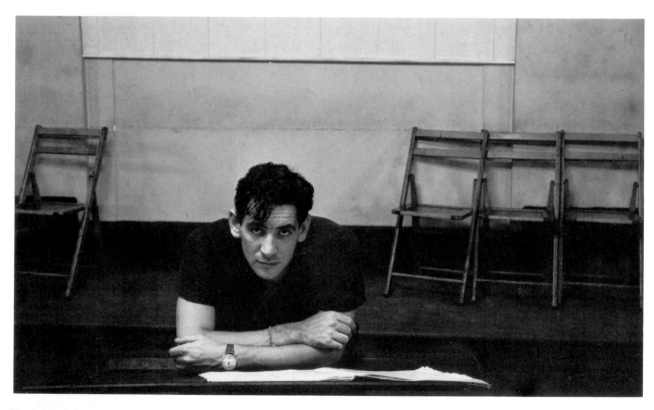

32. *Leonard Bernstein,* City Center Rehearsal Hall, New York City, 1946

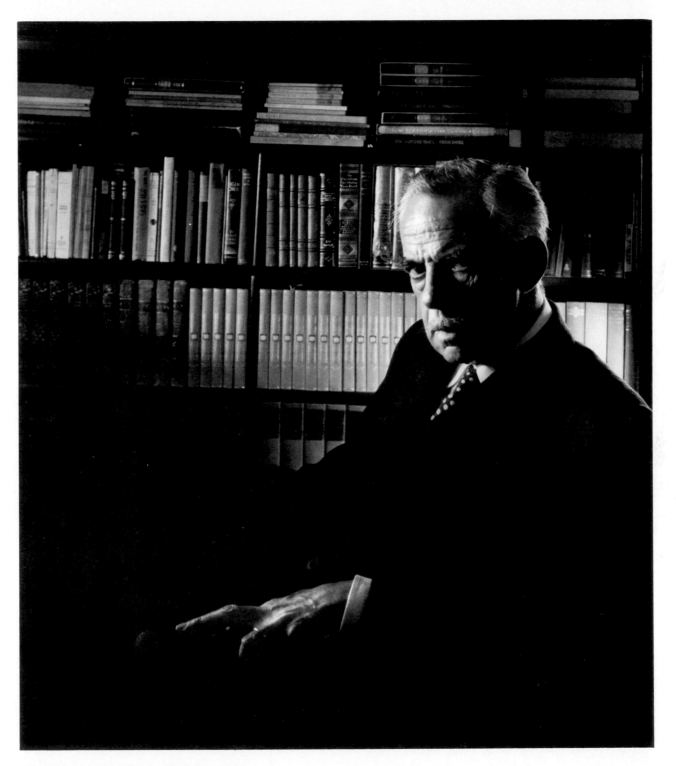

33. *Eugene O'Neill,* New York City, 1946

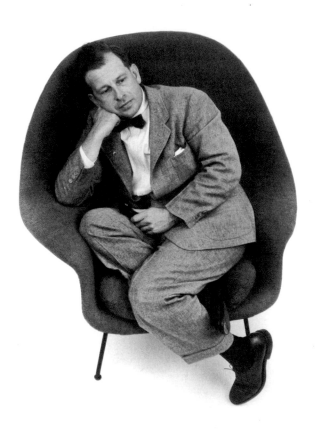

34. *Eero Saarinen,* New York City, 1948

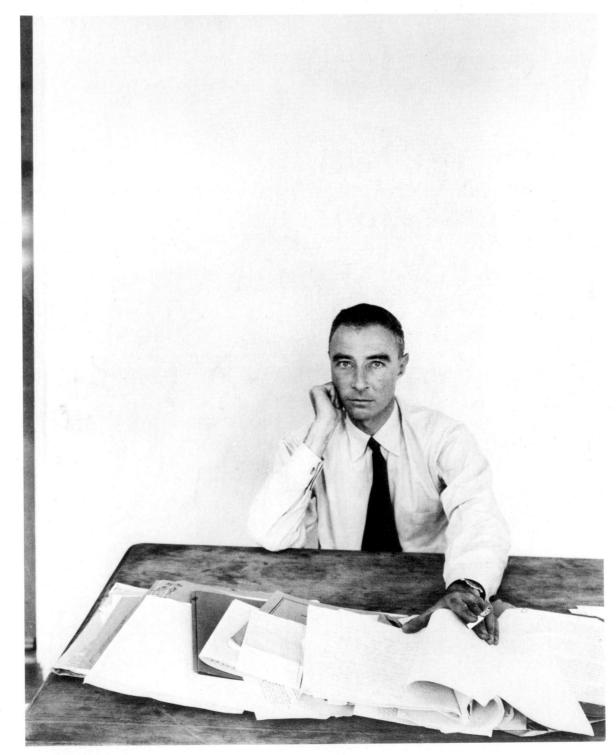

35. *Dr. J. Robert Oppenheimer*, Berkeley, California, 1948

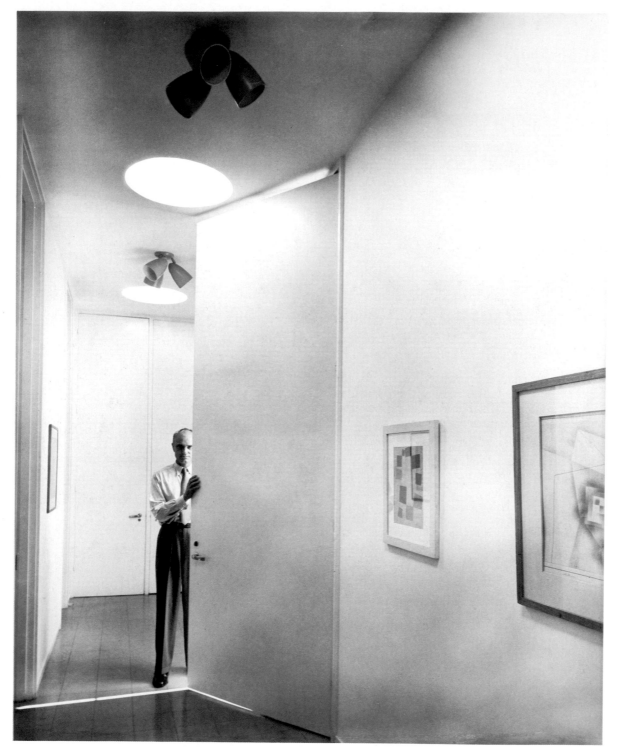

36. *Philip Johnson*, New Canaan, Connecticut, 1949

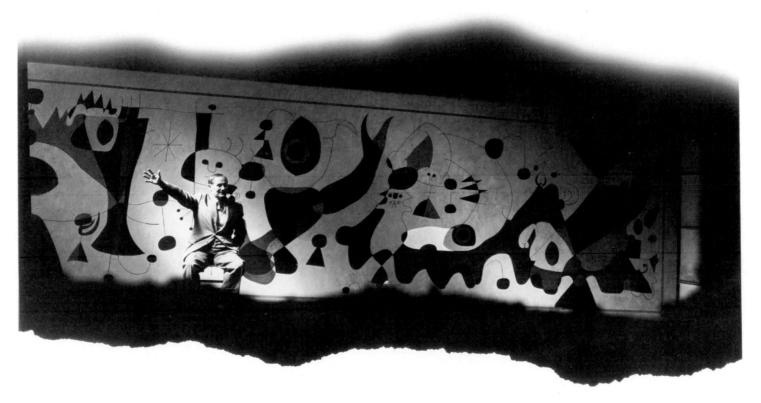

37. *Joan Miró*, New York City, 1947

38. *Heitor Villa-Lobos*, New York City, 1950

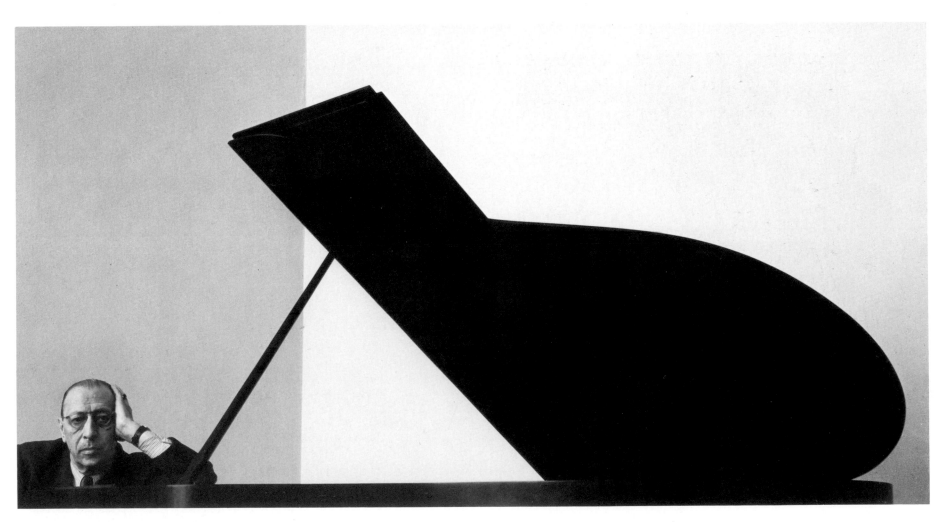

39. *Igor Stravinsky,* New York City, 1946

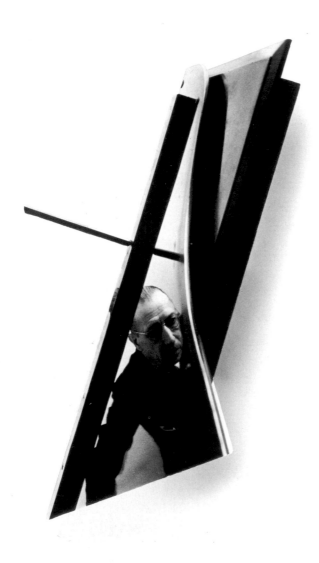

40. *Igor Stravinsky cutout*, New York City, 1946

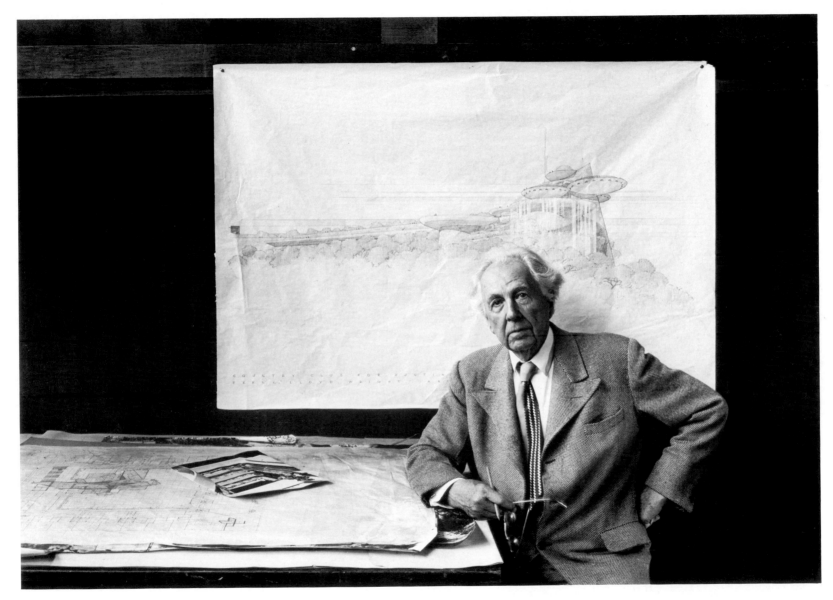

41. *Frank Lloyd Wright,* Taliesin East, Wisconsin, 1947

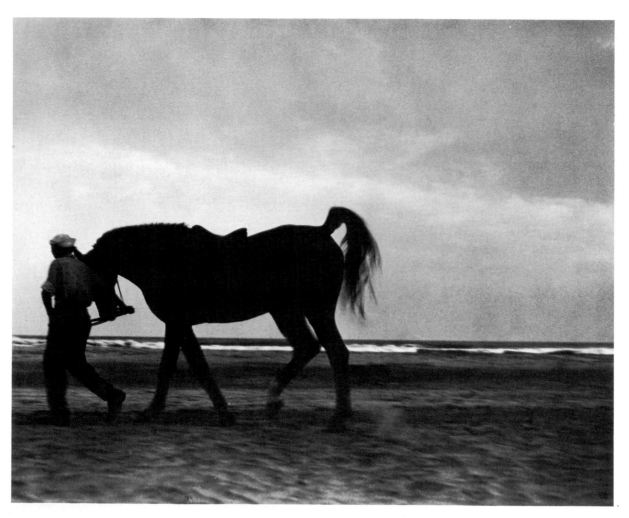

42. *Boy and horse*, Atlantic City, New Jersey, 1947

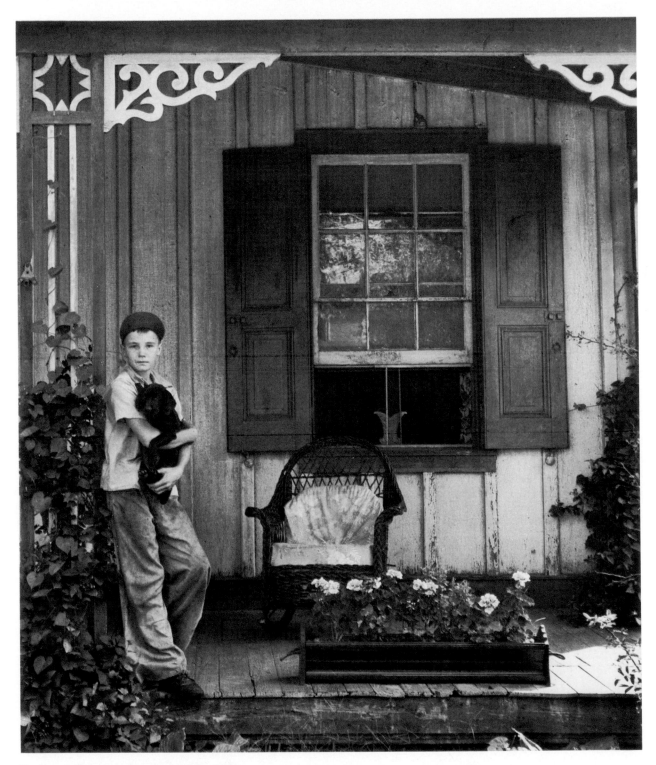

43. *Boy and dog,* Arden, Delaware, 1947

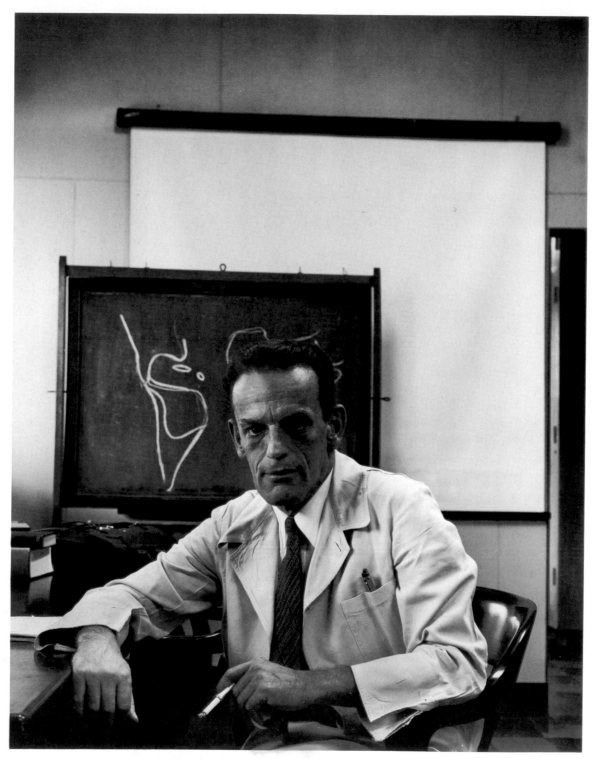

44. *Dr. Max Theiler,* Nobel Prize winner, New York City, 1951

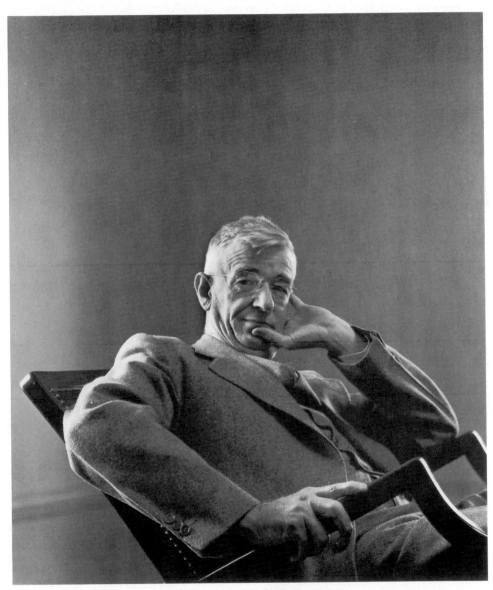

45. *Dr. Vannevar Bush*, Massachusetts Institute of Technology, Cambridge, 1949

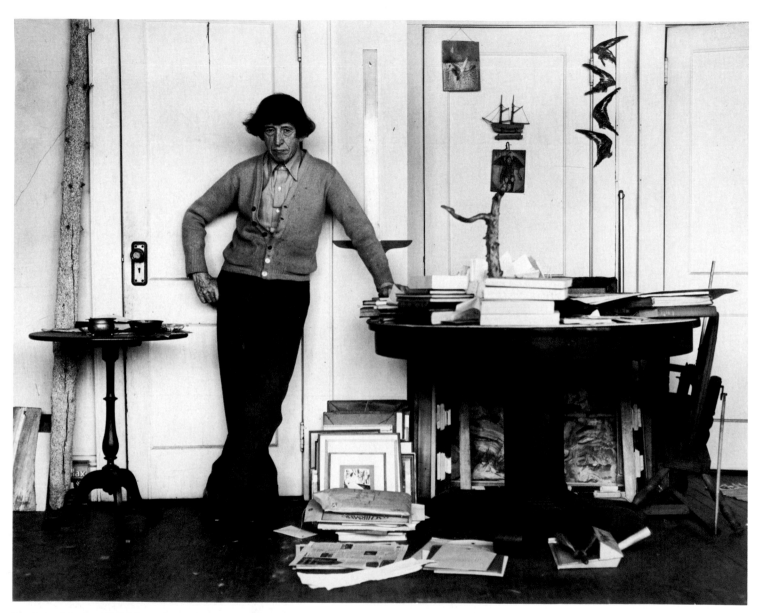

46. *John Marin*, Cliffside Park, New Jersey, 1947

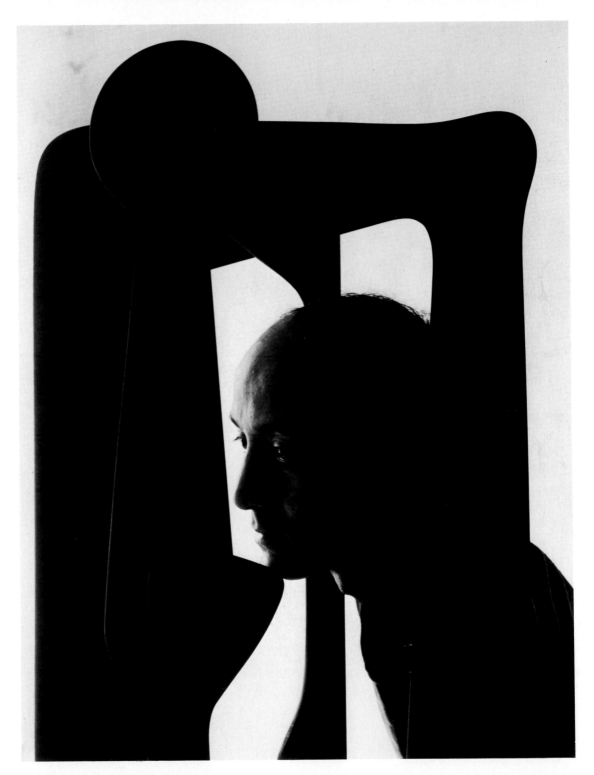

47. *Isamu Noguchi,* New York City, 1947

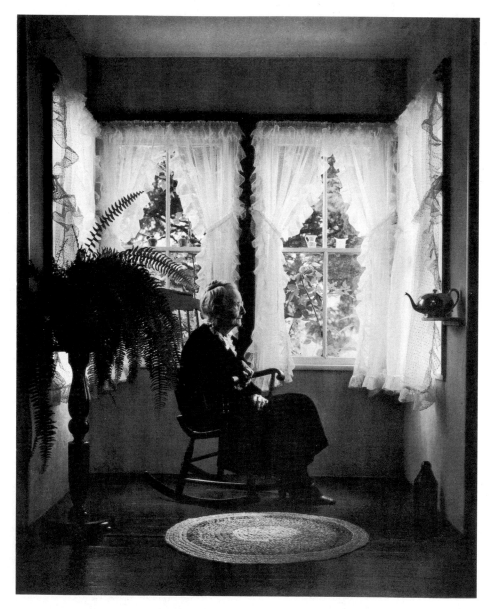

48. *Grandma Moses,* Eagle Bridge, New York, 1949

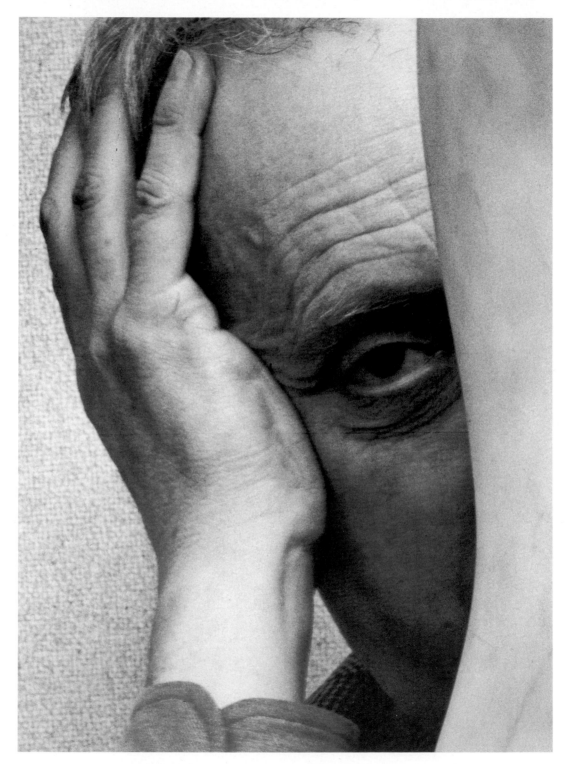

49. *Jean Arp,* at Buchholz Gallery, New York City, 1949

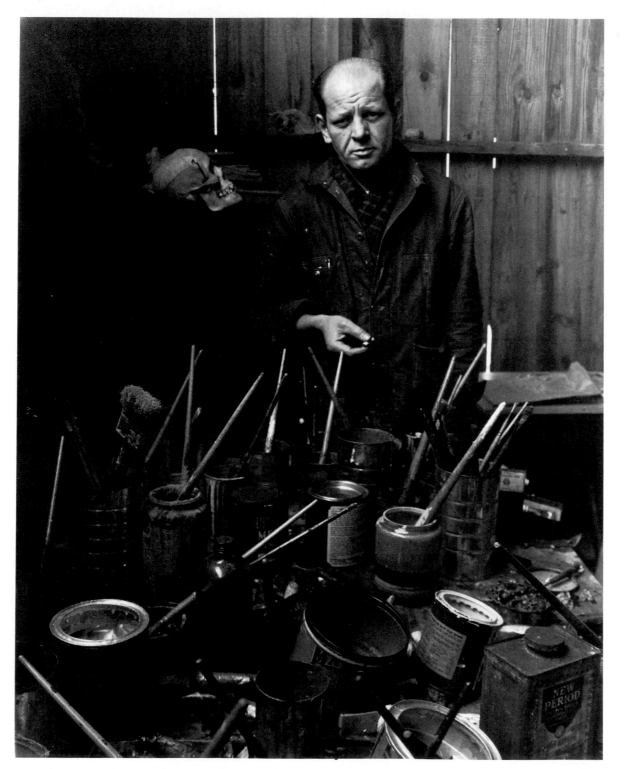

50. *Jackson Pollock,* Springs, New York, 1949

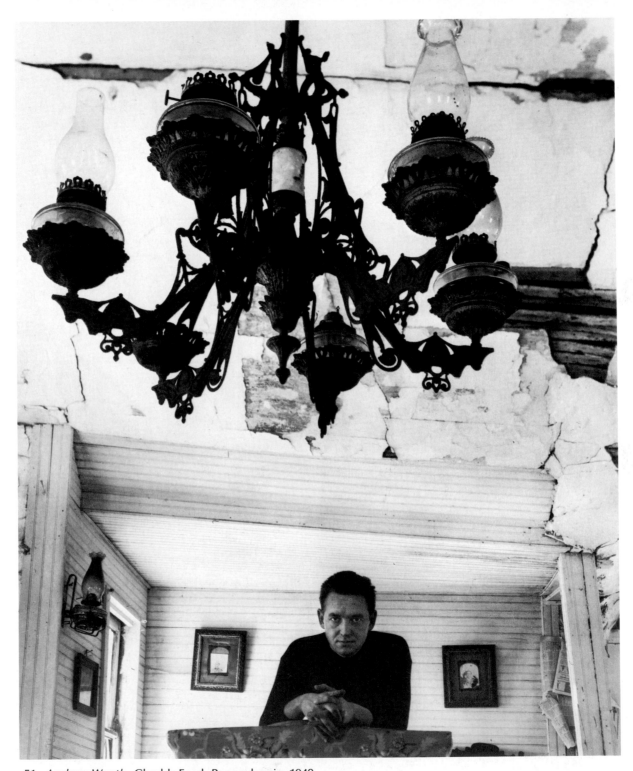

51. *Andrew Wyeth,* Chadds Ford, Pennsylvania, 1949

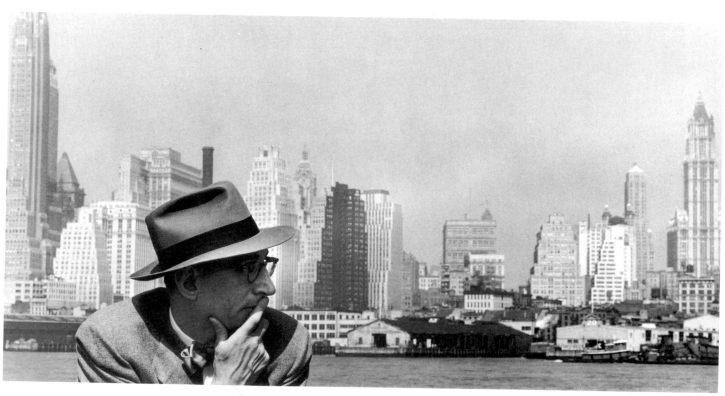

52. *Meyer Berger, New York Times* columnist, New York City, 1951

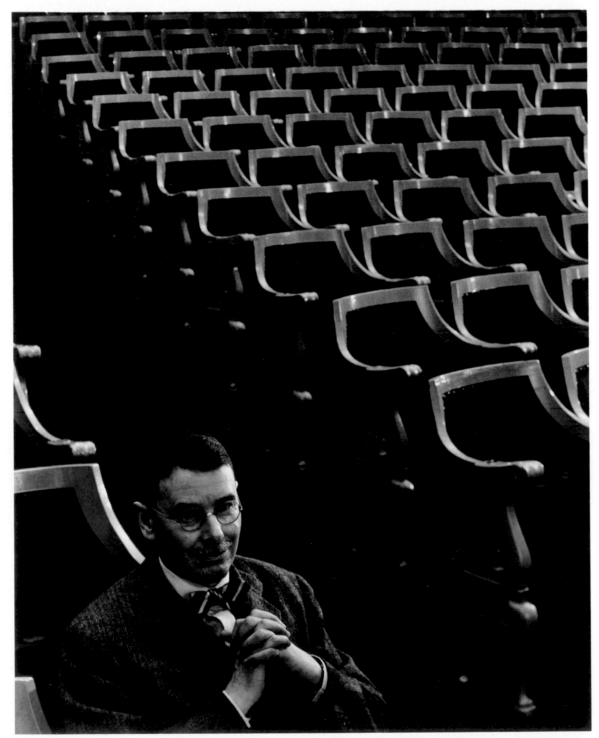

53. *Brooks Atkinson, New York Times* drama critic, at the Morosco Theatre, New York City, 1951

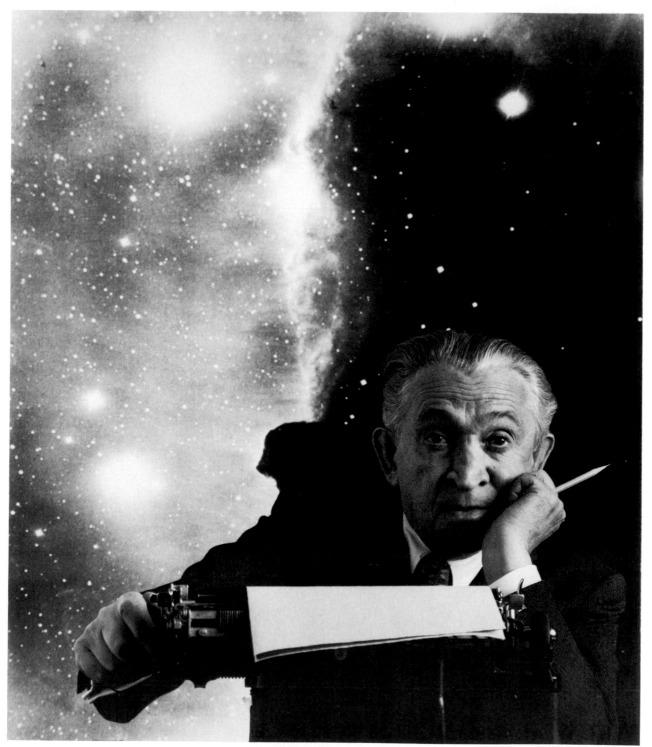

54. *William L. Laurence, New York Times science editor, New York City, 1955*

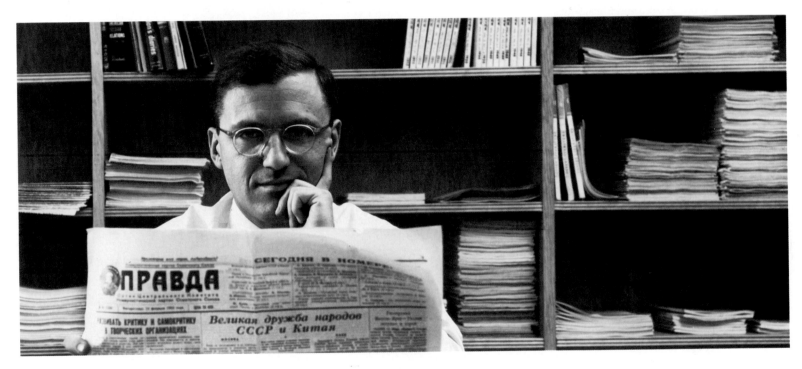

55. *Harry Schwartz, New York Times* Russian expert, New York City, 1953

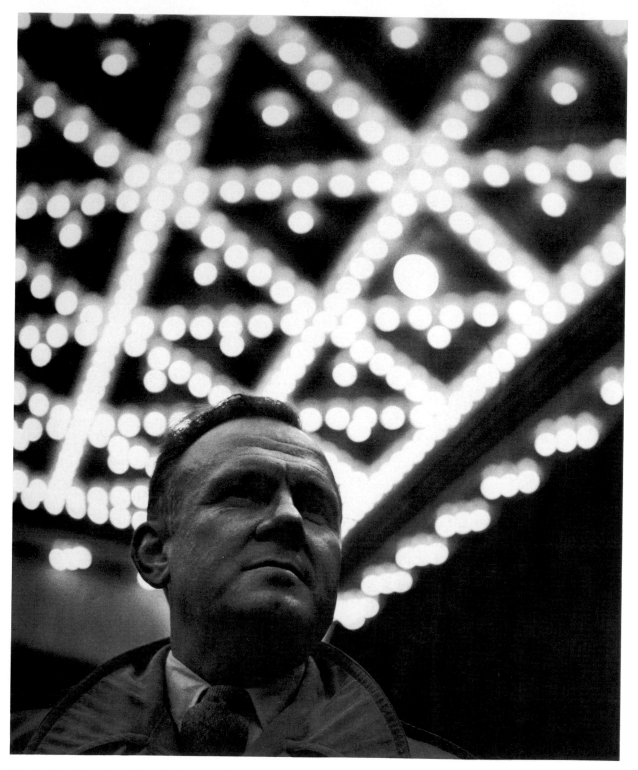

56. *Bosley Crowther, New York Times* film critic, New York City, 1952

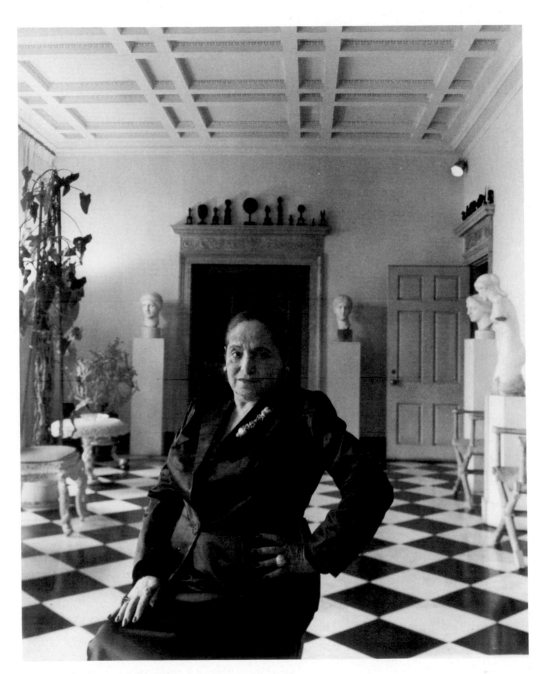

57. *Madame Helena Rubinstein*, New York City, 1948

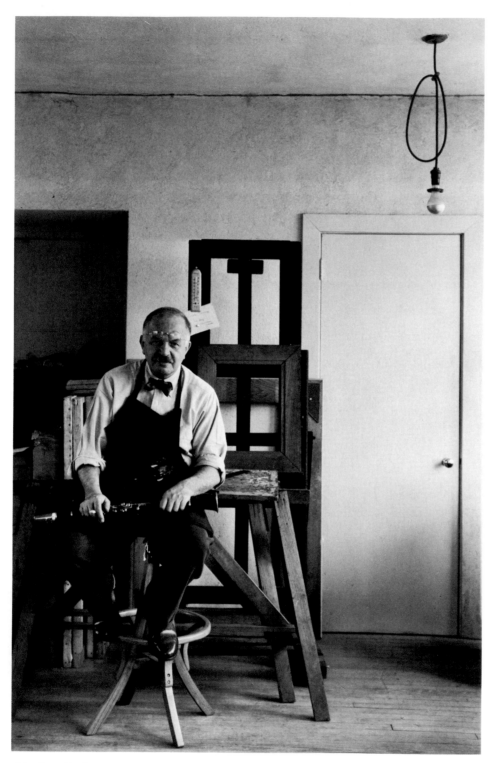

58. *Ben Shahn*, Roosevelt, New Jersey, 1951

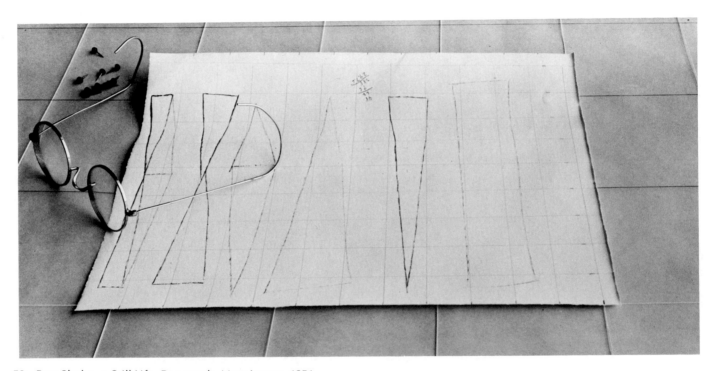

59. *Ben Shahn, a Still Life*, Roosevelt, New Jersey, 1951

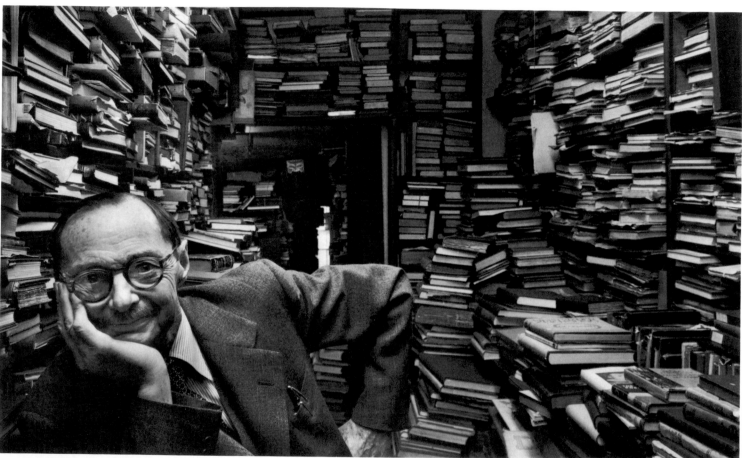

60. *Erhard Weyhe* in his bookshop and gallery, New York City, 1952

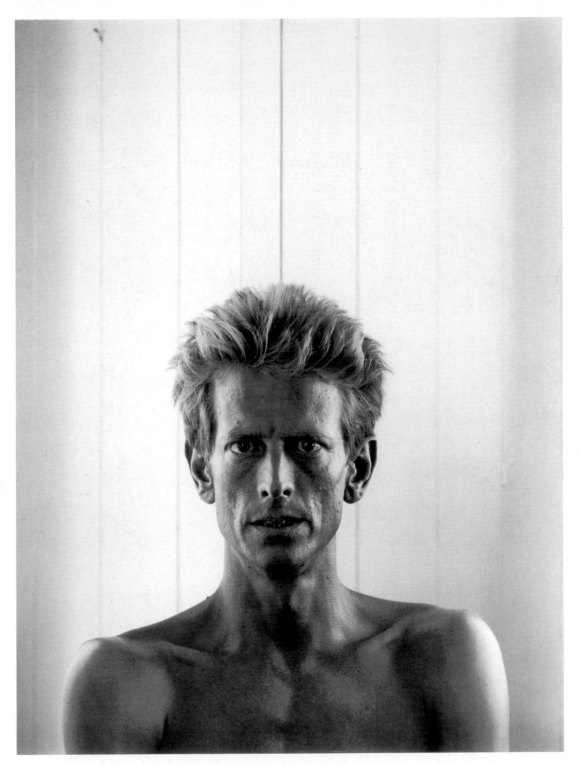

61. *David Hare*, sculptor, Provincetown, Massachusetts, 1952

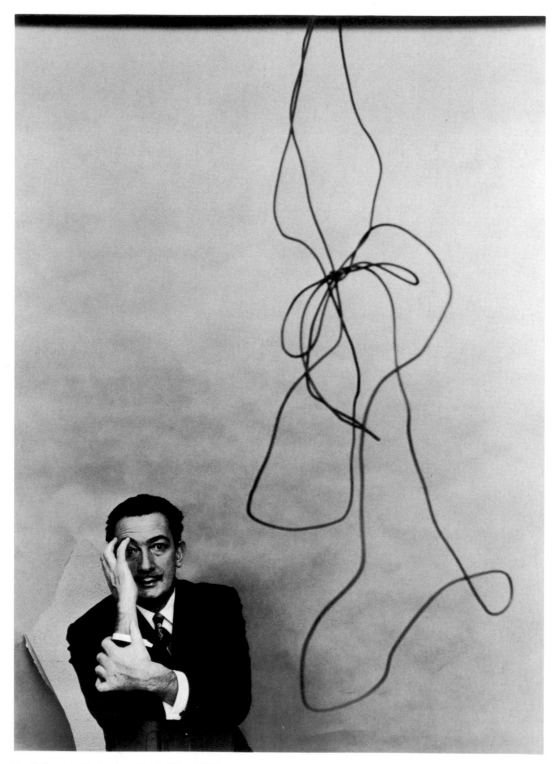

62. *Salvador Dali*, New York City, 1951

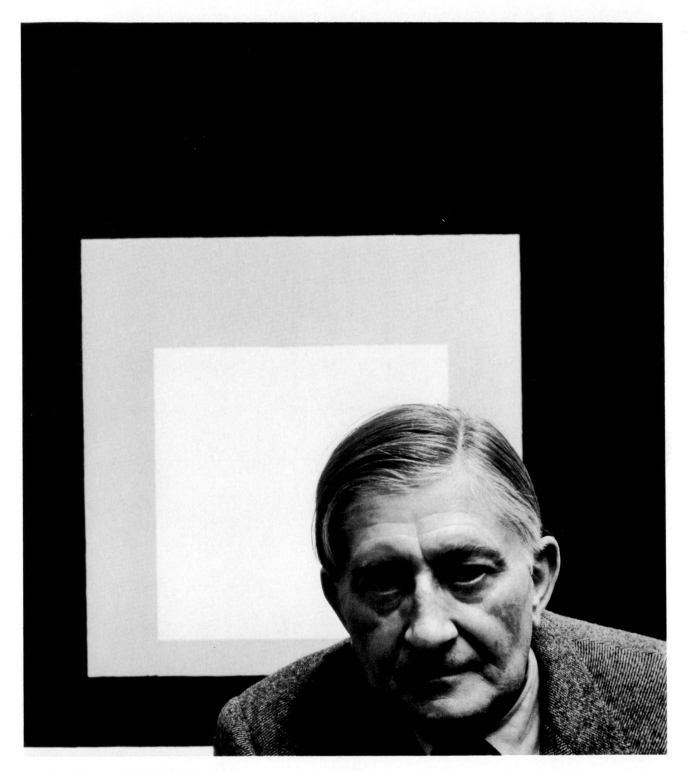

63. *Josef Albers*, New York City, 1952

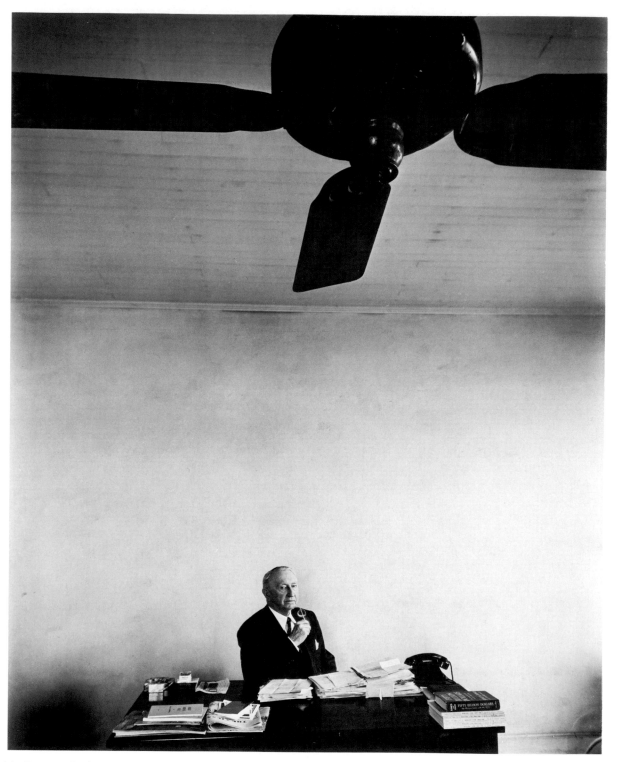

64. *Senator Walter F. George* at his Vienna, Georgia, office, 1951

65. *Senator Harry F. Byrd* at his Winchester, Virginia, office, 1951

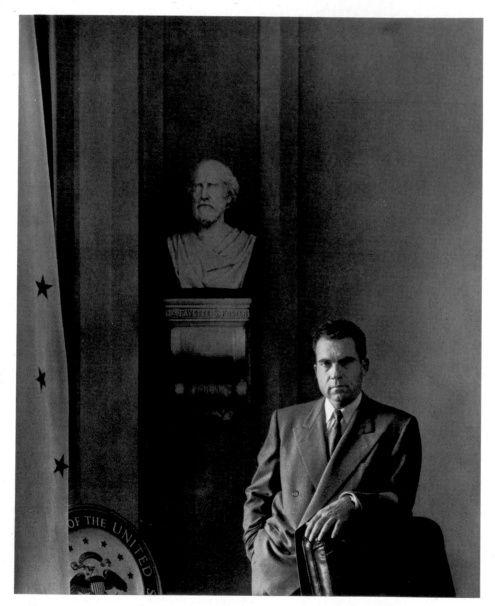

66. *Vice President Richard M. Nixon,* Washington, D.C., 1953

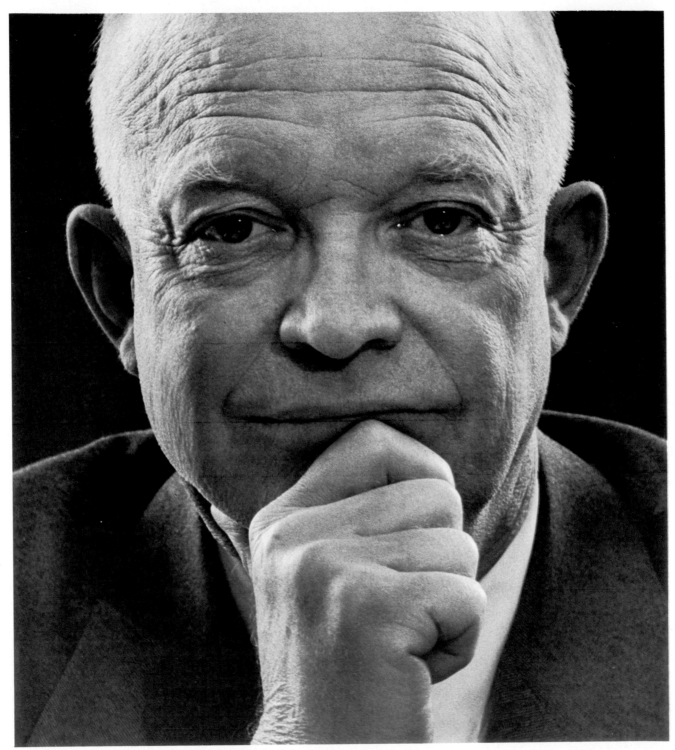

67. *Dwight D. Eisenhower,* President, Columbia University, New York City, 1950

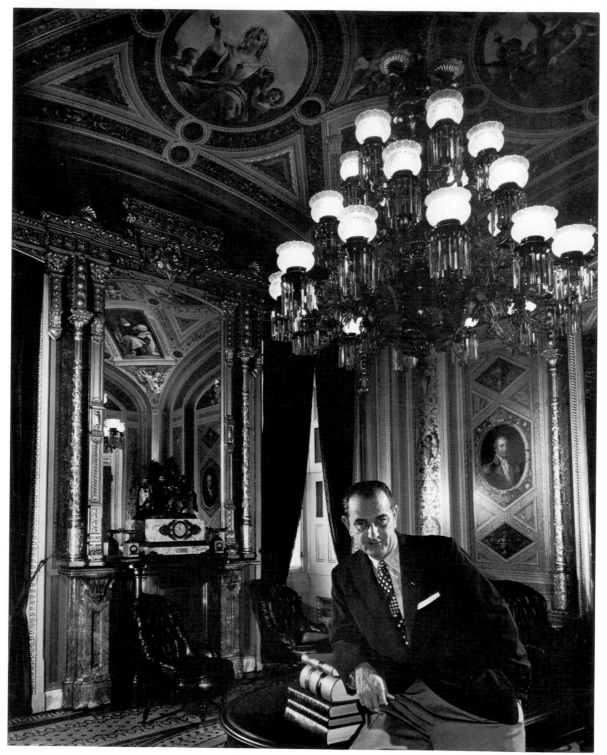

68. *Senate Majority Leader Lyndon B. Johnson,* Washington, D.C., 1953

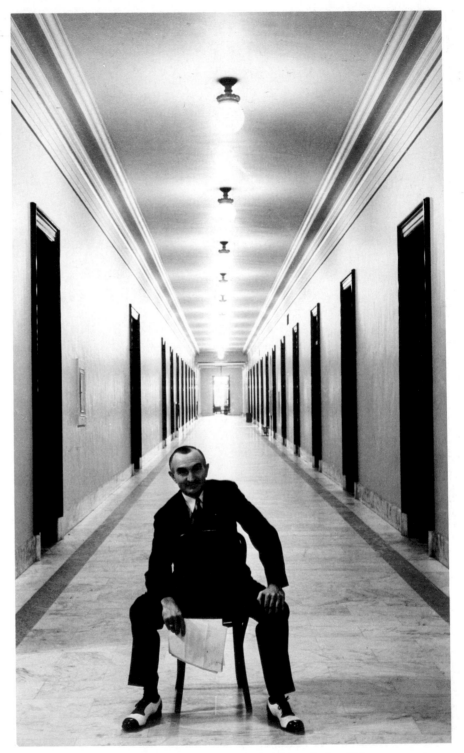

69. *Senator Wayne Morse*, Independent, Washington, D.C., 1953

70. *Senator Clyde R. Hoey,* Washington, D.C., 1953

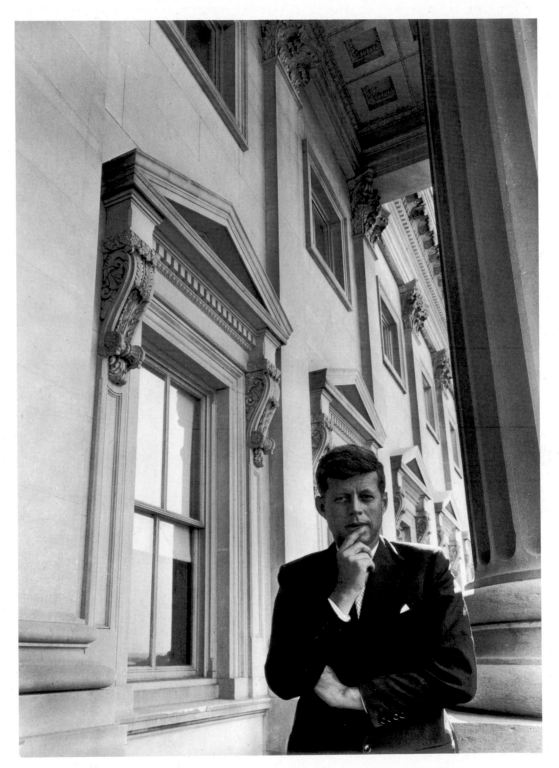

71. *Junior Senator from Massachusetts, John F. Kennedy,* Washington, D.C., 1953

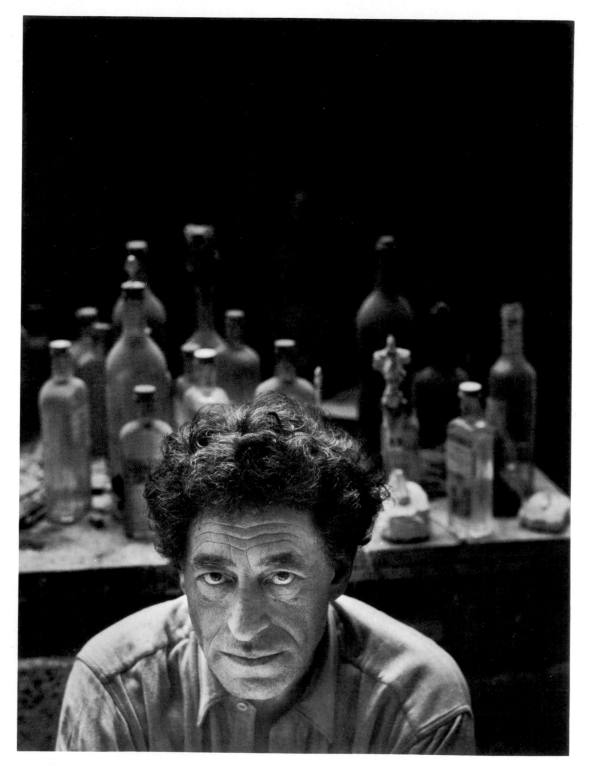

72. *Alberto Giacometti*, Paris, 1954

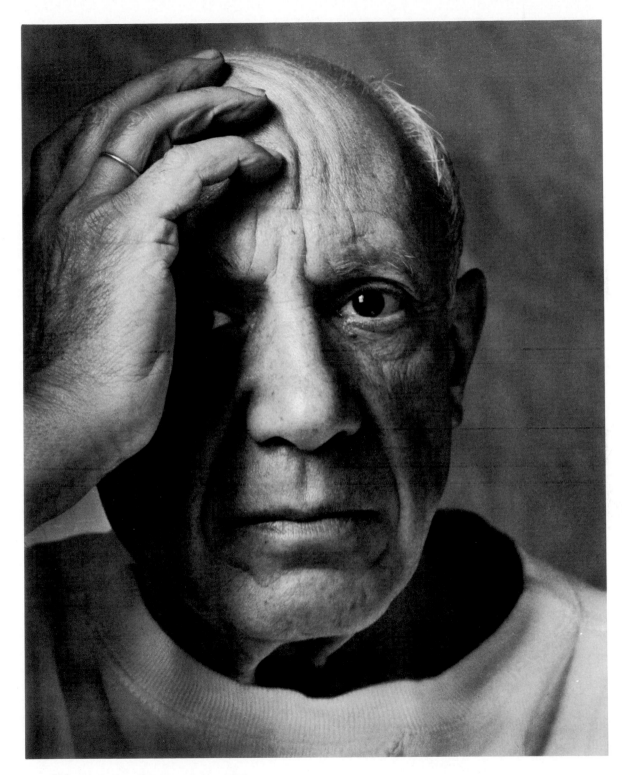

73. *Pablo Picasso*, Vallauris, France, 1954

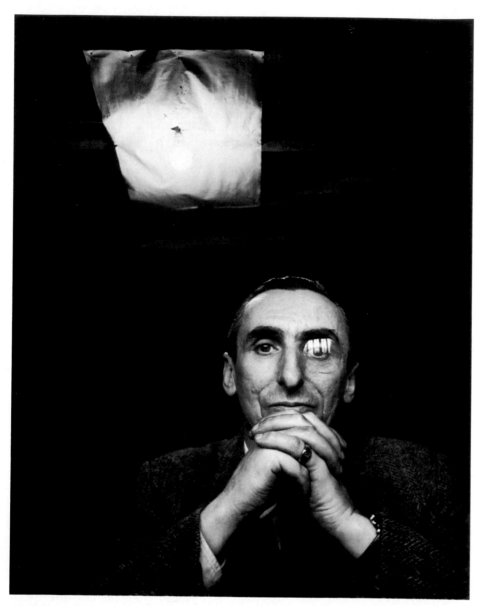

74. *Michel Tapié,* art critic and dealer, Paris, 1954

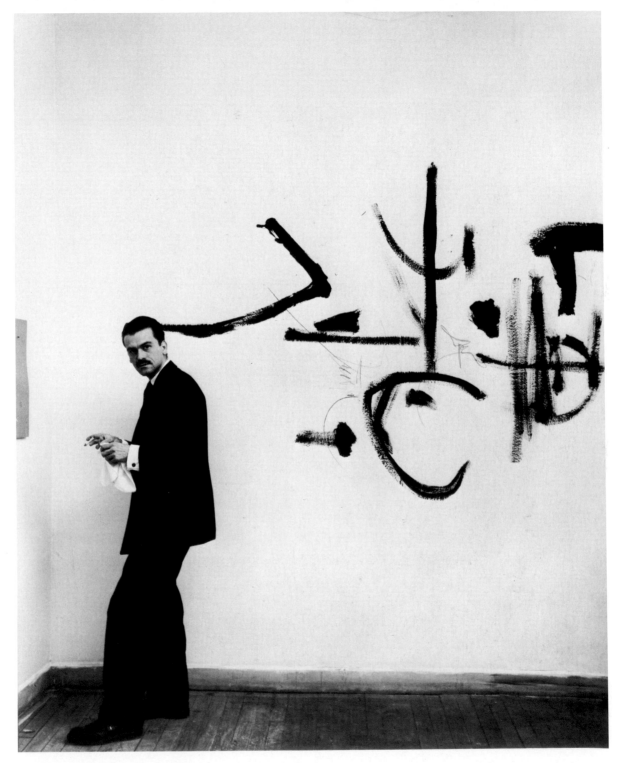

75. *Georges Mathieu*, Paris, 1954

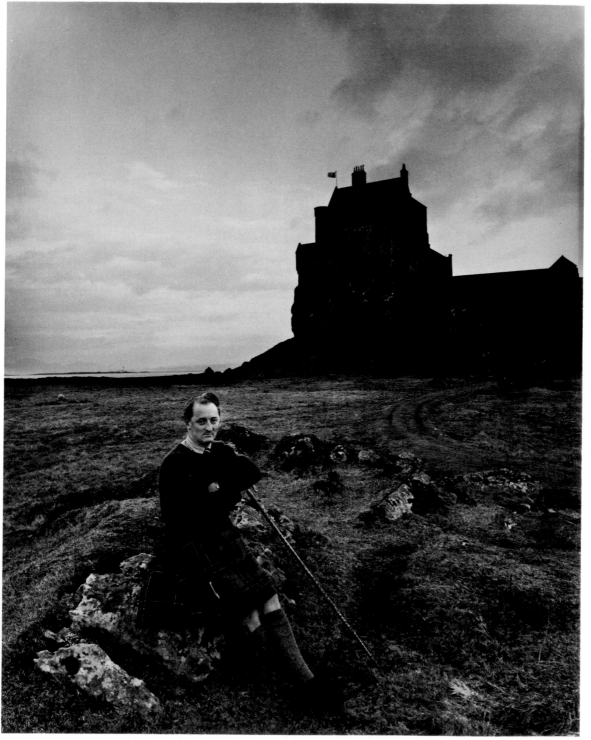

76. *Sir Charles Maclean of Duart,* the Isle of Mull, Scotland, 1954

77. *Ian, Duke of Argyll,* Inveraray Castle, Scotland, 1954

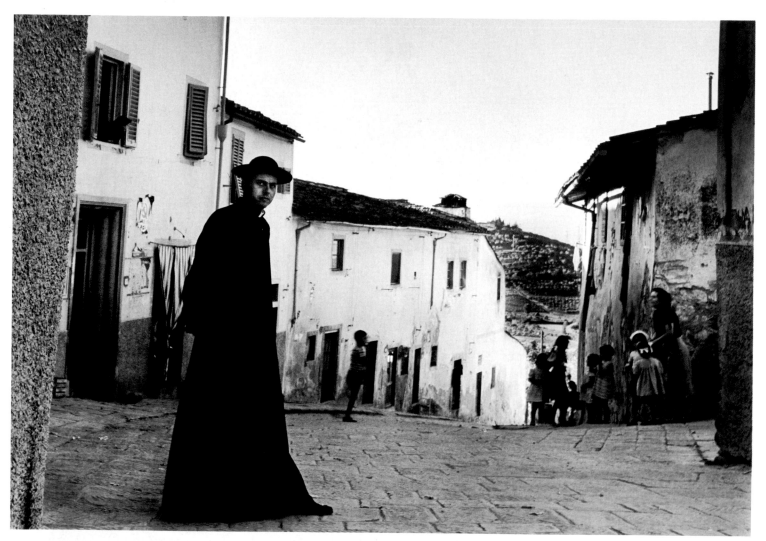

78. *Village priest*, Tavarnuzze, Italy, 1954

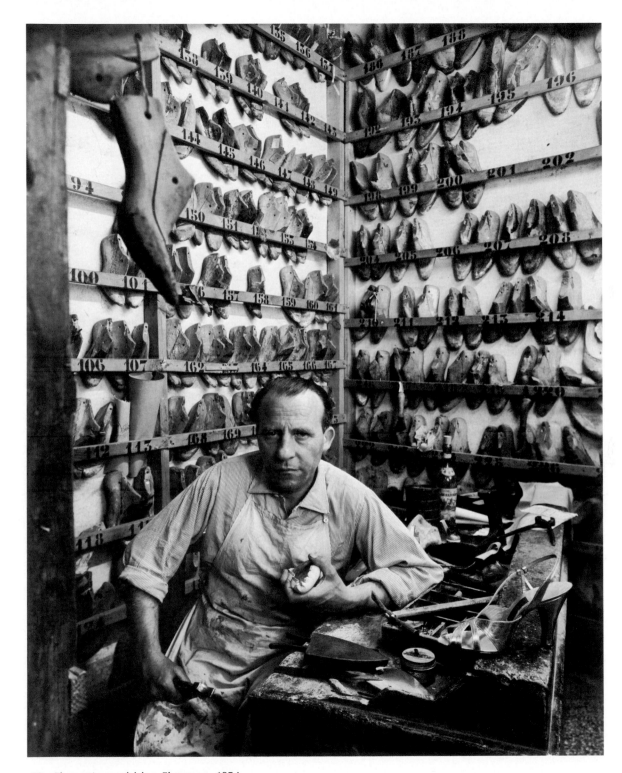

79. *Florentine cobbler,* Florence, 1954

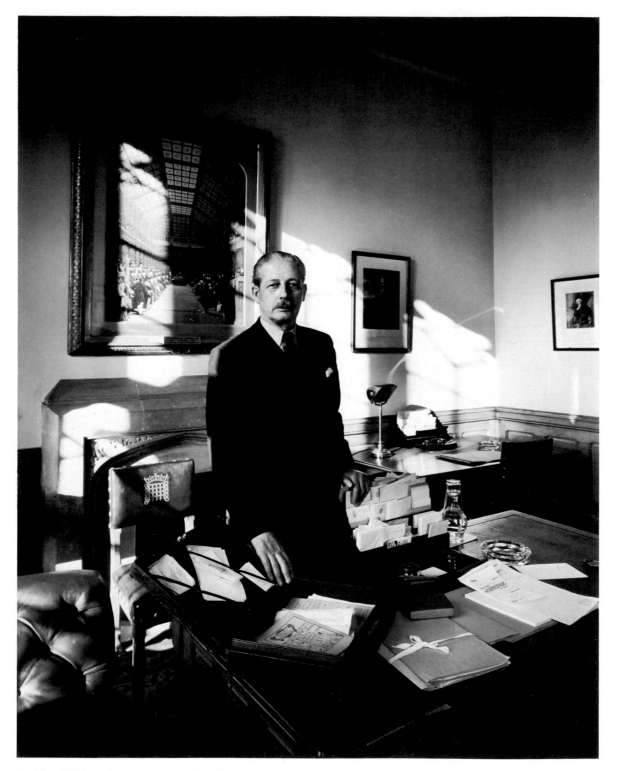

80. *Harold Macmillan,* Houses of Parliament, London, 1954

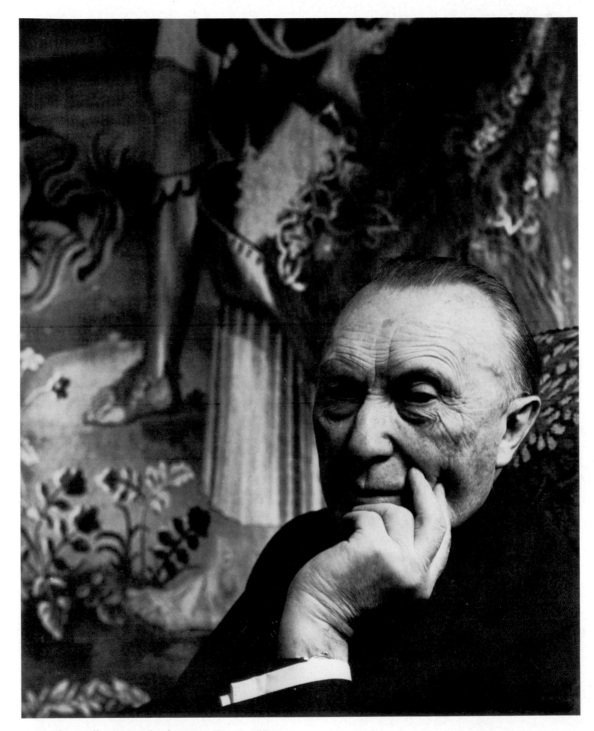

81. *Chancellor Konrad Adenauer*, Bonn, 1954

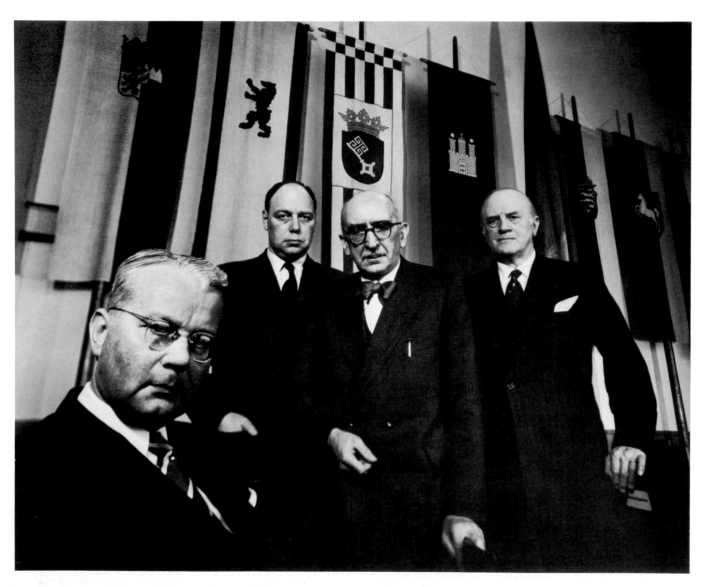

82. *Four German Cabinet Ministers*, Bonn, 1954

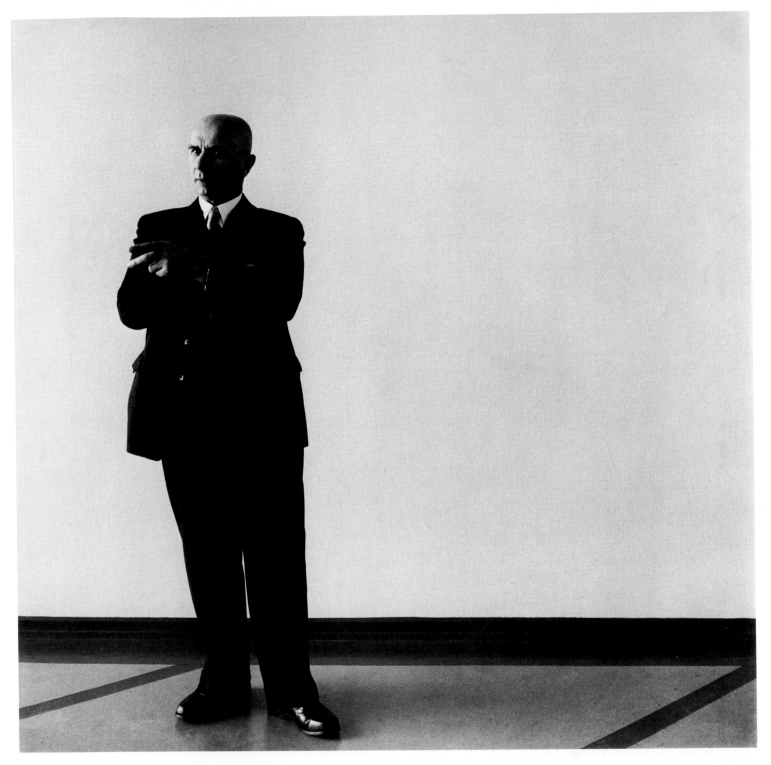

83. *Cabinet Minister Jakob Kaiser*, Bonn, 1954

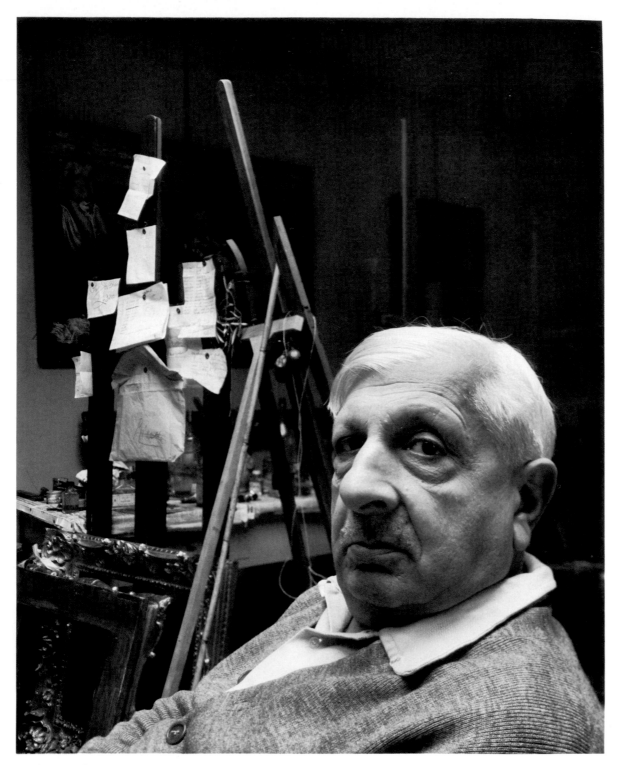

84. *Giorgio de Chirico*, Rome, 1957

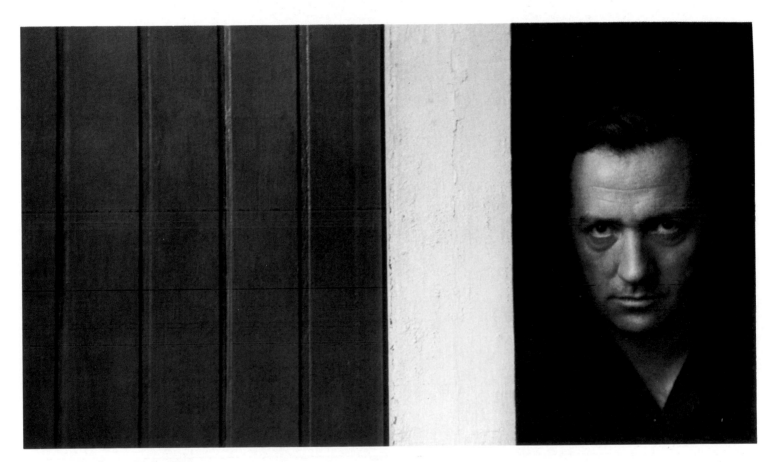

85. *Pierre Soulages*, Paris, 1954

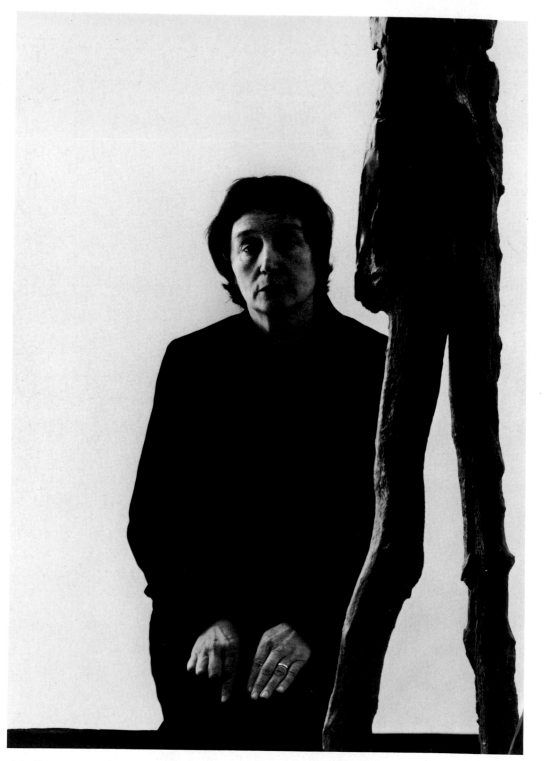

86. *Germaine Richier* at her Musée d'Art Moderne exhibit, Paris, 1956

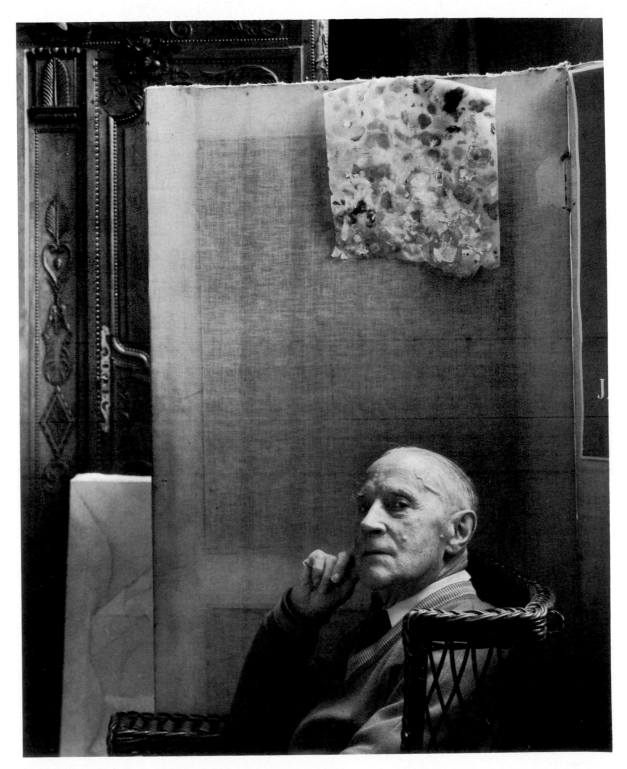

87. *Jacques Villon*, Paris, 1957

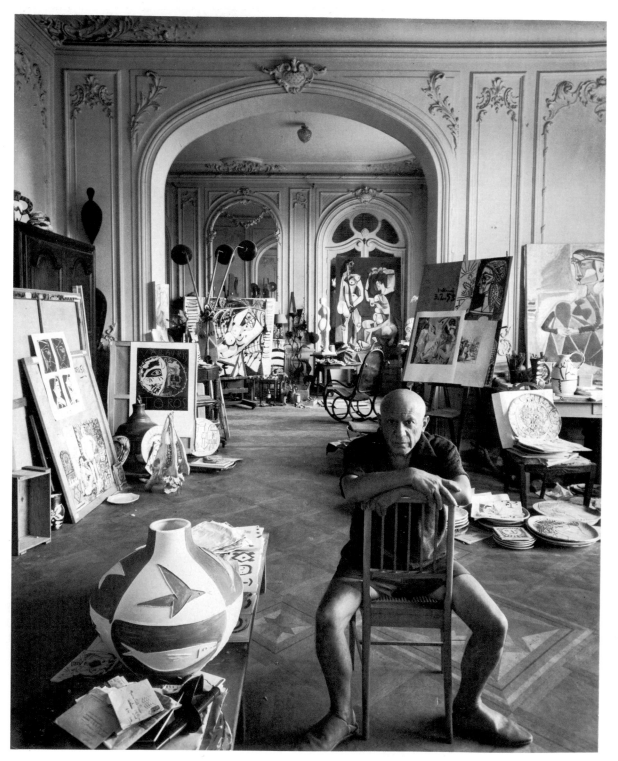

88. *Pablo Picasso,* 'La Californie,' Cannes, 1956

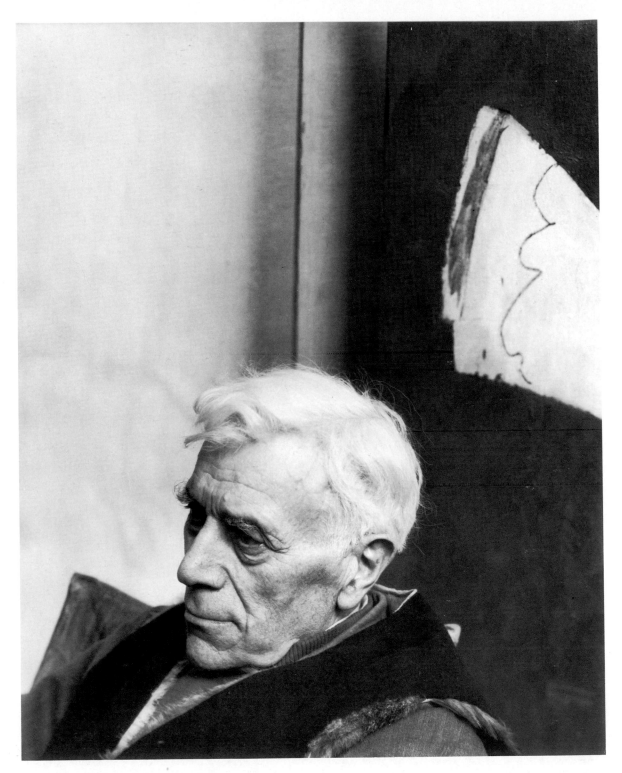

89. *Georges Braque*, Normandy, France, 1956

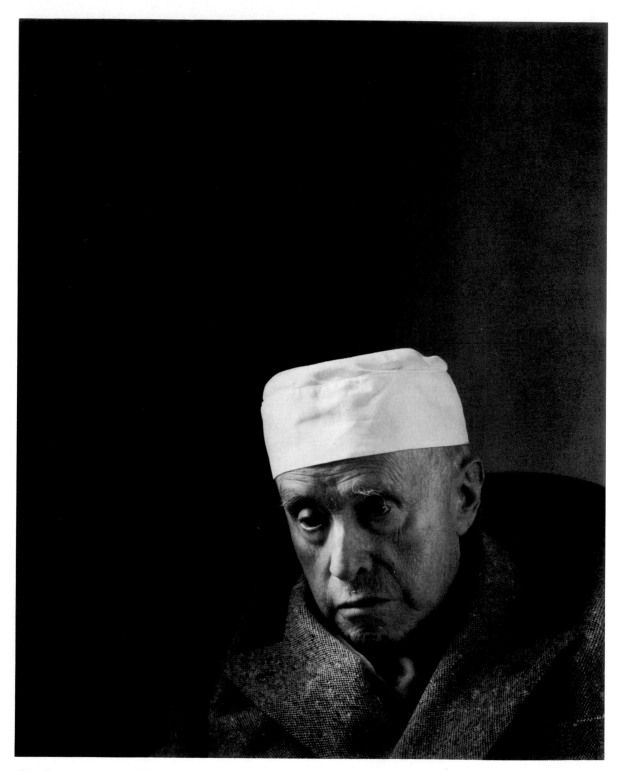

90. *Georges Rouault,* Paris, 1957

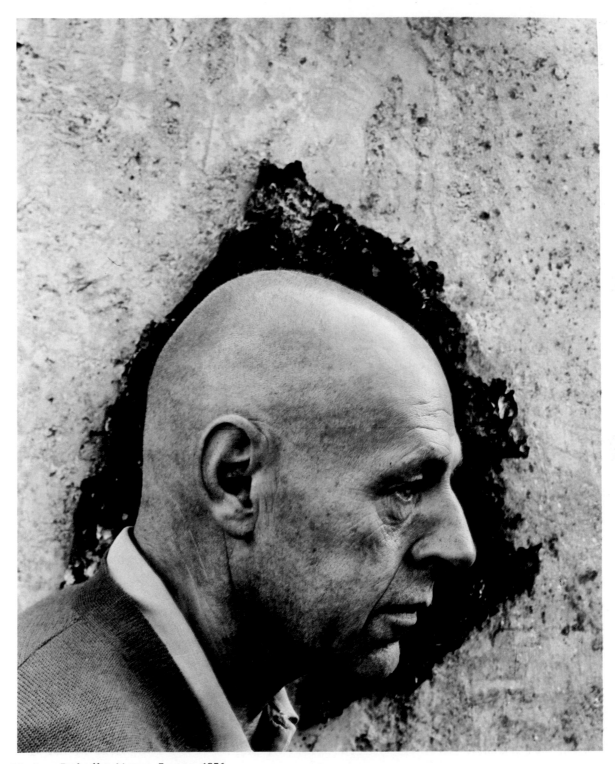

91. *Jean Dubuffet*, Vence, France, 1956

92. *Jacob Lawrence,* Brooklyn, 1959

93. *Rufino Tomayo,* New York City, 1959

94. *David Smith*, New York City, 1957

95. *Alexander Calder,* Roxbury, Connecticut, 1957

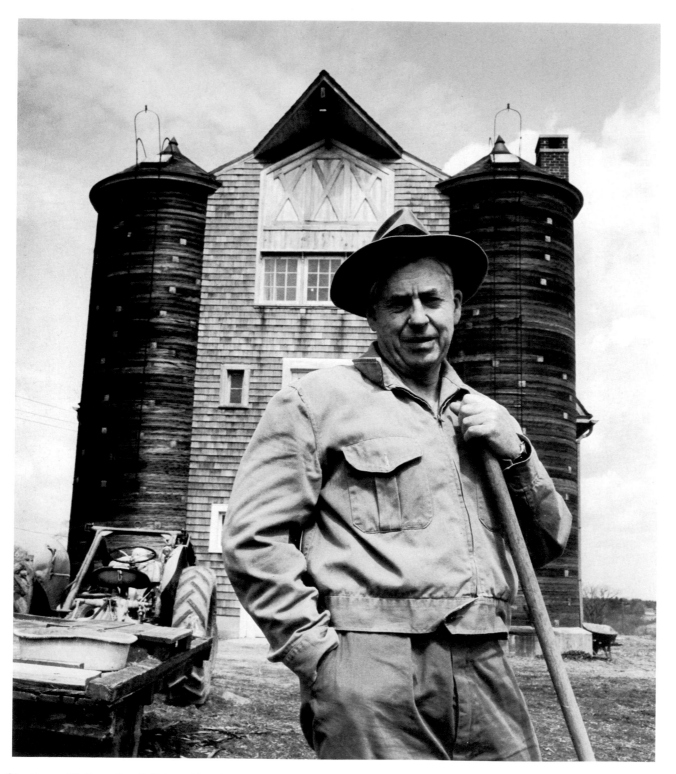

96. *Henry Wallace,* South Salem, New York, 1956

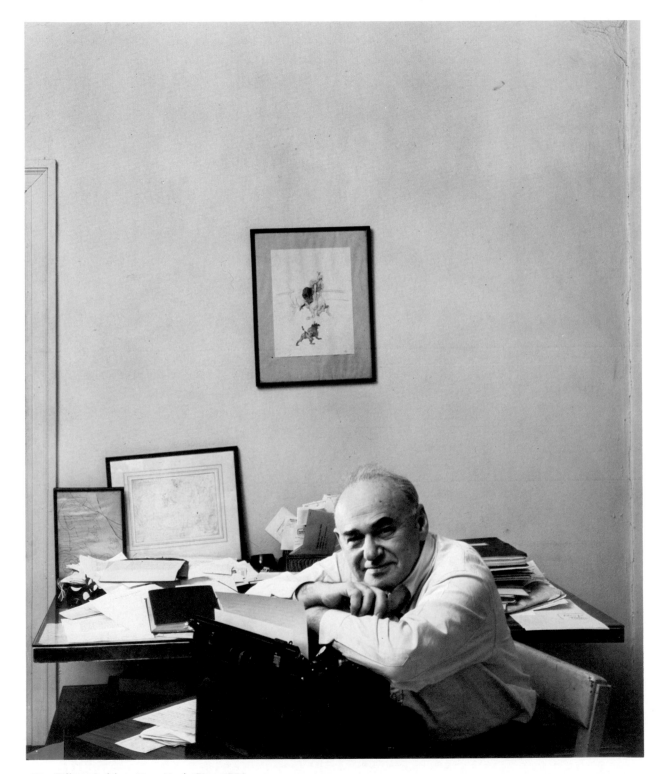

97. *Gilbert Seldes,* New York City, 1956

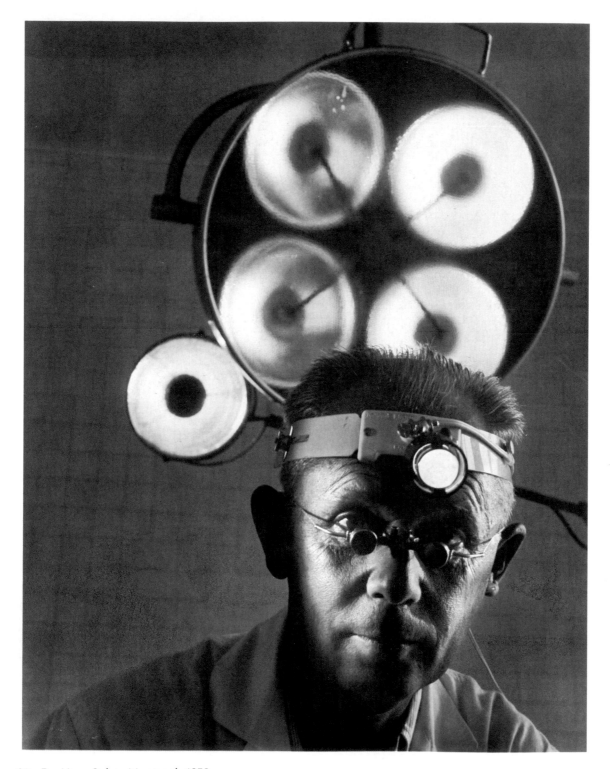

98. *Dr. Hans Selye*, Montreal, 1958

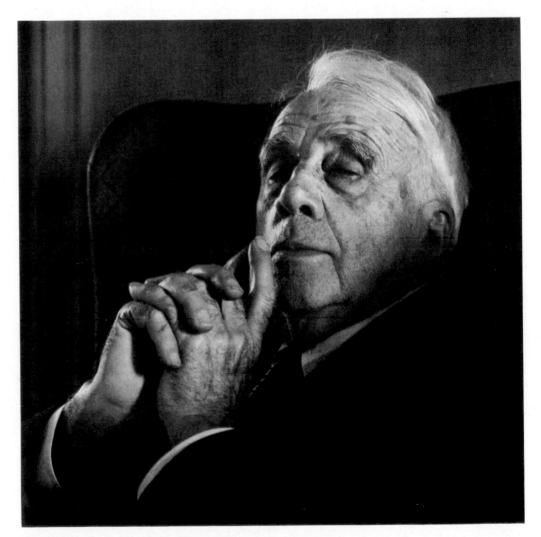

99. *Robert Frost*, New York City, 1956

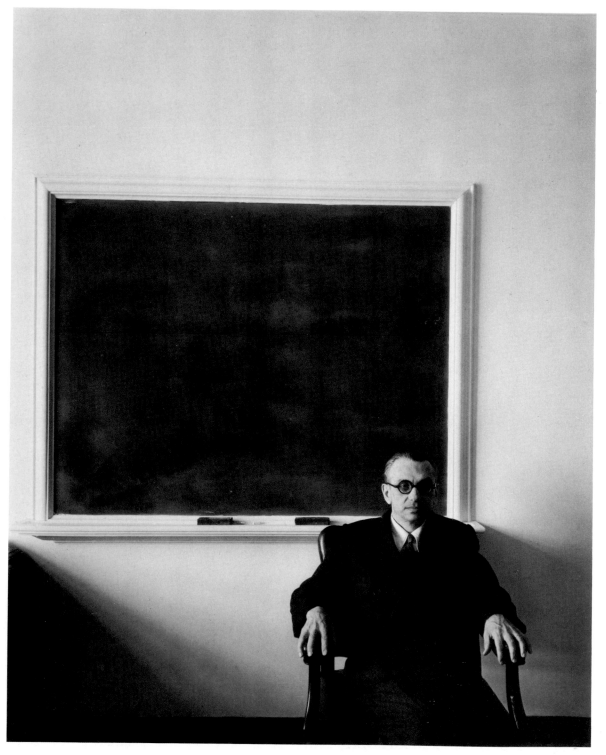

100. *Dr. Kurt Gödel,* Institute for Advanced Study, Princeton, New Jersey, 1956

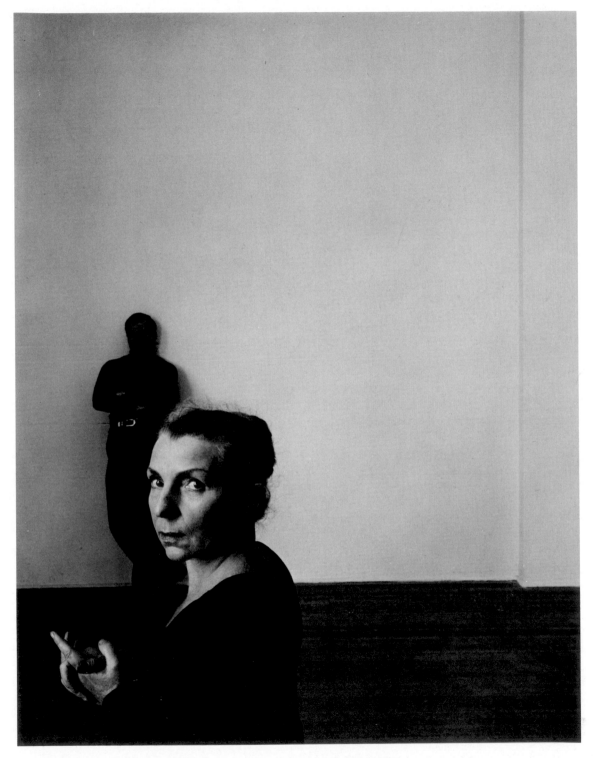

101. *Hanya Holm*, choreographer, and son Klaus, New York City, 1957

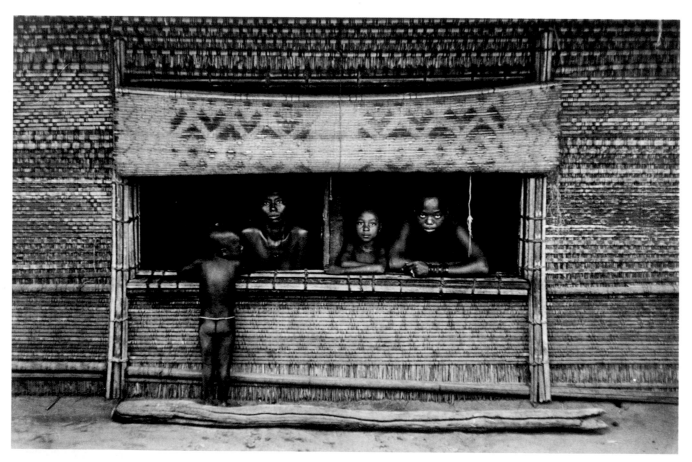

102. *Wives and children of the King of the Bakubas*, Mushenge, the Congo, 1958

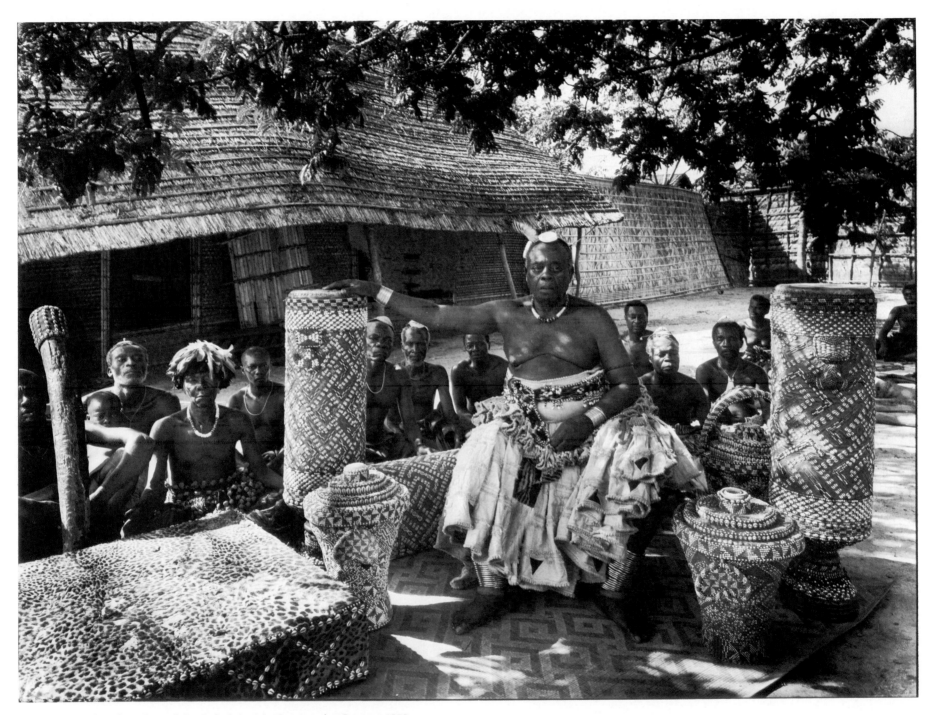

103. *Bope Mabinshe,* King of the Bakubas, Mushenge, the Congo, 1958

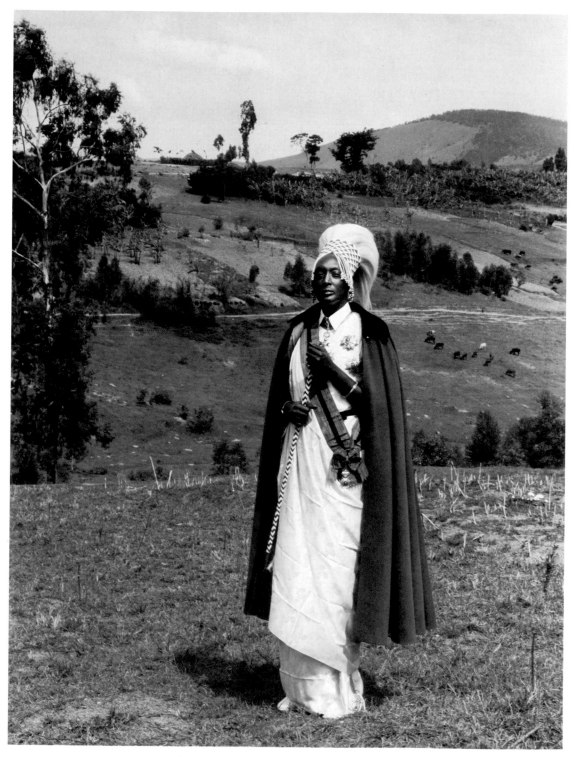

104. *Charles Mutara III Rudahigwa,* King of the Watusi, Rwanda, Africa, 1958

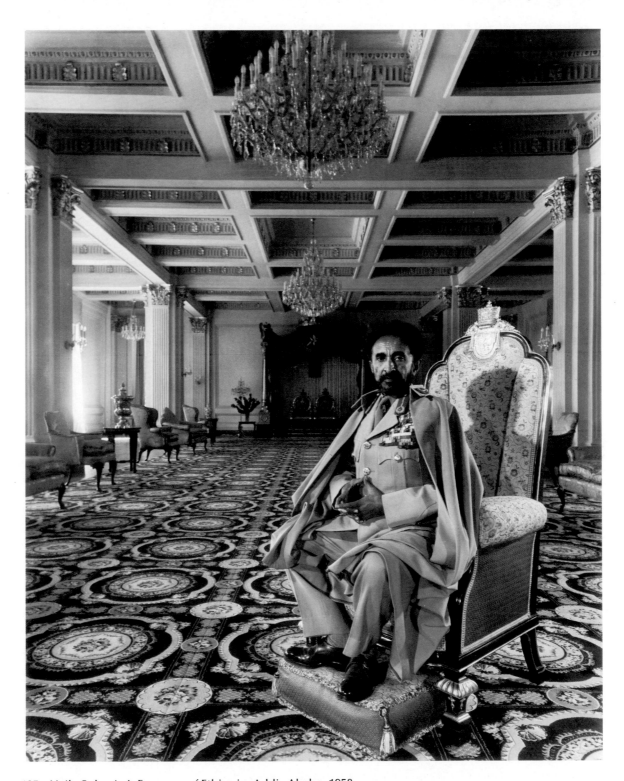

105. *Haile Selassie I*, Emperor of Ethiopia, Addis Ababa, 1958

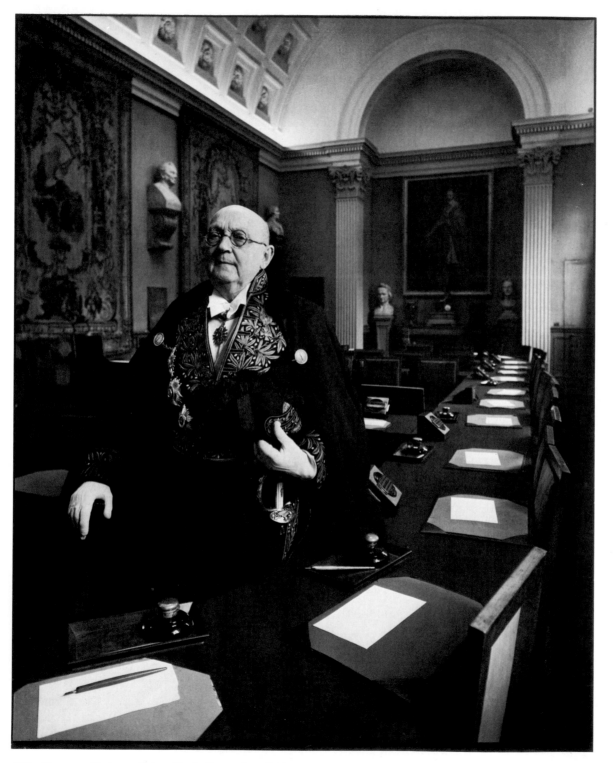

106. *Georges Duhamel,* Académie Française, Paris, 1956

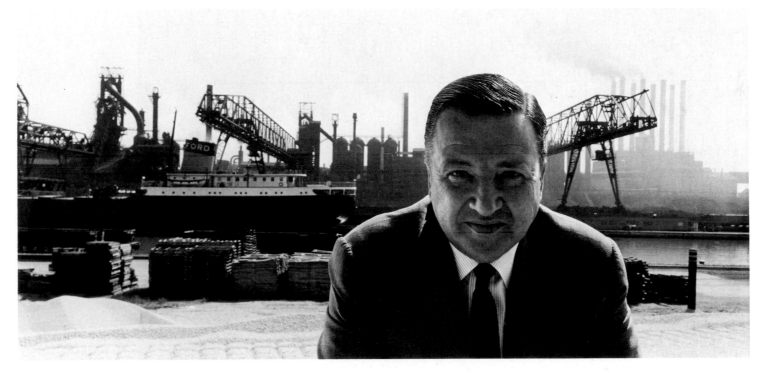

107. *Henry Ford II*, River Rouge, Michigan, 1960

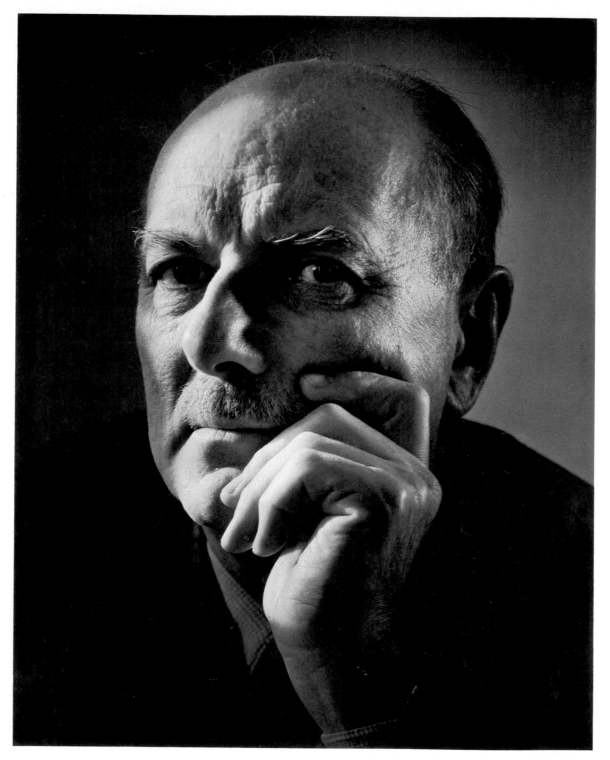

108. *Lewis Mumford,* Philadelphia, 1959

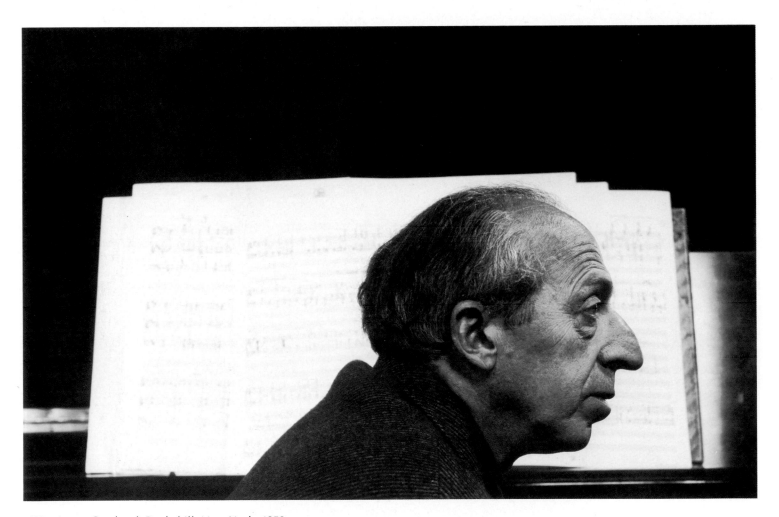

109. *Aaron Copland,* Peekskill, New York, 1959

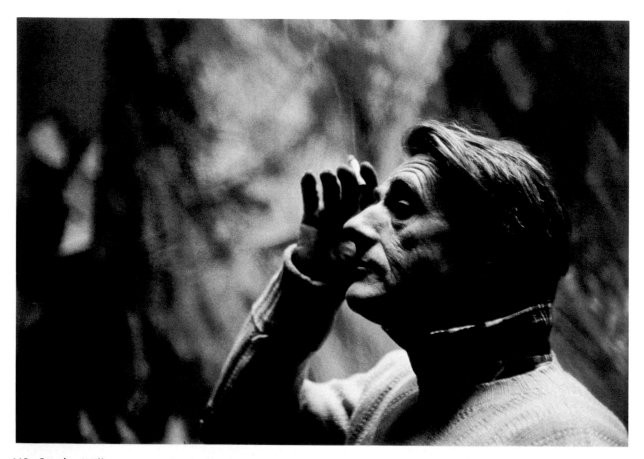

110. *Stanley William Hayter*, Paris, 1959

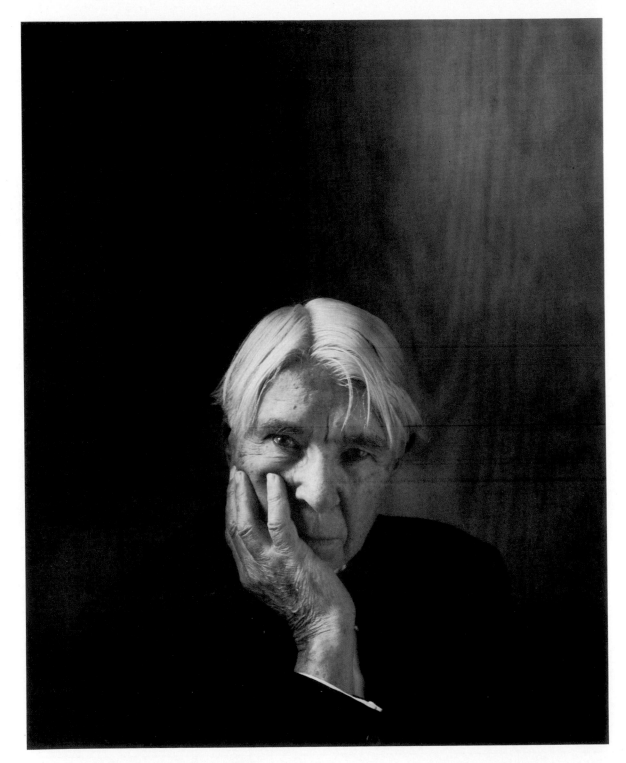

111. *Carl Sandburg,* New York City, **1955**

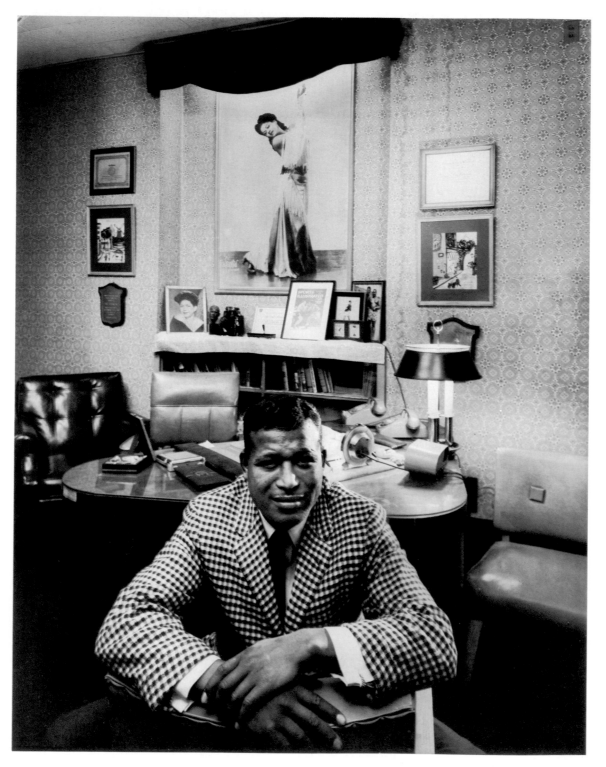

112. *Sugar Ray Robinson*, New York City, 1960

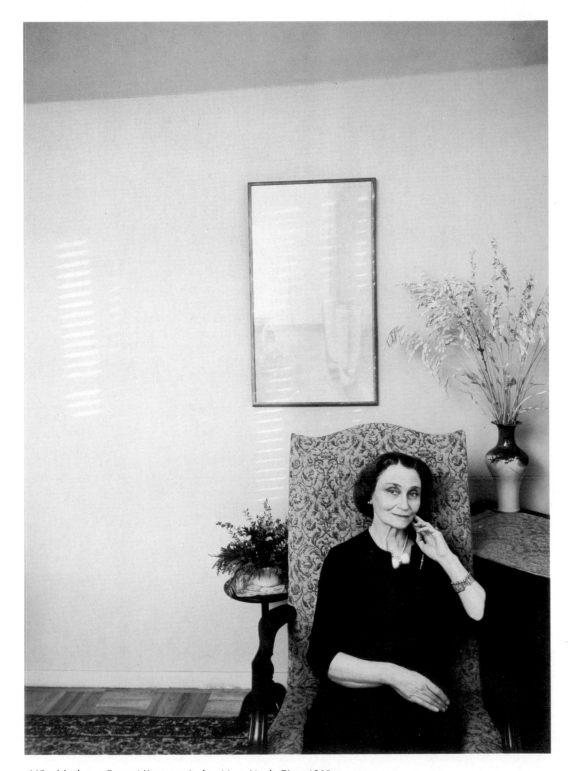

113. *Madame Sergei Koussevitzky,* New York City, 1960

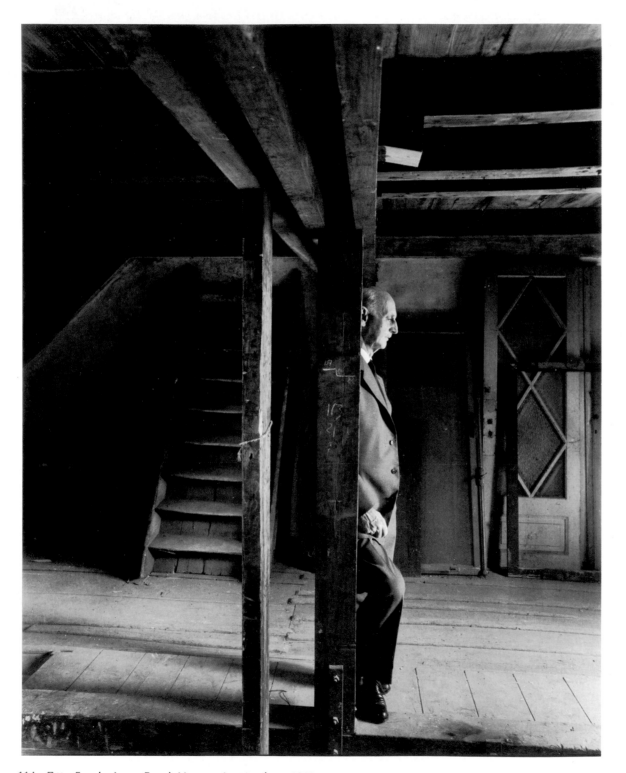

114. *Otto Frank,* Anne Frank House, Amsterdam, 1960

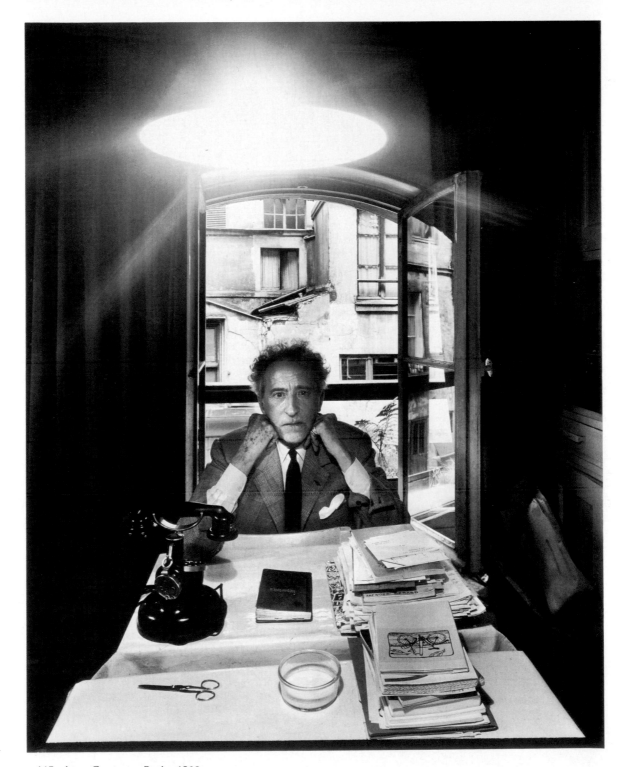

115. *Jean Cocteau*, Paris, 1960

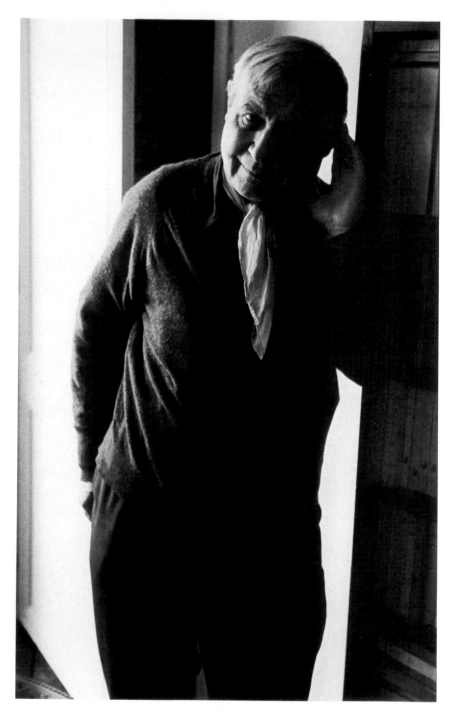

116. *André Masson,* Paris, 1959

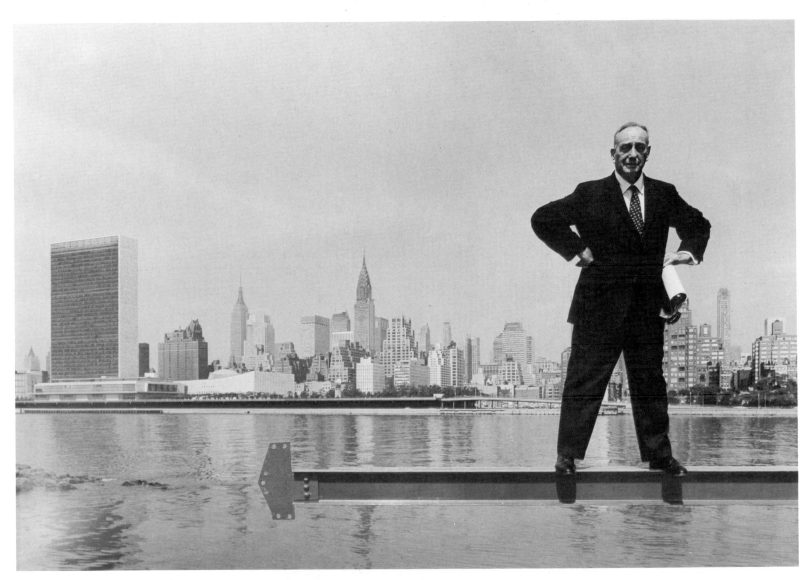

117. *Robert Moses,* New York City, 1959

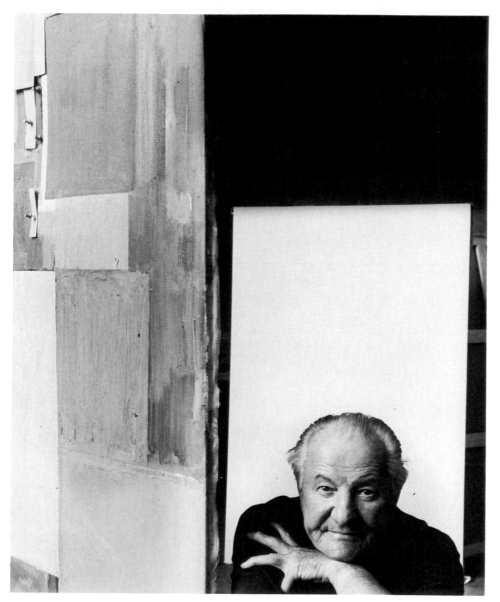

118. *Hans Hofmann*, Provincetown, 1960

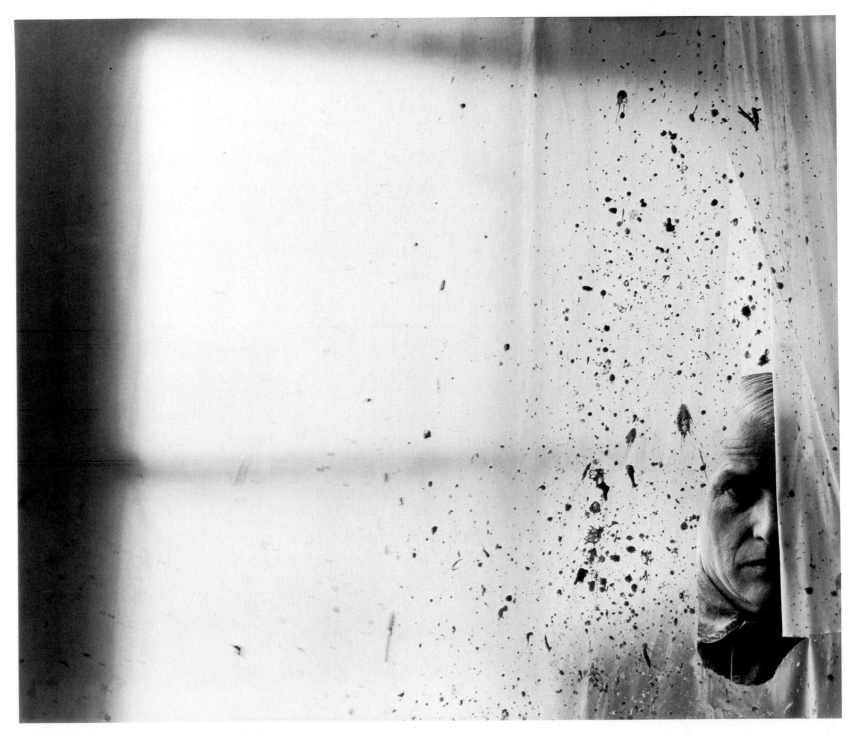

119. *Willem de Kooning,* New York City, 1959

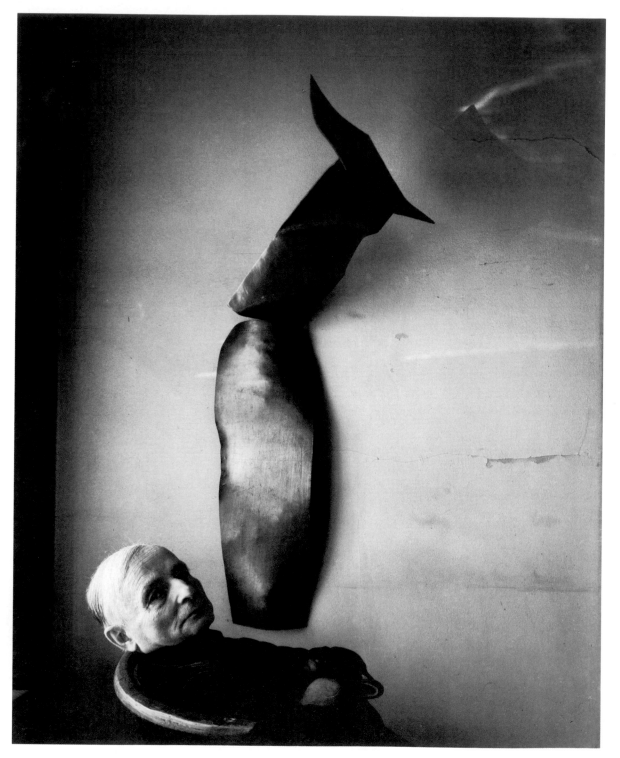

120. *Frederick Kiesler,* architect and sculptor, New York City, 1962

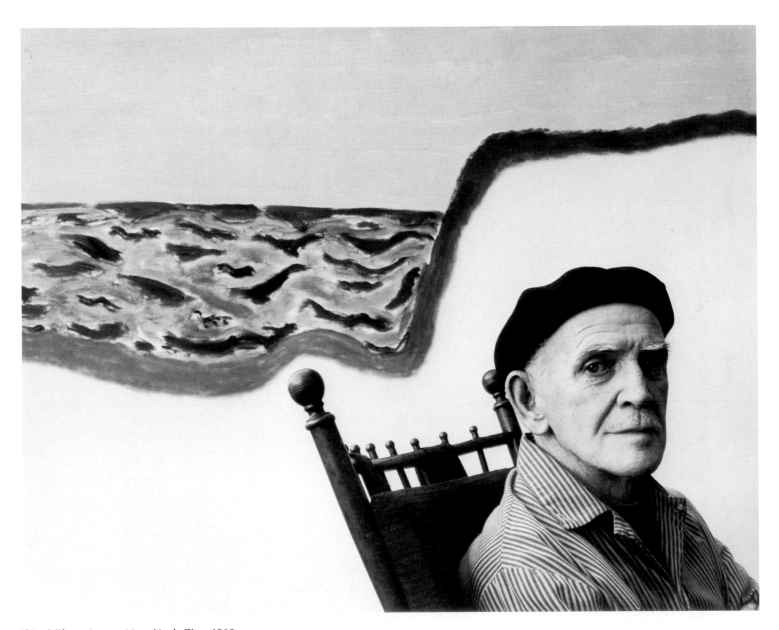

121. *Milton Avery*, New York City, 1960

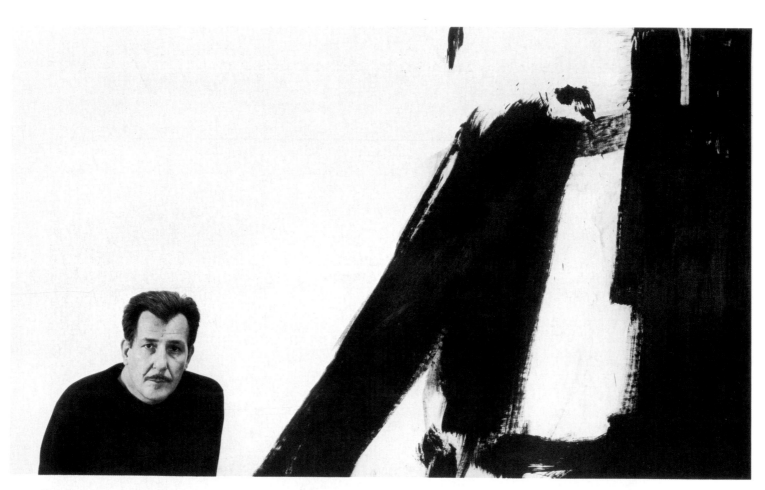

122. *Franz Kline*, Provincetown, 1960

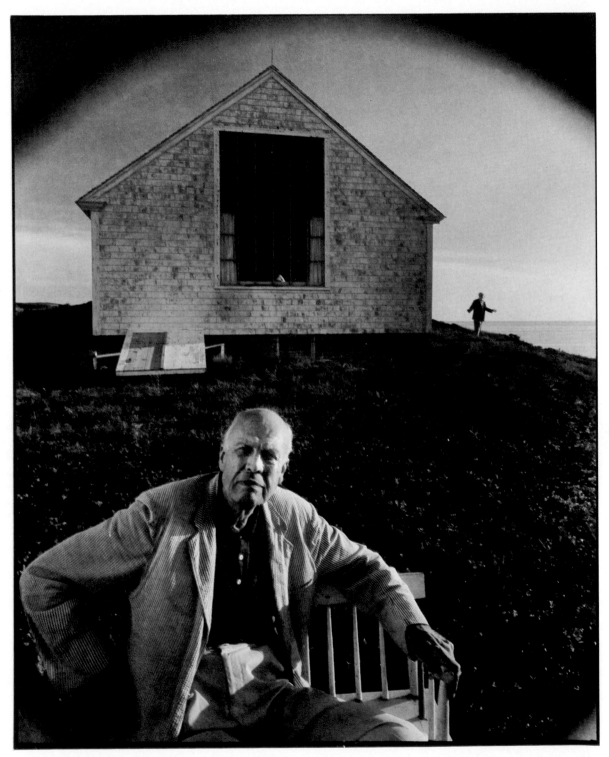

123. *Edward Hopper,* Truro, Massachusetts, 1960

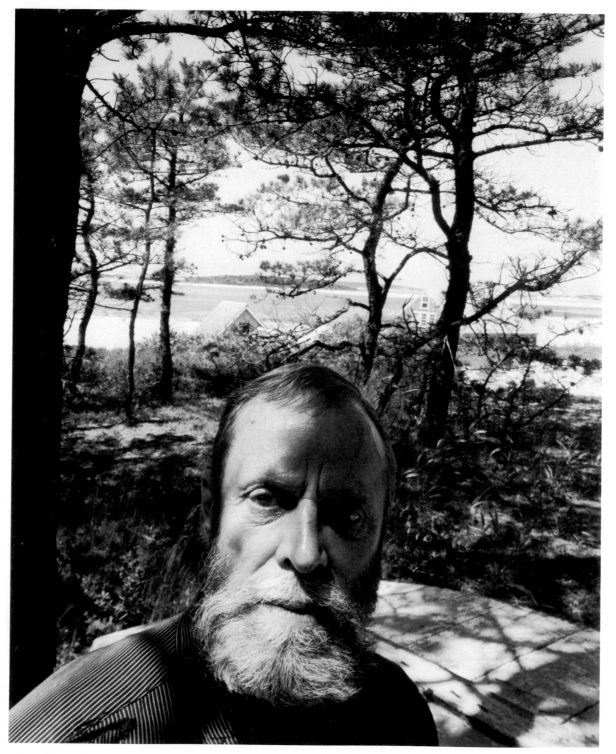

124. *Edwin Dickinson*, Wellfleet, Massachusetts, 1960

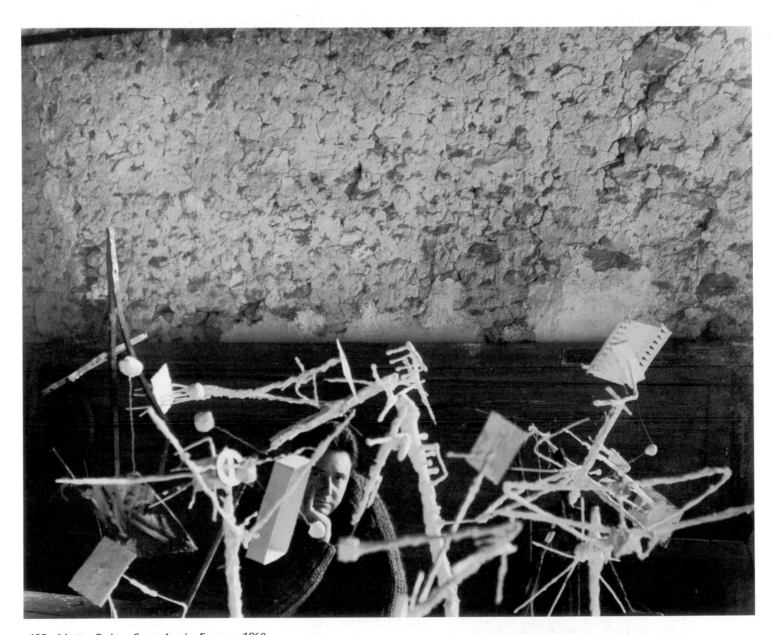

125. *Matta*, Boissy Sans-Avoir, France, 1960

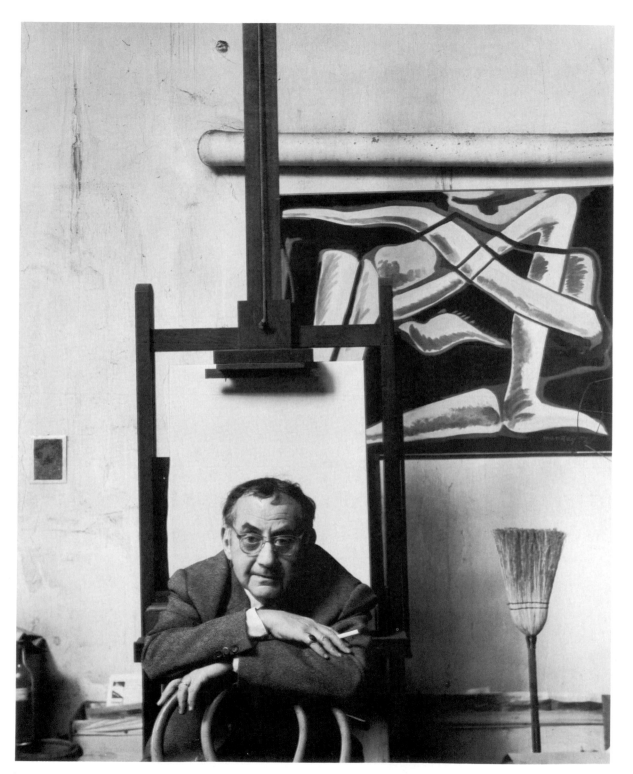

126. *Man Ray*, Paris, 1960

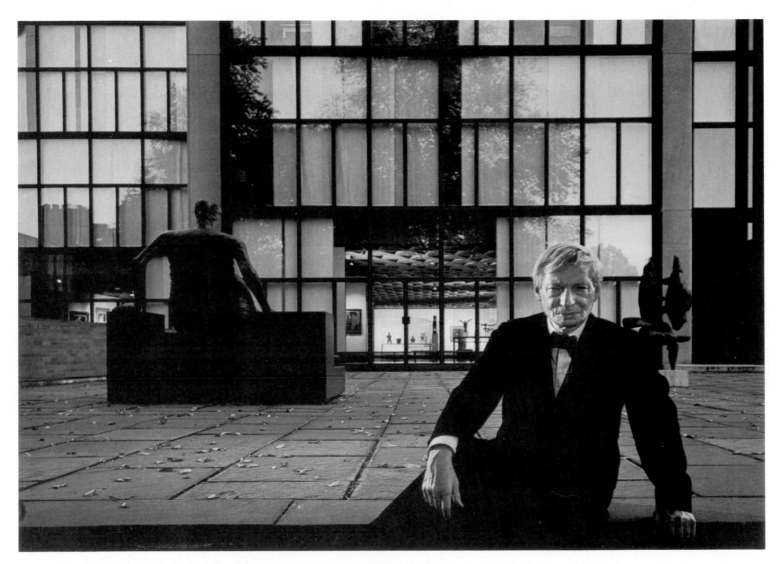

127. *Louis Kahn* at his Yale University Art Gallery, New Haven, 1964

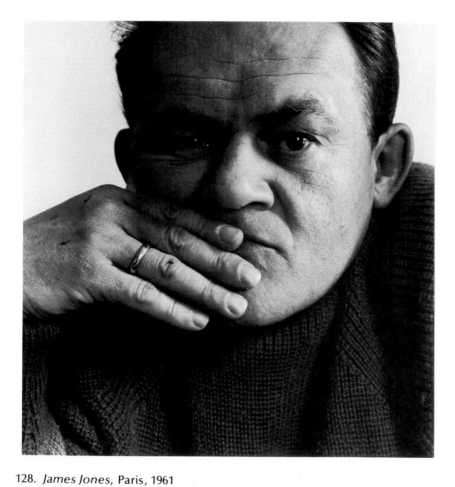

128. *James Jones*, Paris, 1961

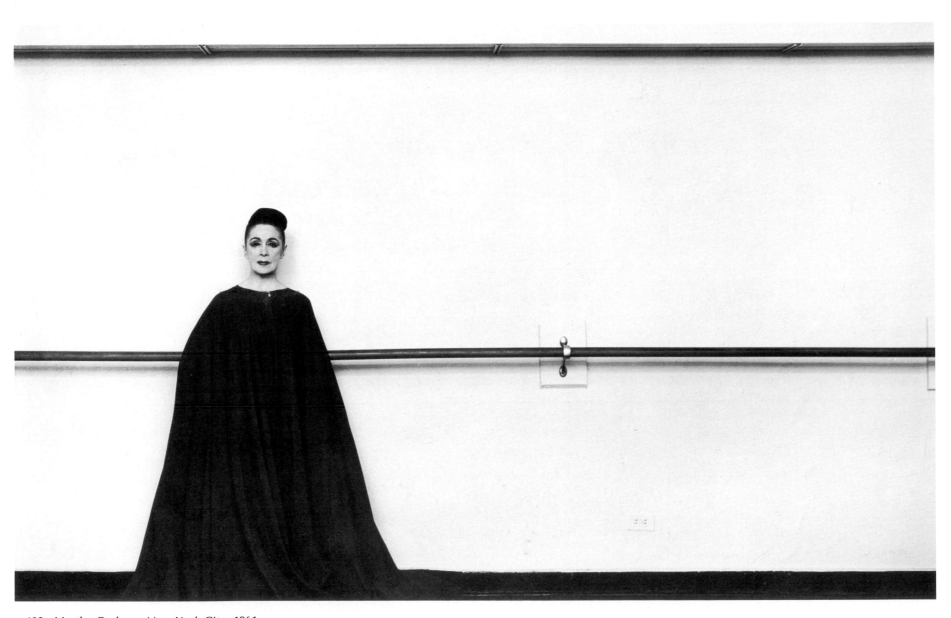

129. *Martha Graham*, New York City, 1961

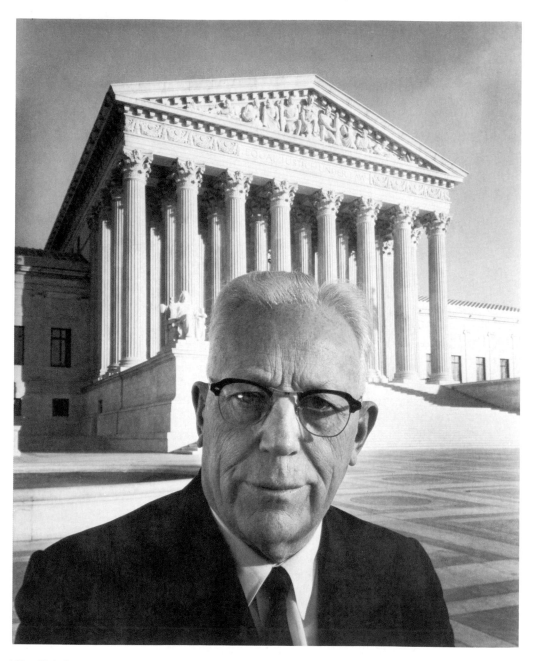

130. *Chief Justice Earl Warren*, Washington, D.C., 1961

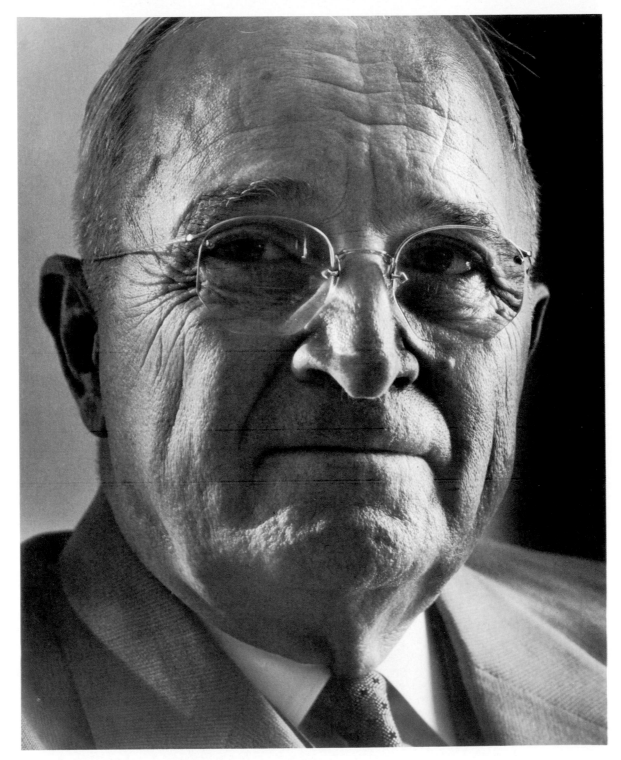

131. *President Harry S. Truman*, New York City, 1960

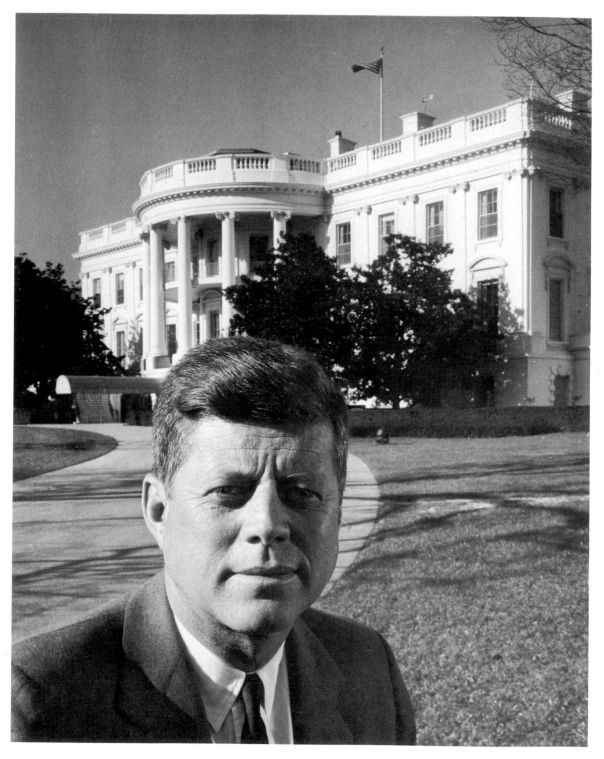

132. *President John F. Kennedy,* Washington, D.C., 1961

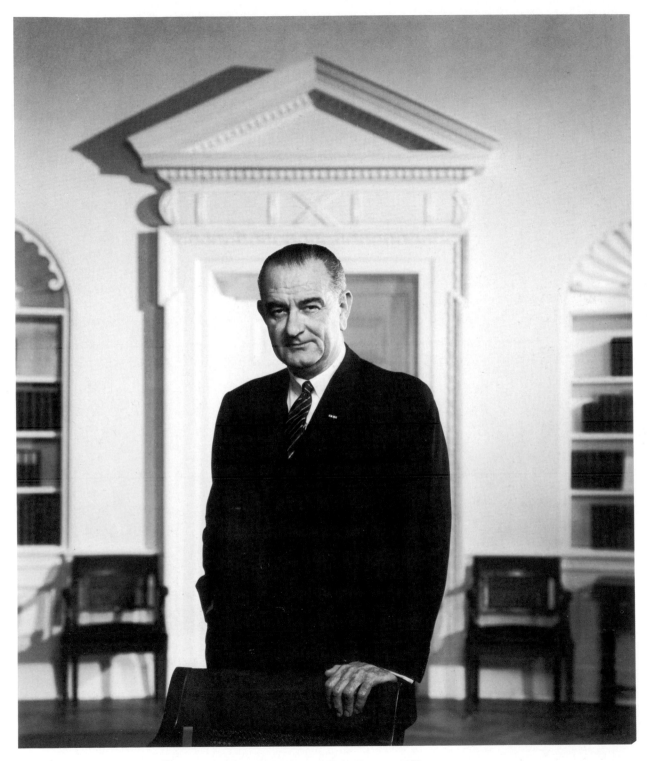

133. *President Lyndon B. Johnson* (official portrait), the White House, 1963

134. *'Five Rebel Senators,'* Edmund S. Muskie, Gale McGee, Eugene J. McCarthy,
 Philip A. Hart, Frank E. Moss, Washington, D.C., 1960

135. *Secretary of State Dean Rusk,* State Department, Washington, D.C., 1962

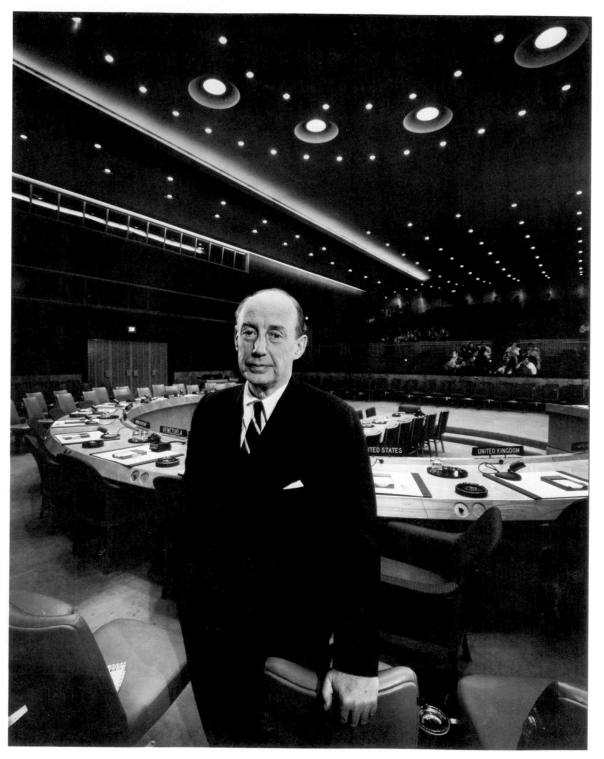

136. *Ambassador Adlai E. Stevenson,* United Nations, New York City, 1962

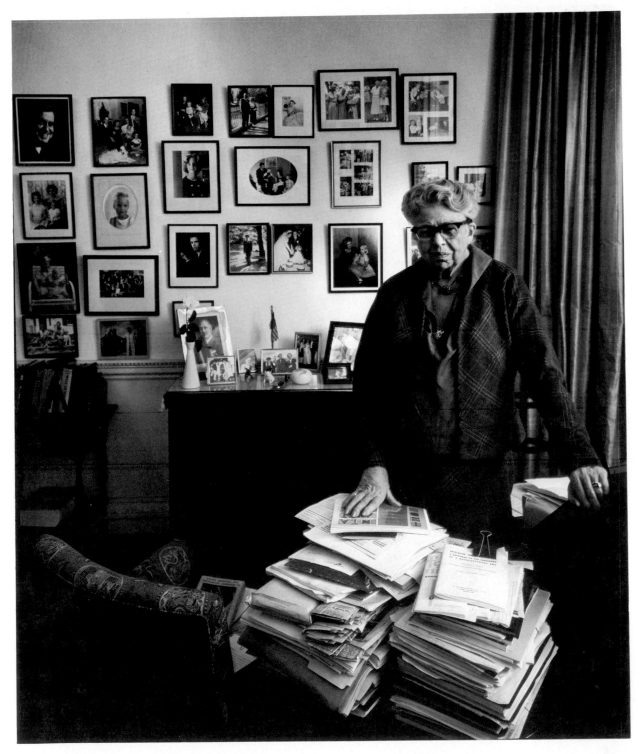

137. *Eleanor Roosevelt*, New York City, 1962

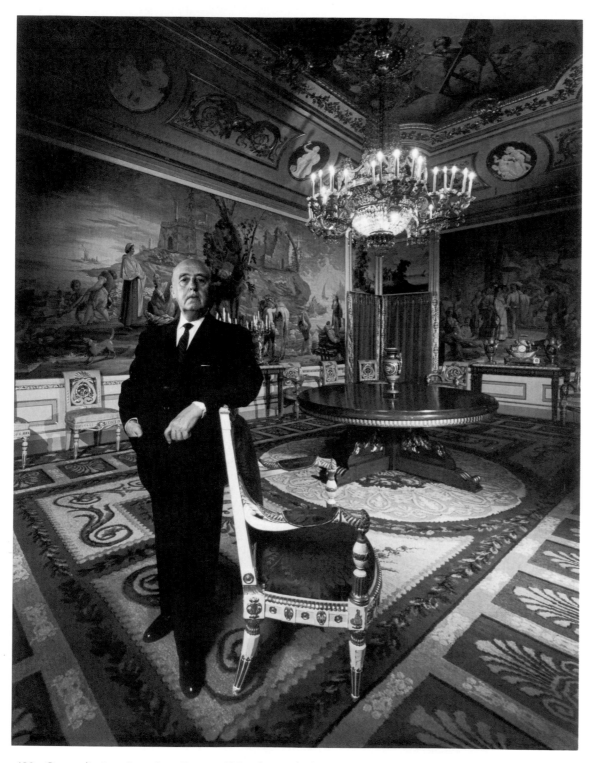

138. *Generalissimo Francisco Franco,* El Prado, Madrid, 1964

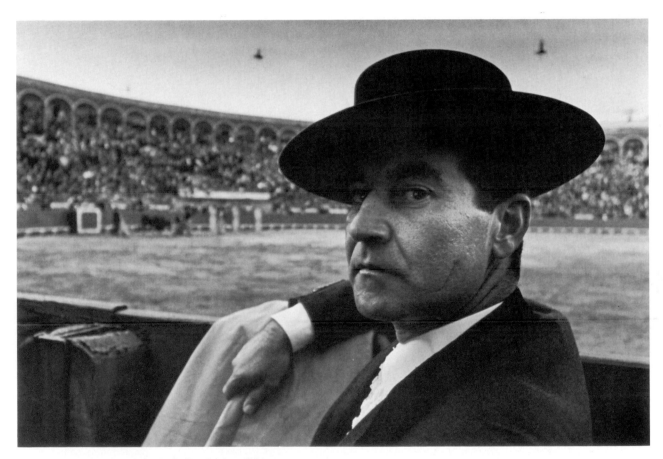

139. *Antonio Bienvenida*, Toledo, Spain, 1964

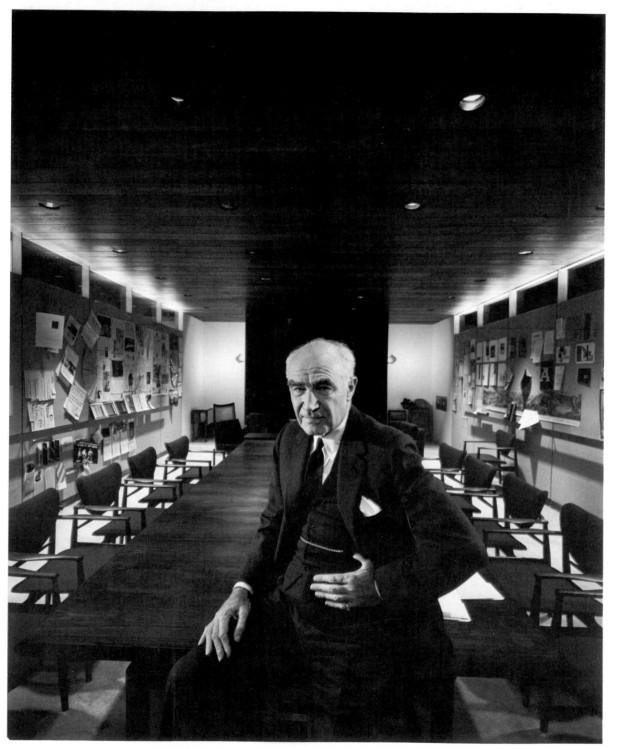

140. *Henry R. Luce,* New York City, 1962

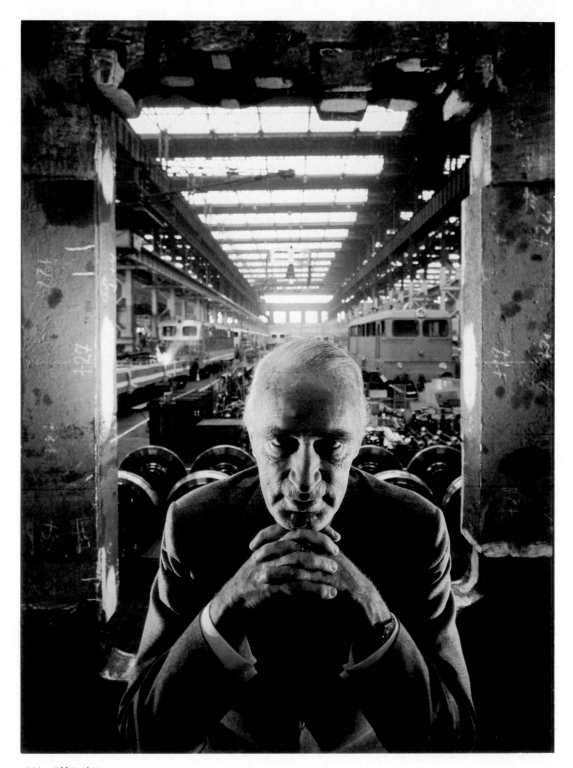

141. *Alfried Krupp,* Essen, Germany, 1963

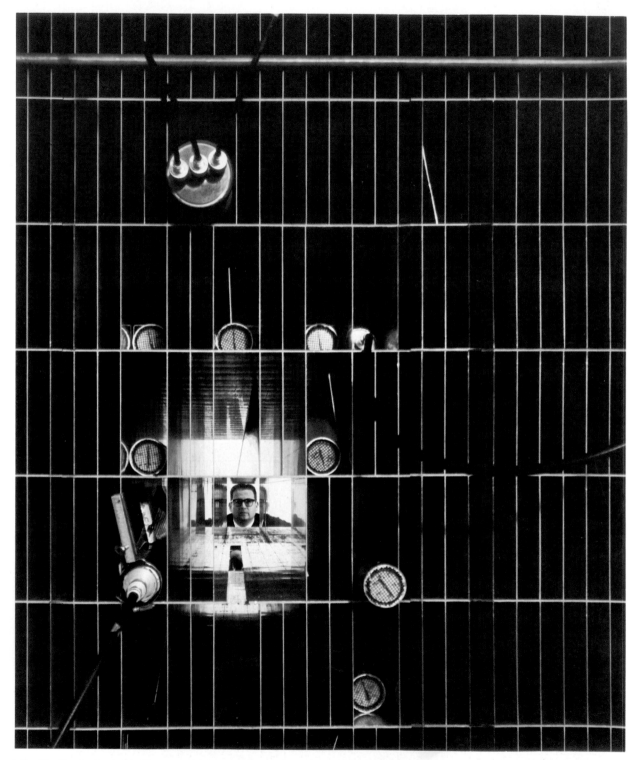

142. *Dr. Frederic de Hoffmann* of General Dynamics Corporation, San Diego, 1962

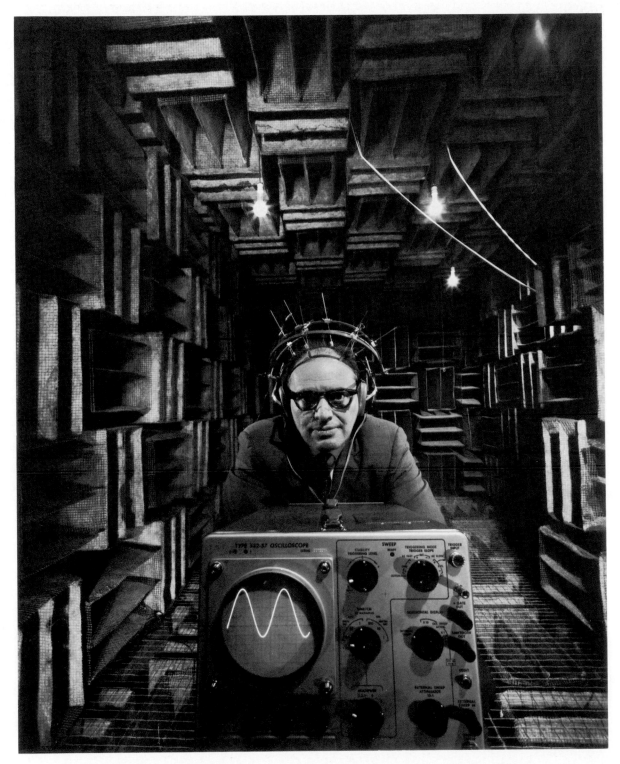

143. *Professor Walter Rosenblith*, Massachusetts Institute of Technology, Cambridge, 1962

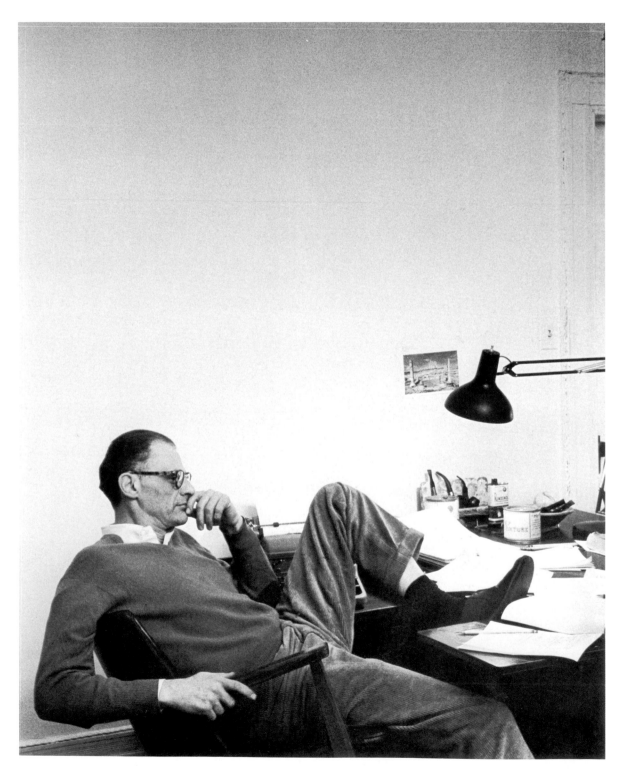

144. *Arthur Miller*, New York City, 1962

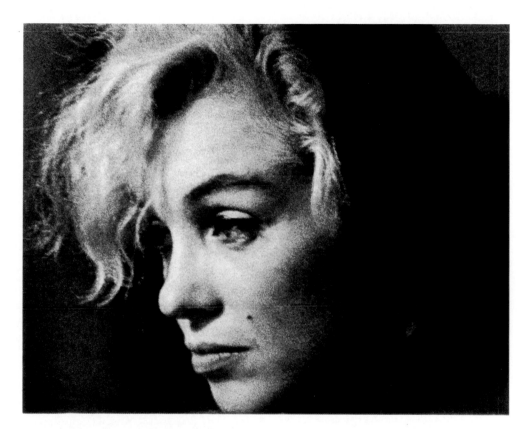

145. *Marilyn Monroe*, Beverly Hills, 1962

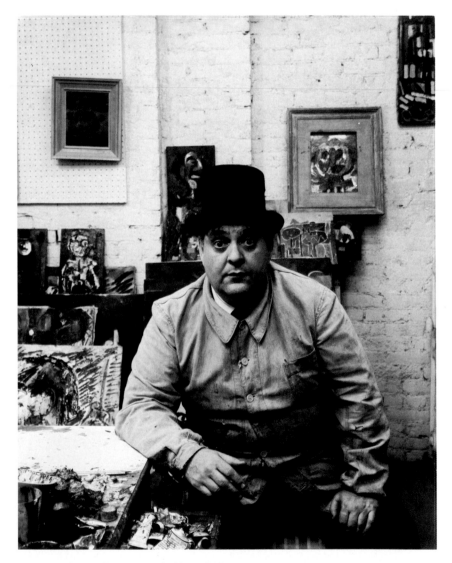

146. *Zero Mostel*, New York City, 1962

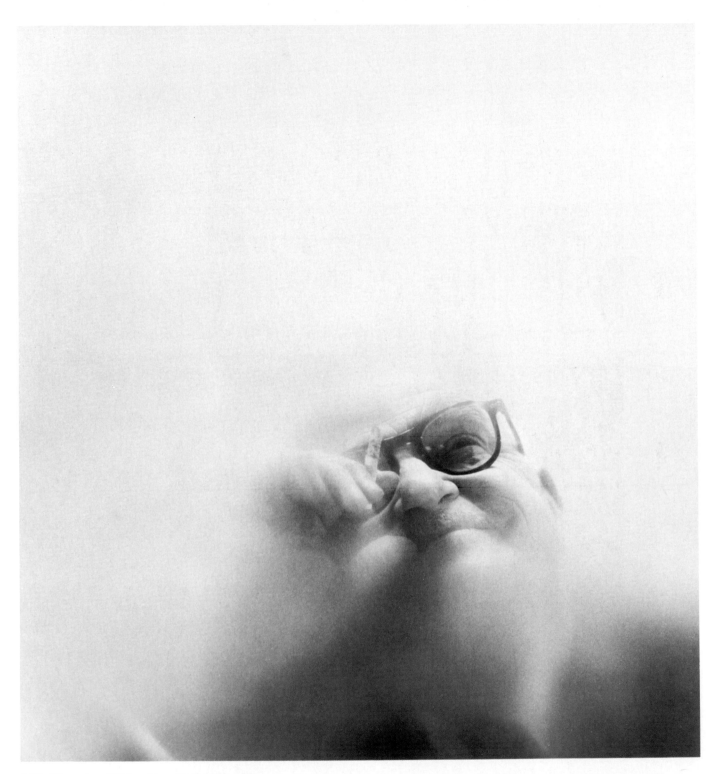

147. *Thornton Wilder,* New York City, 1962

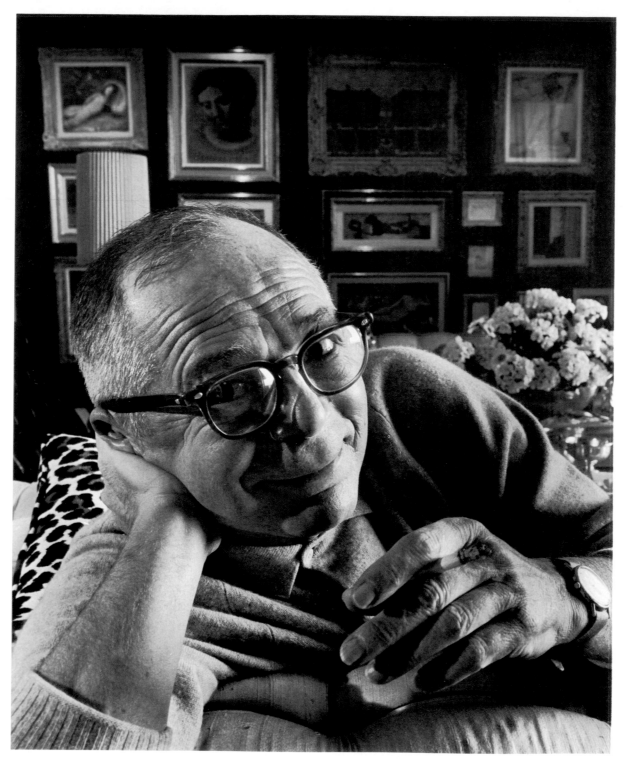

148. *Billy Wilder*, Los Angeles, 1962

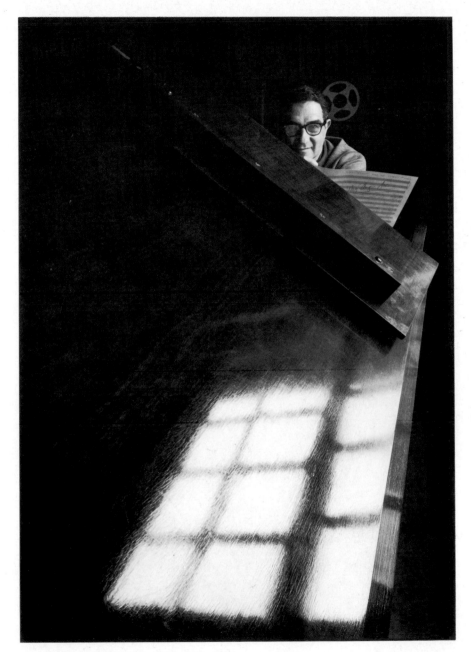

149. *Harold Rome*, New York City, 1961

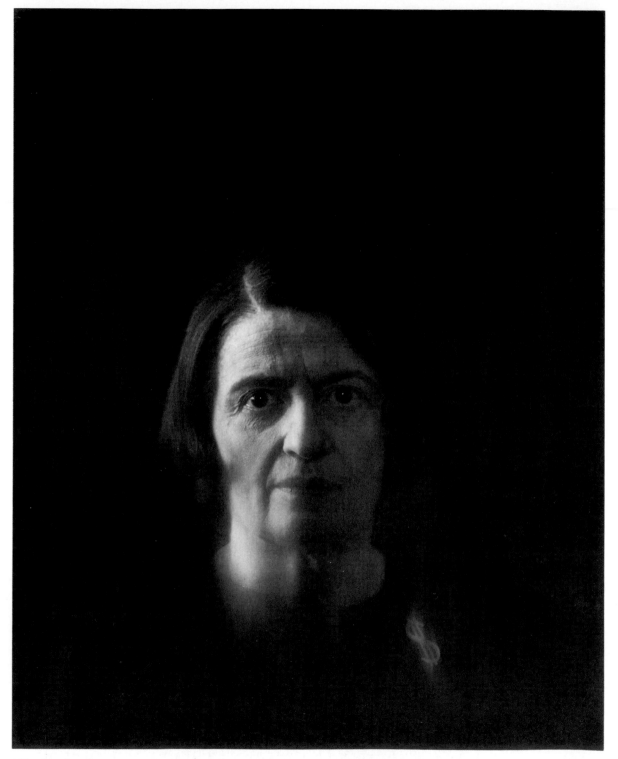

150. *Ayn Rand*, New York City, 1964

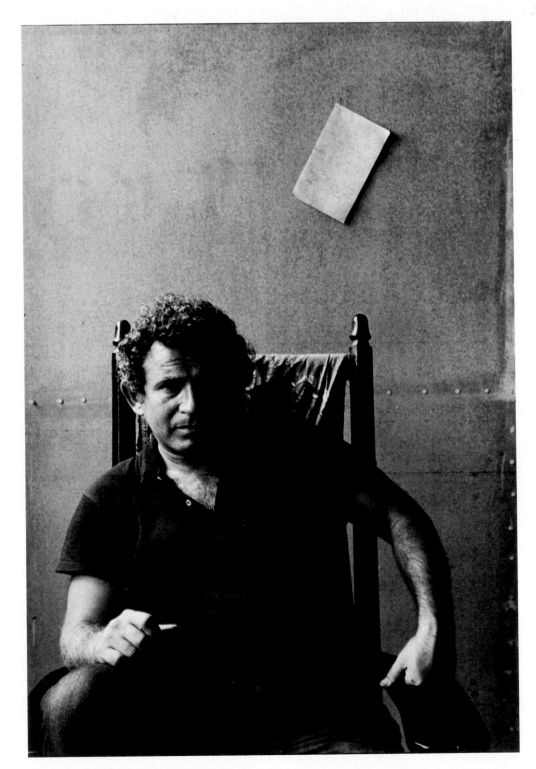

151. *Norman Mailer*, Provincetown, 1964

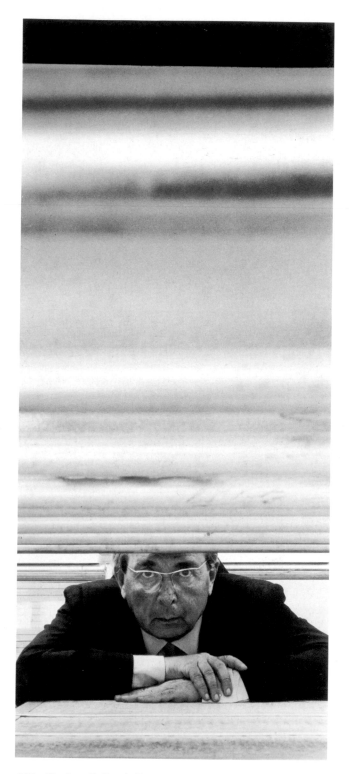

152. *Dr. Leo Szilard,* Geneva, 1963

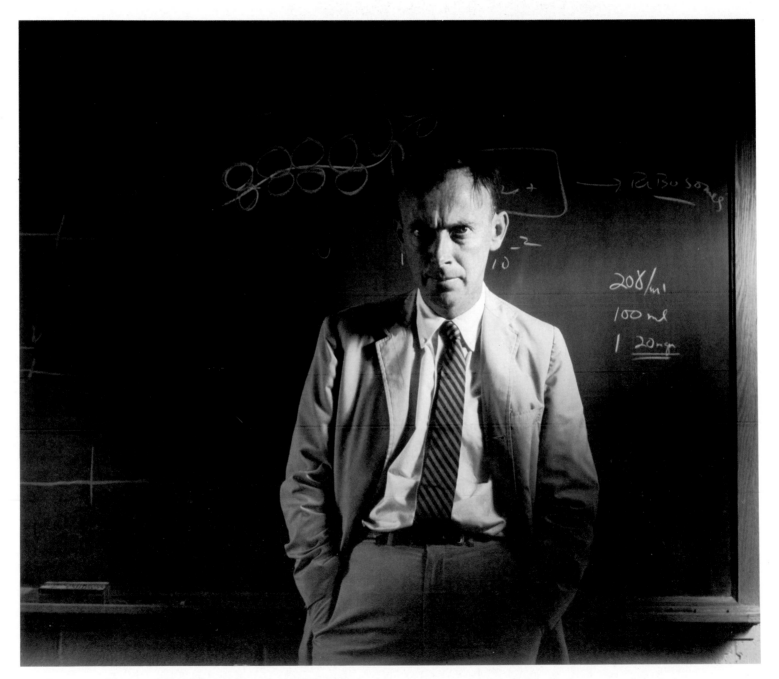

153. *Dr. James Watson,* Harvard University, Cambridge, 1964

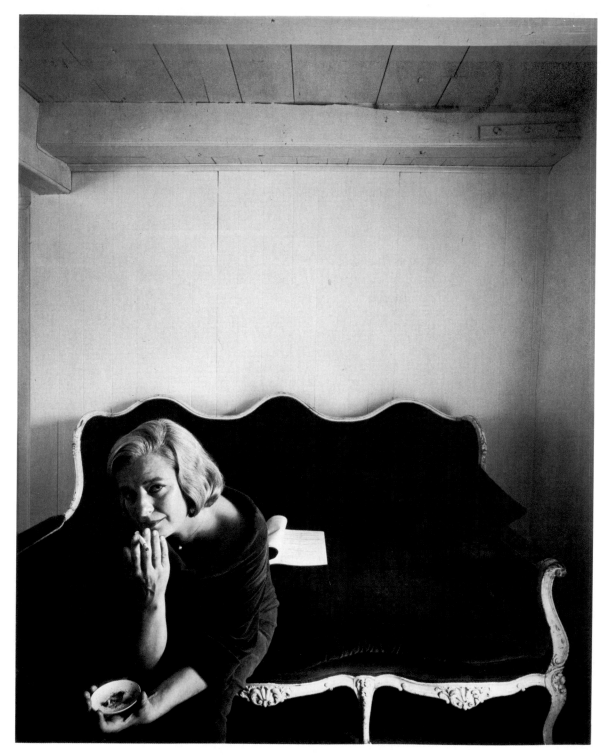

154. *Kim Stanley,* Congers, New York, 1963

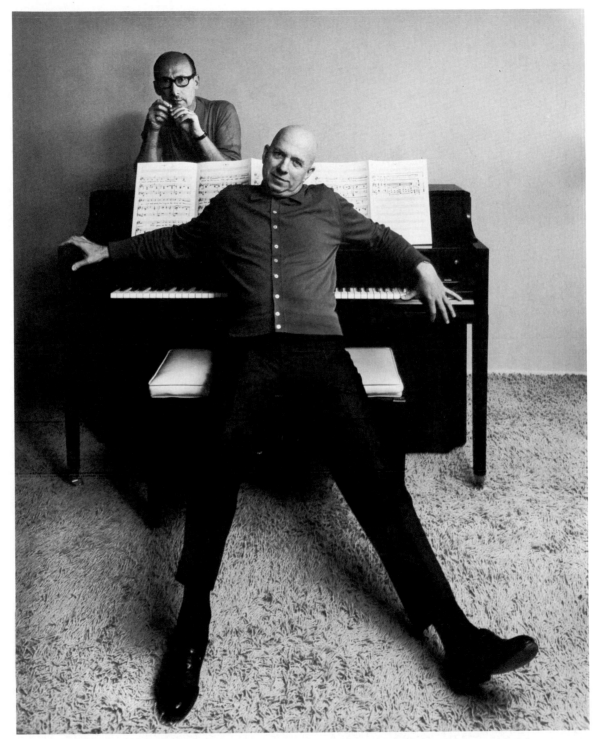

155. *Sammy Cahn and Jimmy Van Heusen,* Palm Springs, California, 1963

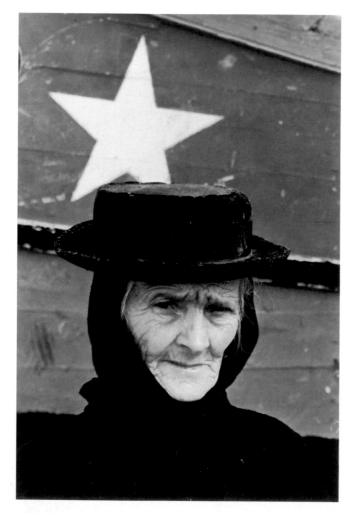

156. *Woman of Nazere*, Portugal, 1970

157. *Igor Stravinsky* at rehearsal, New York City, 1966

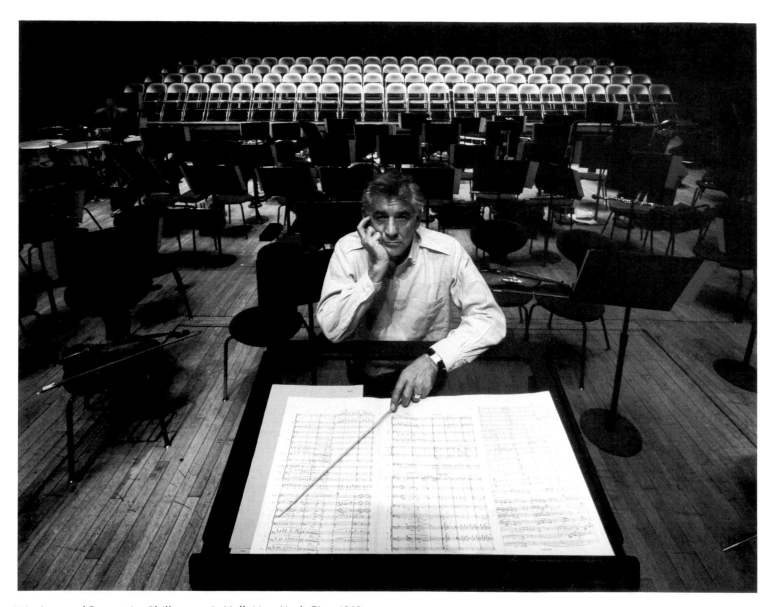

158. *Leonard Bernstein,* Philharmonic Hall, New York City, 1968

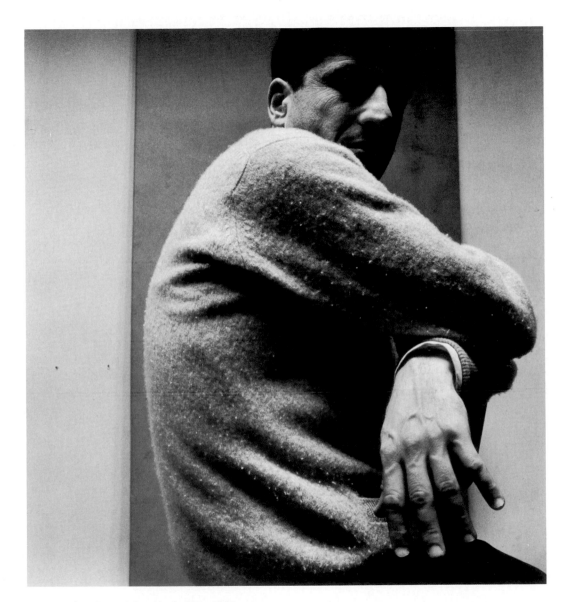

159. *Lukas Foss*, New York City, 1962

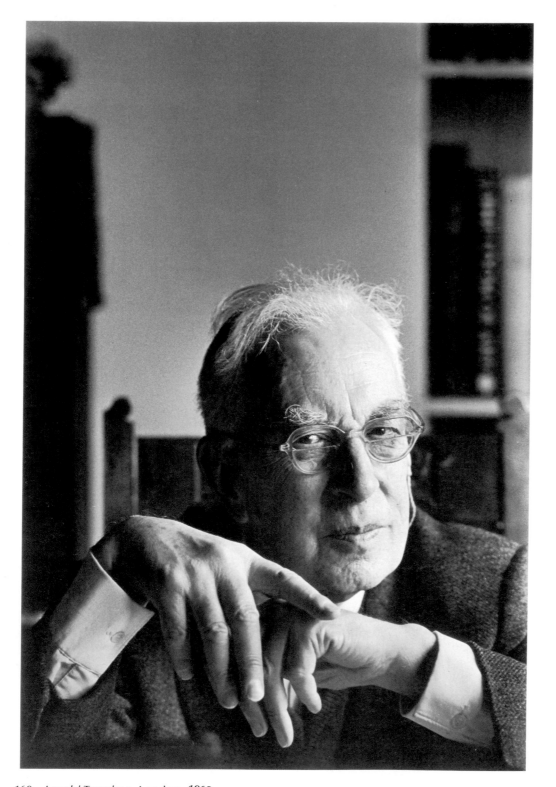

160. *Arnold Toynbee*, London, 1969

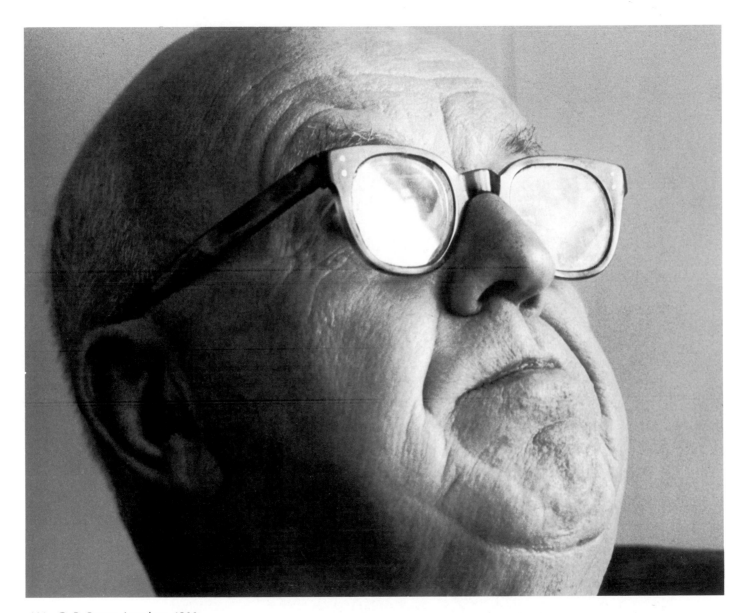

161. *C. P. Snow*, London, 1966

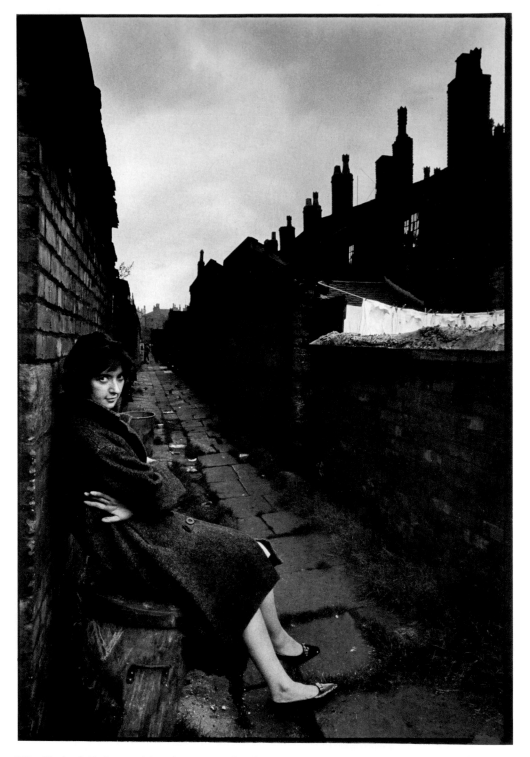

162. *Shelagh Delaney*, Manchester, England, 1961

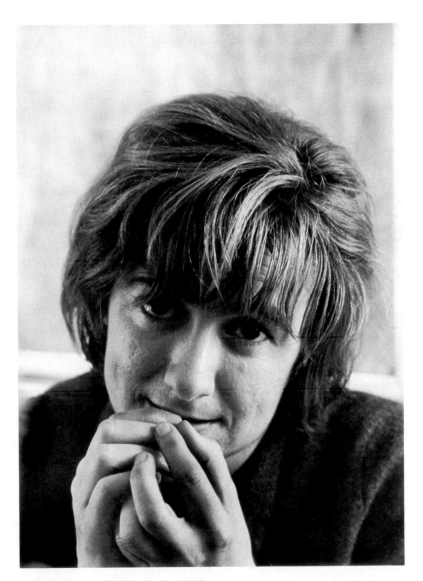

163. *Françoise Sagan*, Paris, 1968

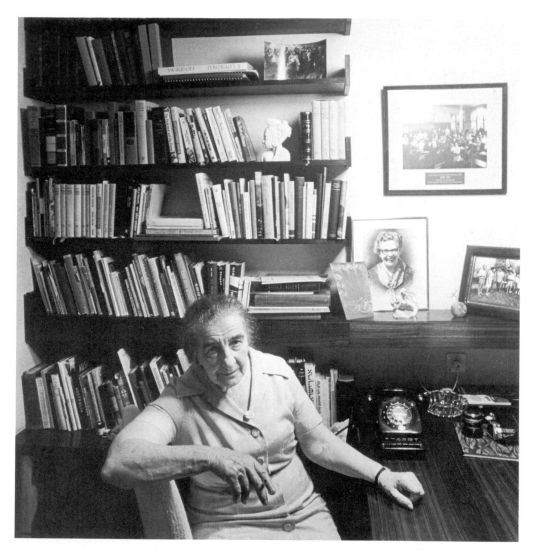

164. *Prime Minister Golda Meir,* Jerusalem, 1970

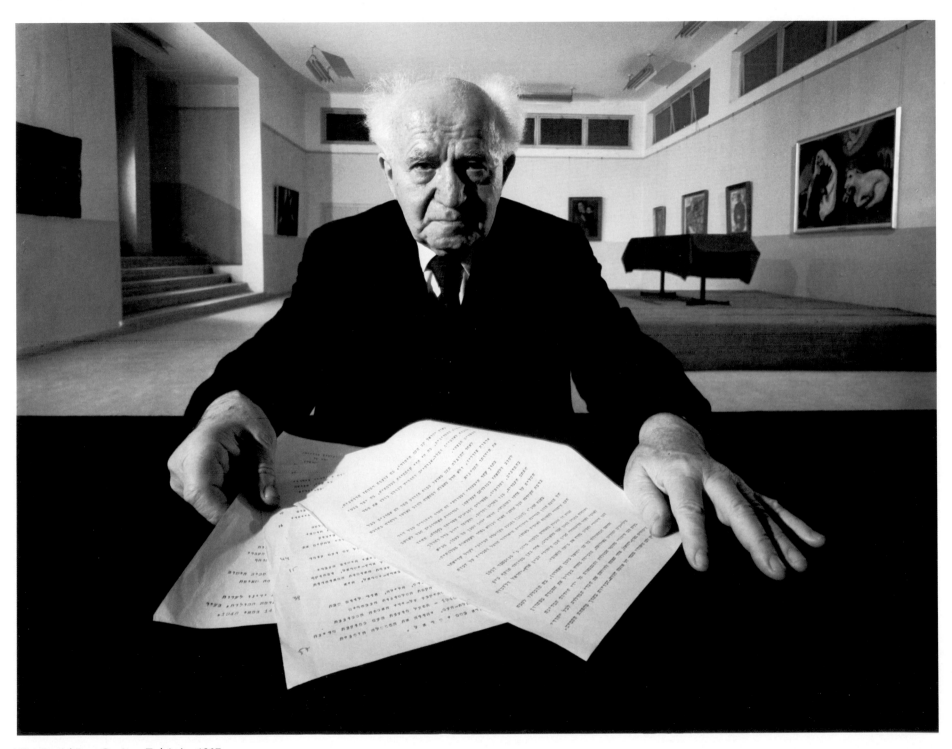

165. *David Ben-Gurion*, Tel Aviv, 1967

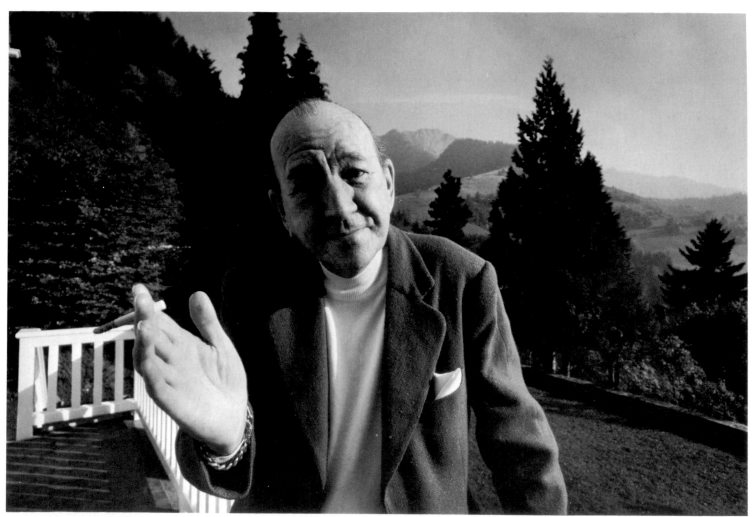

166. *Sir Noel Coward*, Les Avants, Montreux, Switzerland, 1968

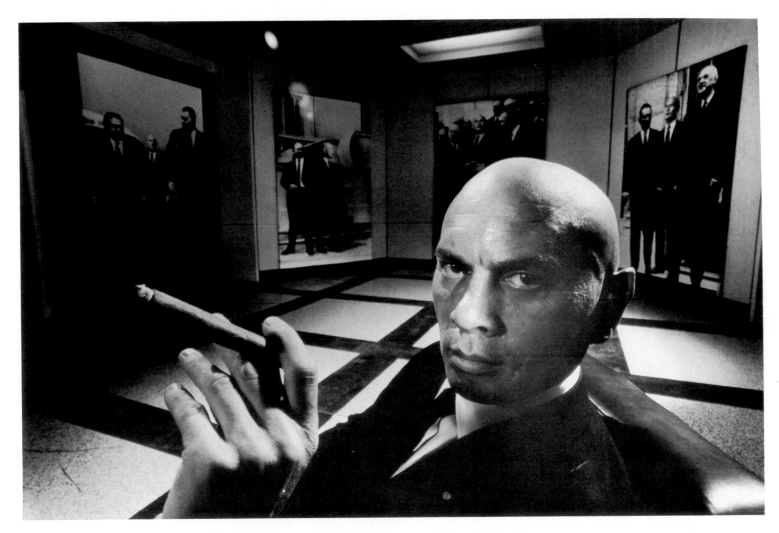

167. *Yul Brynner in* *The Mad Woman of Chaillot,* Nice, France, 1968

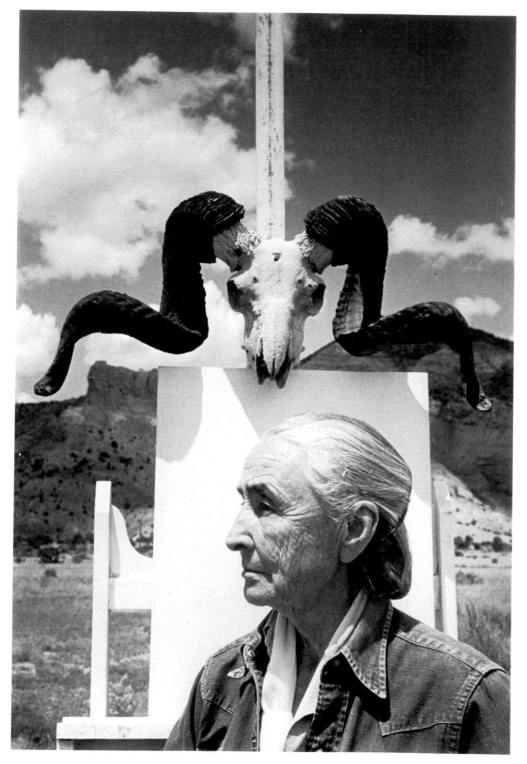

168. *Georgia O'Keeffe,* Ghost Ranch, New Mexico, 1968

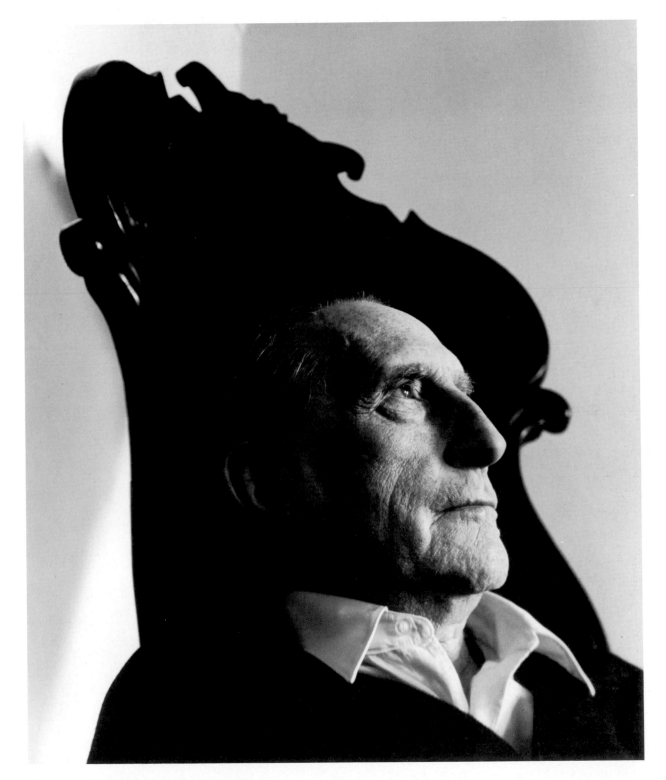

169. *Marcel Duchamp*, New York City, 1966

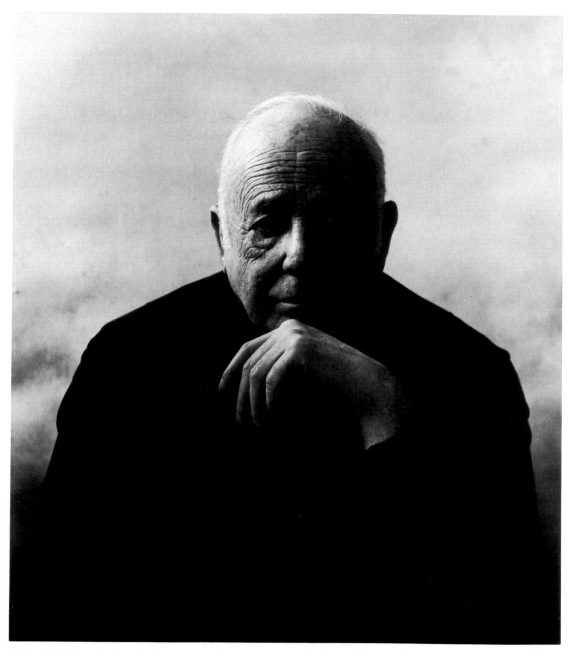

170. *Paul Strand*, New York City, 1966

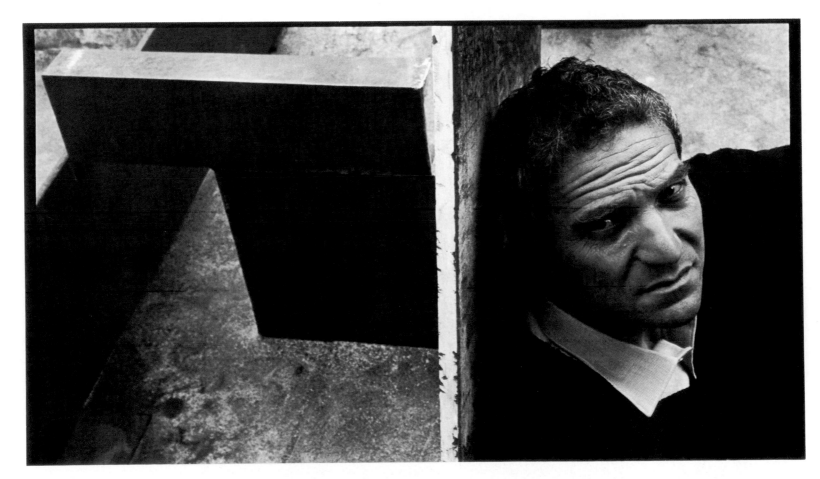

171. *Anthony Caro,* London, 1966

172. *Kenneth Armitage,* London, 1966

173. *Henry Moore* (collage), Much Hadham, England, 1966-72

174. *Bridget Riley,* London, 1966

175. *Phillip King*, London, 1966

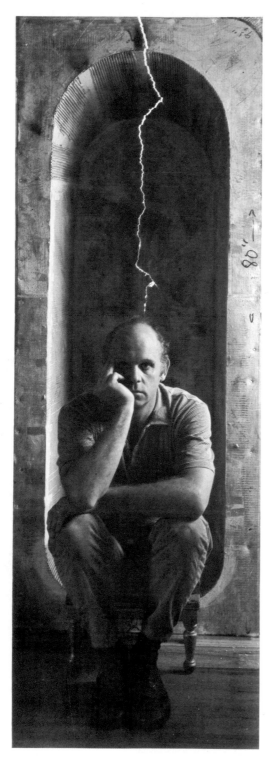

176. *Claes Oldenburg*, New York City, 1967-1972

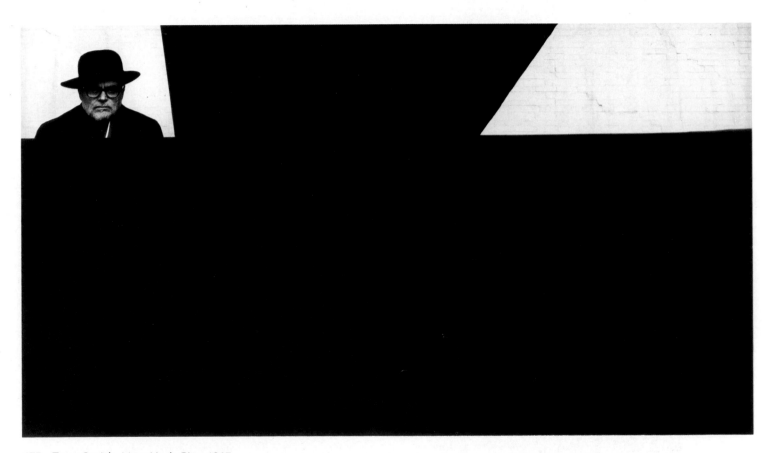

177. *Tony Smith*, New York City, 1967

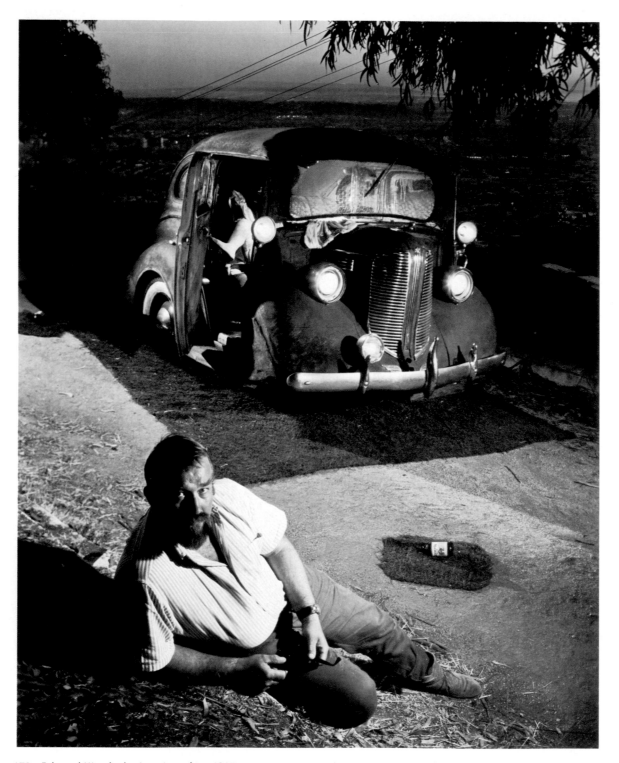

178. *Edward Kienholz,* Los Angeles, 1967

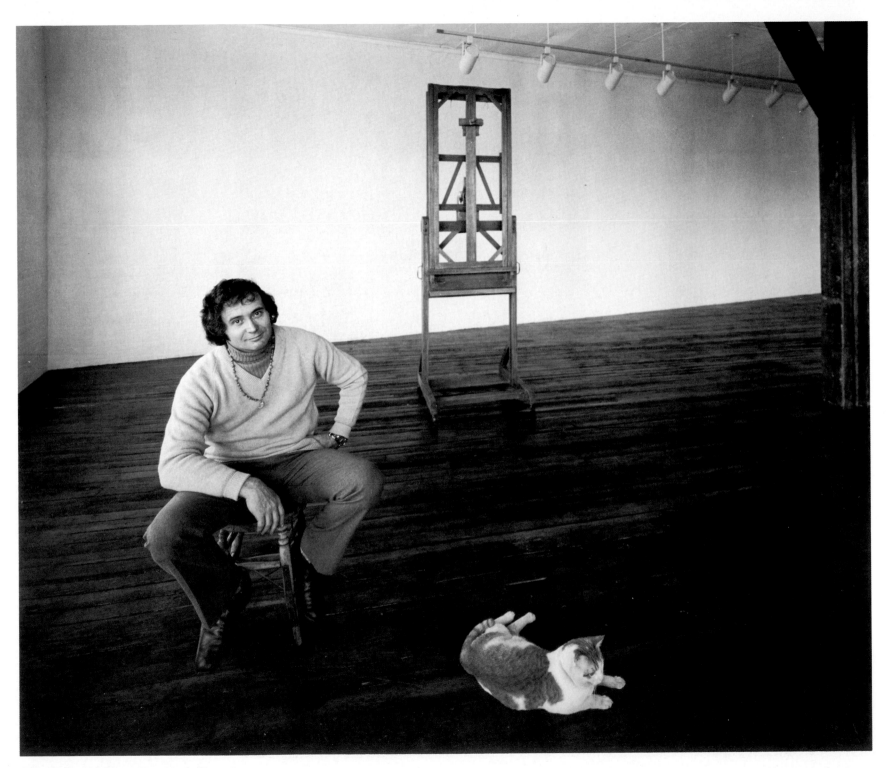

179. *Robert Indiana*, New York City, 1971

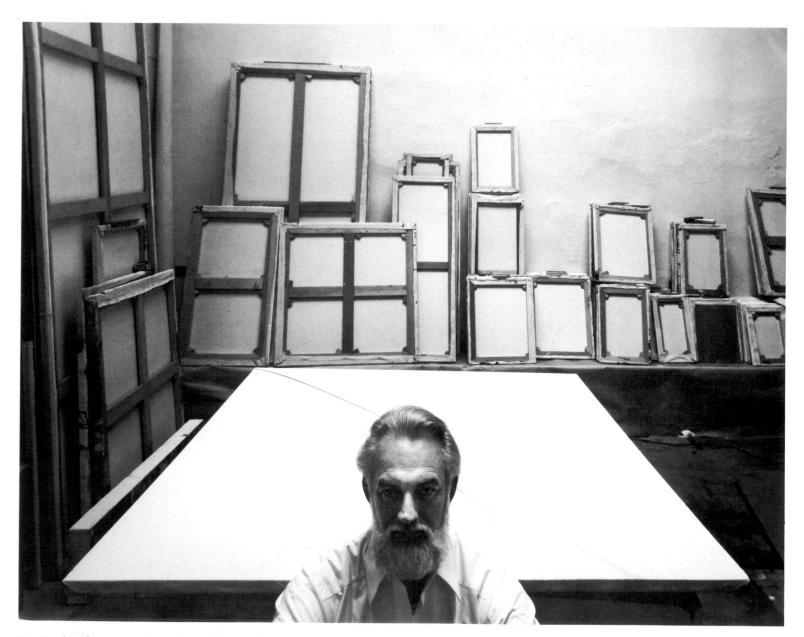

180. *Paul Jenkins*, New York City, 1968

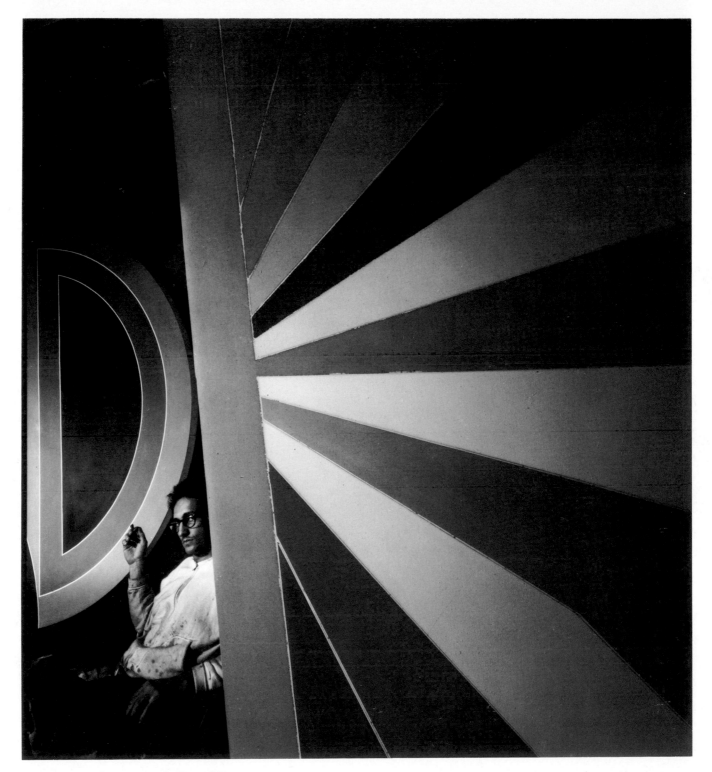

181. *Frank Stella*, New York City, 1967

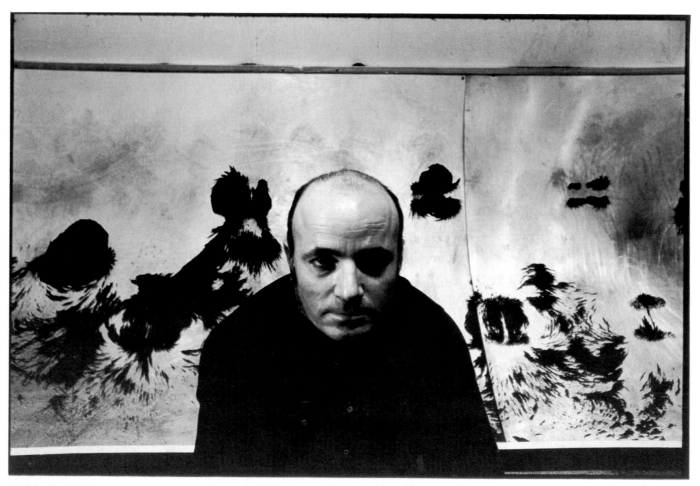

182. *Takis*, New York City, 1970

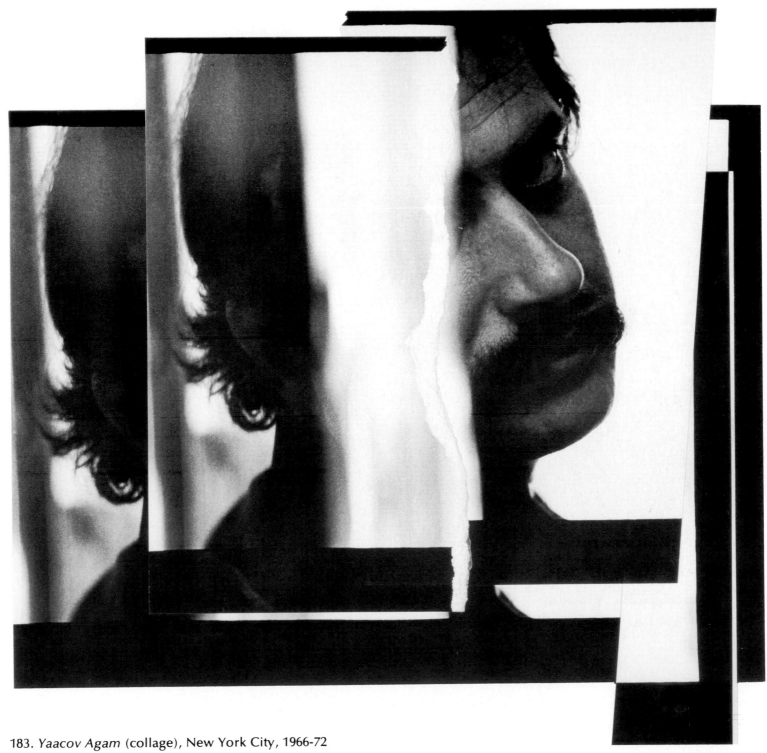

183. *Yaacov Agam* (collage), New York City, 1966-72

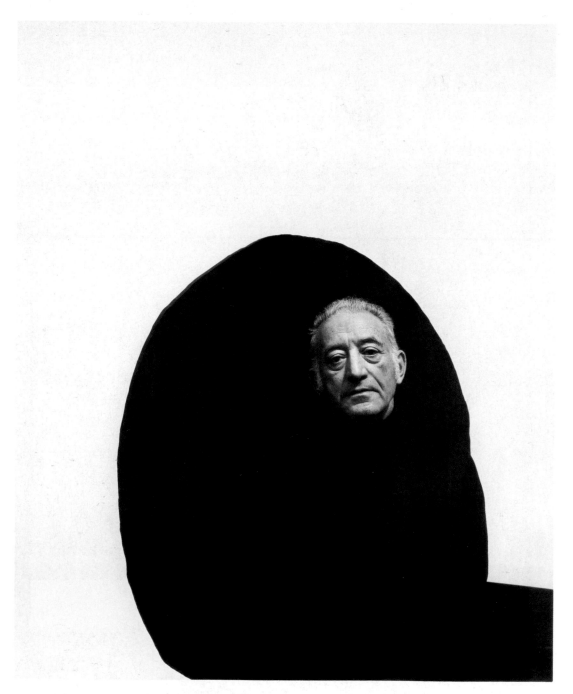

184. *Adolph Gottlieb,* New York City, 1970

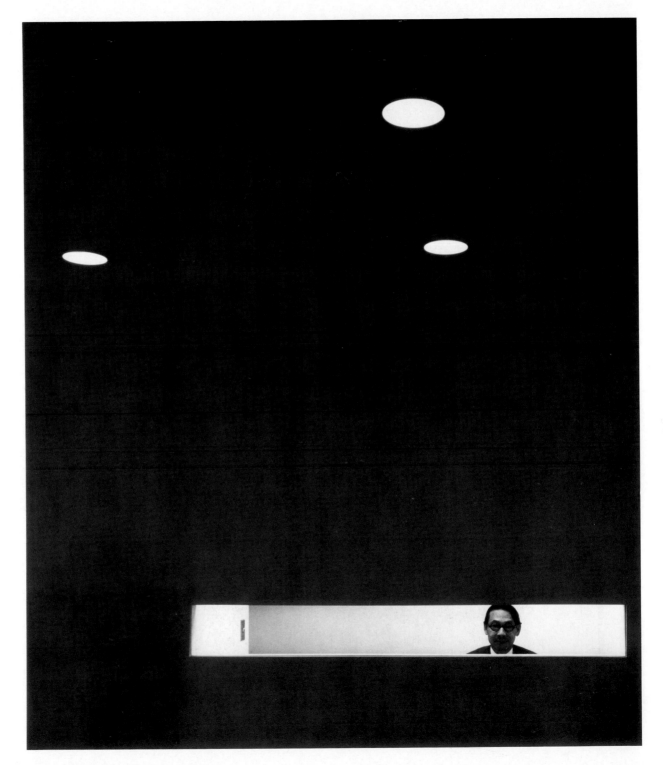

185. *I. M. Pei,* New York City, 1967

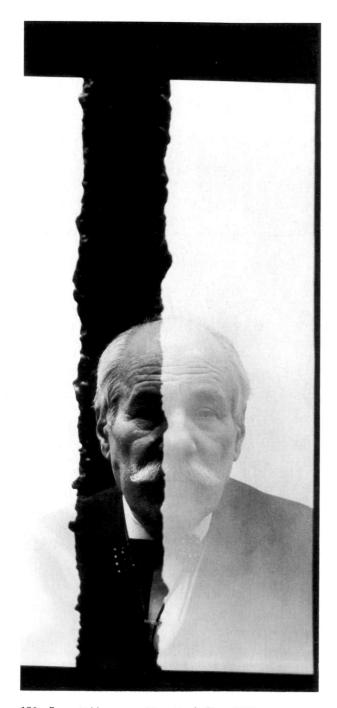

186. *Barnett Newman*, New York City, 1970

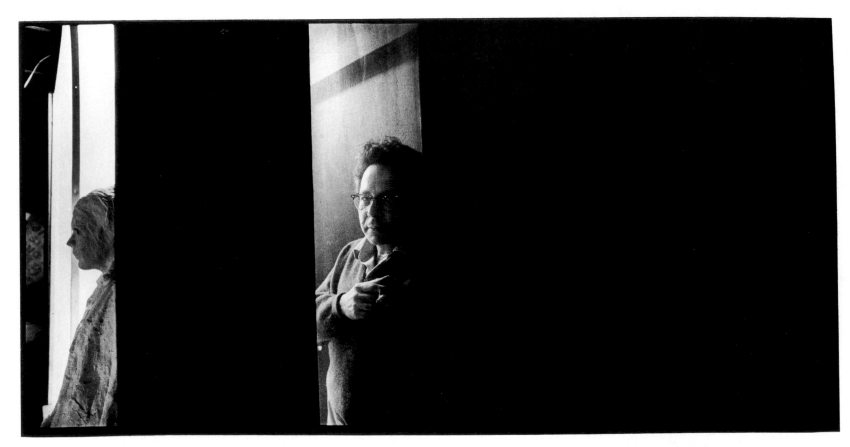

187. *George Segal,* South Brunswick, New Jersey, 1970

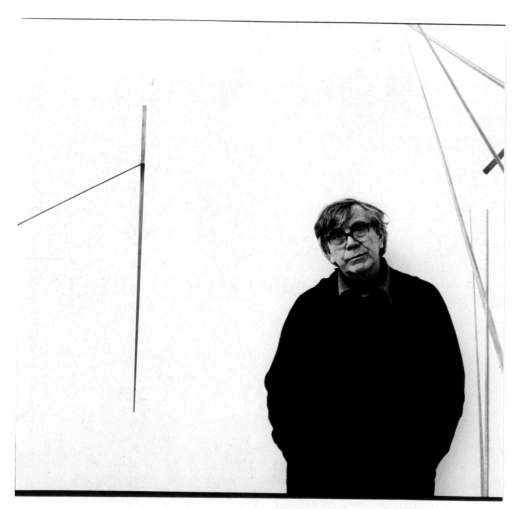

188. *George Rickey*, East Chatham, New York, 1973

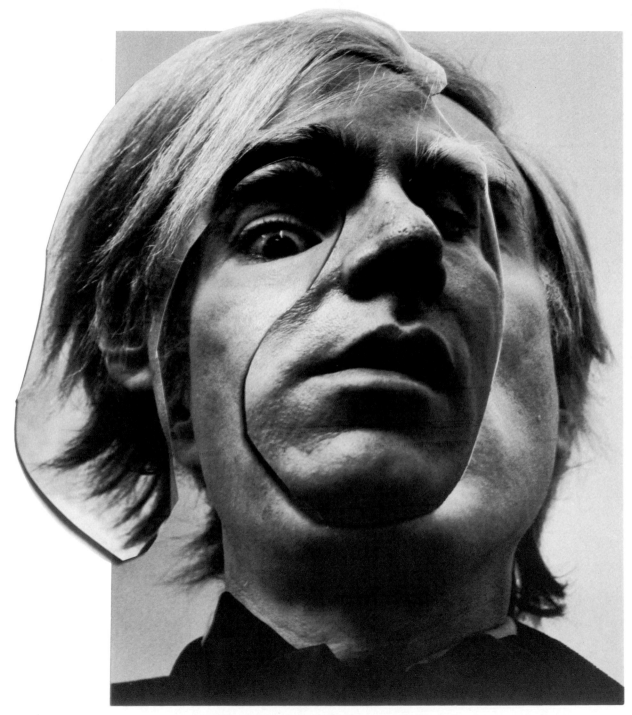

189. *Andy Warhol* (collage), New York City, 1973-74

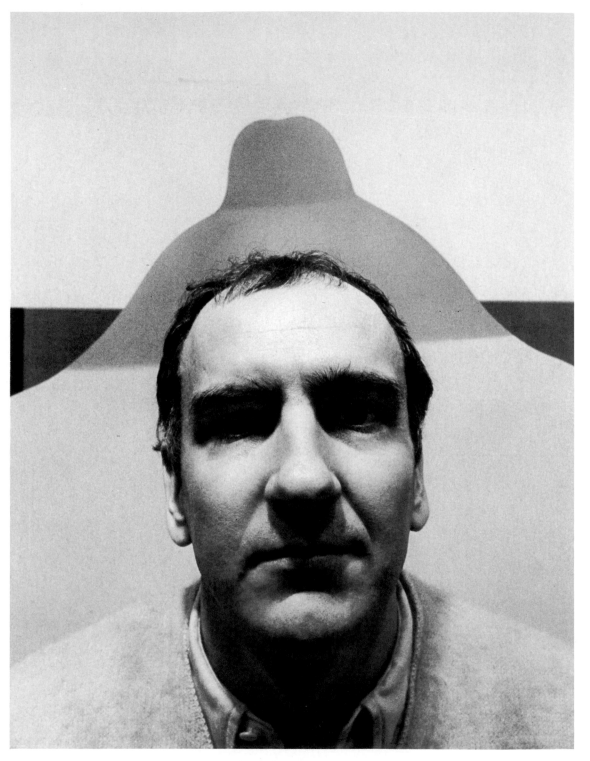

190. *Tom Wesselmann,* New York City, 1970

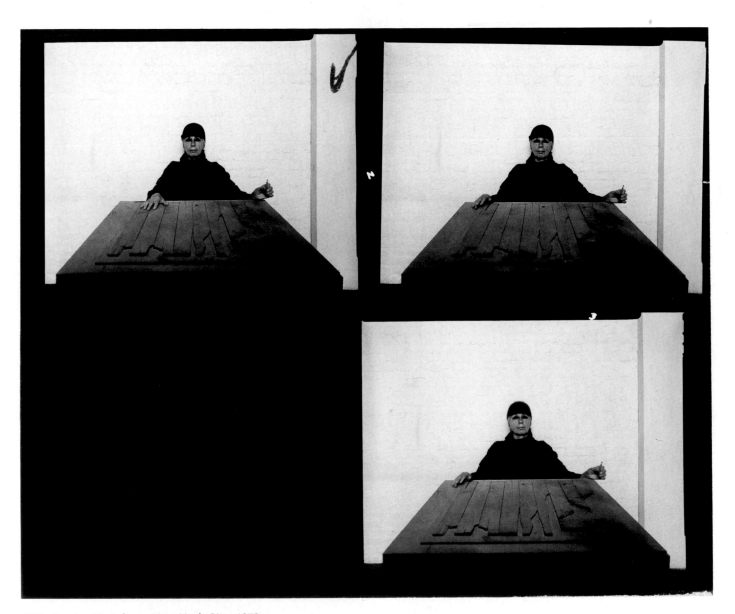

191. *Louise Nevelson*, New York City, 1972

192. *Trova*, New York City, 1971

APPENDIX

TECHNICAL NOTES

CAMERAS, lights, and photographic materials are tools to be selected as needed, depending upon the creative and technical problems. It is pointless to discuss specific cameras or other equipment or material, since they always change and improve.

My first camera was a borrowed 2¼x3¼ view camera fitted with an eye-level view-finder for handheld shots. Since 1940, my basic camera has been the 4x5 view camera used on a tripod. For professional and creative reasons, I have purchased and used every size up to 8x10.

In recent years, particularly as a result of technical advances, an increasingly larger portion of my work is shot with Single Lens Reflex (SLR) 35mm cameras. The principal reason is that it enables me to be freer while retaining a 'view camera' image, even when working handheld in fast-moving situations.

I prefer natural lighting with all its delightfully infinite varieties, indoors and out. When needed, I augment it with artificial light or reflectors and, on rarer but sometimes necessary occasions, with strobe. When I use 'artificial light' exclusively (floods, sometimes a spot or two), they are generally bounced (reflected) off walls, ceilings, or, when color is important, sheets. Bouncing is more 'natural'; it makes the lighting effective but unobtrusive. Lighting is a personal tool and I keep experimenting.

Like most professionals, I standardize my developing and printing, keeping it as simple as possible in order to concentrate on the creative problems. I work from contact sheets, analyzing and at times rethinking and changing my original compositions, often to a hair-splitting degree. For depth of field and other problems, I often use only a portion of a negative, but the original cropping is always invisibly present. My prints are archivally finished and are mounted on pure rag board.

When shooting color, I try to duplicate the exposure in black and white. Switching from color to black and white holders at will is not difficult with carefully planned view camera sittings. Shooting 35mm is more difficult, particularly when action or fleeting expressions are involved. Then I prefer to convert the color into black and white. In some instances, I have also had to convert 4x5 (see index).

There are no rules for techniques, only solutions. Today's darkrooms may soon be replaced with electronic consoles. Yet after thirty years, Stieglitz's advice to me remains constant: 'The only thing that matters is the finished photograph.'

A.N.

ARNOLD NEWMAN CHRONOLOGY

1918 Born March 3, New York City (second of three sons of Isador and Freda Newman).

1920–1934 Family moves to Atlantic City, New Jersey, in dry goods then hotel business. Attends elementary and first years of high school there. Meets Ben Rose upon joining Boy Scouts. Art becomes principal interest.

1934–1936 Family in hotel business at Miami Beach in winter and Atlantic City in summer. Active in art on school publications and paints for self.

1936–1938 Graduates high school, Miami Beach. Receives working scholarship to University of Miami (Coral Gables, Florida) art classes.

1938 Leaves school because of financial problems; accepts employment in portrait studio in Philadelphia. Begins own experiments. Lives with Ben Rose and associates with former Brodevitch students, Philadelphia School of Industrial Arts.

1939 Works in Philadelphia, Baltimore, and Allentown, Pennsylvania, for same studio. Meets Alfred Stieglitz in New York. In December takes job as studio manager in West Palm Beach, Florida. Begins 'cutout' experiments.

1941–1942 June 17–19, visits New York City. Receives encouragement from Beaumont Newhall and Alfred Stieglitz. Offered a two-man exhibit with Ben Rose by Dr. Robert Leslie, A.D. Gallery. Moves to New York upon opening of exhibit in September. Museum of Modern Art purchases first prints. Begins first 'experimental' portraits using artists as subjects.

1942–1945 Fall 1942, returns to Miami Beach for army induction; is deferred. Operates own studio in Miami Beach and continues artists' portrait series during visits to New York.

1945–1946 One-man exhibit, 'Artists Look Like This,' at Philadelphia Museum of Art. Exhibit purchased by the Museum and widely circulated.

1946 Moves to New York. Receives assignments from *Harper's Bazaar*, *Fortune*, and other publications. Photographs Eugene O'Neill, first of *Life* assignments, and Stravinsky. Shares New York studio, 20 East 84 Street, with Ben Rose.

1947 August 25, first of many covers for *Life*.

1948 Begins advertising assignments. October, moves to combined studio and home, 39 West 67 Street.

1949 March 6, marries Augusta Rubenstein. Portrait assignment for *Portfolio* begins long association with Frank Zachary, continuing later at *Holiday*, *Travel & Leisure*, and *Town & Country*.

1950 May 9, son, Eric Allan, born. 'What Do U.S. Museums Buy?' essay for *Life*.

1951 One-man exhibit at the Camera Club, New York. Begins the *New York Times* ad series photographing their executives, columnists, feature writers, critics; continues until 1958. First of continuing series of assignments for *Holiday*. Moves to larger quarters, 33 West 67 Street. Receives Photokina (Cologne, Germany) award.

1952 March 26, son, David Saul, born. Commissioned by *Life* to photograph presidential possibilities, Eisenhower, Stevenson, Taft, et cetera, for covers.

1953 'The U.S. Senate' essay for *Holiday* includes his first photographs of future Presidents Kennedy, Johnson, and Nixon.

1954 February–August, sails with family and loaded station wagon to Europe for *Holiday*, *Life*, and others – first of continuing assignments abroad over the years. Introduced to Paris art world and photographs Picasso in Vallauris.

1955 'American Arts and Skills' series for *Life*. One-man exhibit at Limelight Gallery, New York.

1956 Moves studio back to 39 West 67 Street, retains '33' as residence. Presidential candidates cover series for *Life* includes portraits of Kennedy, Eisenhower, and Nixon. 'French Essay' for *Holiday* and photographs Braque, Dubuffet, and Picasso (at La Californie, Cannes).

1957 Receives First Annual Photojournalism Conference Award, University of Miami, Coral Gables. Receives Financial World Annual Report Award for the Ford Motor Company 'Best 1957 Annual Report All Industries.'

1958 October to December, to Africa for *Holiday* photographing modern and tribal leaders plus stories in primitive bush areas in ten countries; covers 24,000 miles.

1959 First trip to Israel for *Holiday*.

1960 'Cape Cod Artists' essay for *Horizon*.

1961 Rothschild family portraits for *Holiday*. Assignments in Europe and Japan, and photographs the heads of the three branches of the U.S. Government for *Holiday*. Receives Newhouse Citation, Syracuse University, and the Philadelphia Museum College of Art citation.

1962 Contracts to do book of portraits with Carl Sandburg as author. Sandburg, living with Newmans, becomes ill and unable to continue. Project dropped.

1963 Renews acquaintance with Stravinsky and photographs him in Los Angeles. 'American Temper' series and John F. Kennedy advisers series for *Holiday*. Photographs Alfried Krupp in Essen, Germany. Does Lyndon B. Johnson's official portrait. One-man exhibit at the Fourth Biennale Internazionale Della Fotografia, Venice, Italy; awarded its Gold Medal.

1964 After editorial upheaval and staff resignations, suspends association with *Holiday* until 1967.

1965 Assigned most of the Smithsonian Institution Anniversary book. Named Adviser to the Photography Department, Israel Museum, Jerusalem.

1966 Begins IBM ad series, continues for two years. Increasing use of 35mm camera changes nature of work. Works on *Bravo Stravinsky* with Robert Craft as author.

1967 *Bravo Stravinsky* published.

1968 Special photography for films in France and England. Begins teaching advance class at Cooper Union, New York.

1970–1971 First assignments for *Travel & Leisure* magazine, now staffed by former *Holiday* editors. Resumes 'cutout' experiments.

1972–1973 Signs with LIGHT Gallery, New York City, and has one-man exhibit there. One-man exhibit, 'Photographs from Three Decades,' at International Museum of Photography, George Eastman House, Rochester, New York. Circulating version of exhibit first shown at the University of California Art Museum, Berkeley.

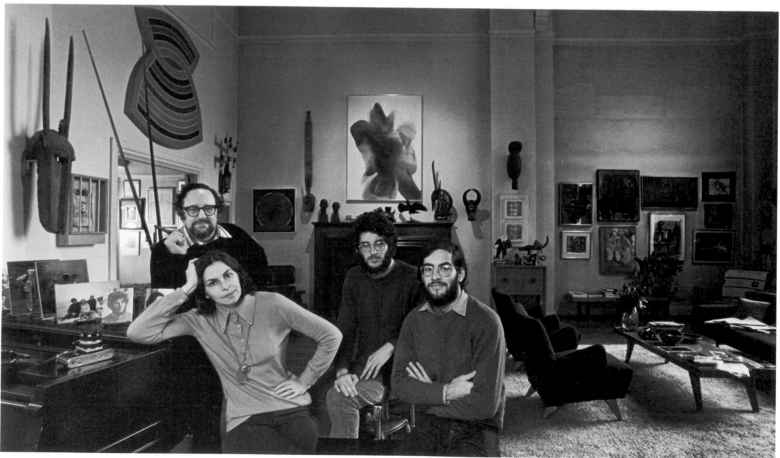

Arnold, Augusta, Eric and David Newman, 1974.

ONE-MAN EXHIBITIONS

*These exhibitions were circulated extensively to museums and other institutions.

1941 'Two American Unknowns – Arnold Newman and Ben Rose.' A-D Gallery, New York. Organized by Dr. Robert L. Leslie and Percy Seitlin. 50 photographs.

1941–1942 'Artists Through the Camera.' The Photography Gallery, Brooklyn Museum. 45 photographs.

***1945–1946** 'Artists Look Like This.' Philadelphia Museum of Art. Organized by E. M. Benson, Chief, Division of Education. Circulated. 87 photographs.

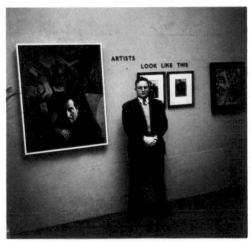

Arnold Newman at the opening of the Newark, New Jersey exhibition of 'Artists Look Like This,' circulated by the Philadelphia Museum of Art. 1946

1950 'Arnold Newman – Early and Recent Works.' The Village Camera Club, New York. 30 photographs.

1951 'Arnold Newman Photographs – Black/White and Color, 1938–1950.' The Camera Club, New York. 110 photographs.

'Arnold Newman Photographs, 1938–1950.' Milwaukee Art Institute. 100 photographs.

1953 'Arnold Newman – Color and Black/White.' The Ed Weiner Gallery, Provincetown, Mass. 30 photographs.

'Arnold Newman Retrospective.' Chicago Art Institute. Arranged by Peter Pollack. 48 photographs.

1955 'Arnold Newman Collective Work.' Portland (Oregon) Art Museum. Arranged by Thomas C. Colt, Jr. 70 photographs.

'Arnold Newman Portraits.' Limelight Photo Gallery, New York. 53 photographs.

'Arnold Newman Portraits.' University of Maine, Orono, Maine. 40 photographs.

1956 'Arnold Newman Photographs, 1940–1954.' Santa Barbara Museum of Art, California. 40 photographs.

'Arnold Newman Photographs, 1940–1954.' Library Gallery, Ohio University, Athens, Ohio. 40 photographs.

'Arnold Newman Photographs, 1941–1954.' Gallery 256, Provincetown, Mass. 41 photographs.

'Arnold Newman Photographs.' Miami Beach Art Center. 85 photographs.

1957 'Arnold Newman Portraits.' University of Virginia Museum of Fine Arts, Charlottesville, Va. 75 photographs.

1958 'Arnold Newman Portraits.' Contemporary Arts Center, Cincinnati Art Museum. 75 photographs.

1959 'African Portraits and Crafts.' The Commercial Museum, Philadelphia. For the exhibit, 'Treasures of Africa.' 28 photographs.

1961 'Arnold Newman Portraits.' Phoenix (Arizona) Art Museum. 60 photographs.

1963 'Arnold Newman Portraits.' The Fourth Biennale Internazionale Della Fotografia, Venice, Italy. Arranged by Romeo Martinez. 48 photographs.

1964 'Photographs Arnold Newman.' VII Photographers Gallery, Provincetown, Mass. 45 photographs.

1972 'Arnold Newman.' The Light Gallery, New York. 63 photographs.

***1972–1973** 'Arnold Newman: Photographs From Three Decades.' International Museum of Photography, George Eastman House, Rochester, N.Y. 81 photographs. Circulated 50 photographs.

1973 'Arnold Newman: Photographs From Three Decades.' University of California Art Museum, Berkeley, Calif. 50 photographs.

1974 'Arnold Newman.' 831 Gallery, Birmingham, Mich. 45 photographs.

GROUP EXHIBITIONS
Partial Listing

1941 'Exhibition and Sale – American Photographs.' Museum of Modern Art, New York.

1943 'Masters of Photography.' Circulating exhibition, Museum of Modern Art, New York.

'100 Years of Portrait Photography.' Museum of Modern Art, New York.

'Christmas Exhibition Sale.' Museum of Modern Art, New York.

1945–1948 'New Photographers.' Circulating exhibition, Museum of Modern Art, New York.

1948 'In and Out of Focus.' Museum of Modern Art, New York. Circulated in the United States, Germany, Italy, and France.

1950 First Exhibition. 'Color Photography.' Museum of Modern Art, New York.

'Exhibition Fifty.' The Camera Club, New York.

'Photography Mid-Century.' Los Angeles County Museum.

'Modern Photographs.' Detroit Institute of Arts.

1951 'Contemporary Photography.' Contemporary Arts Association, Houston, Texas.

1953 'Contemporary American Photography.' National Museum of Modern Art, Tokyo. Fuji Film Building, Osaka.

1956 'Creative Photography – 1956.' University of Kentucky, Lexington, Ky.

1957 'Creative Photography.' Montclair Art Museum, N.J.

'Portraiture: The 19th and 20th Centuries.' Exhibition of paintings, prints, and photographs. Munson-Williams-Proctor Institute, Utica, N.Y. Circulated.

'Faces in American Art.' Metropolitan Museum of Art, New York. 35 portraits. Circulated by the American Federation of Arts.

1958–1959 'Photographs from the Museum Collection.' Museum of Modern Art, New York.

1959 'Art in Photography.' Art: USA '59 Exhibition. New York Coliseum, New York.

'Masterpieces of Photography from the Museum's Collection.' Art Institute of Chicago.

1959–1960 'Photography at Mid-Century.' Tenth Anniversary Exhibition. George Eastman House, Rochester, N.Y. Circulated.

'Toward the New Museum of Modern Art.' Museum of Modern Art, New York.

1960 'The Sense of Abstraction.' Museum of Modern Art, New York.

'Portraits from the Museum Collections.' Paintings, prints, and photographs. Museum of Modern Art, New York.

1962 'Ideas in Images.' Worcester (Mass.) Art Museum. Circulated.

1964 'The Photographer's Eye.' Museum of Modern Art, New York.

1965 'Photography in the Fine Arts.' The Kodak Pavilion. New York World's Fair. Circulated.

1967 'Photography in the Fine Arts' (No. V). Metropolitan Museum of Art, New York. Circulated.

'Homage to Marilyn Monroe.' Exhibition of work by leading artists: paintings, prints, photographs. Sidney Janis Gallery, New York.

1968 'Photography in the Twentieth Century.' George Eastman House, Rochester, N.Y. Circulated.

1969 'Portrait Photographs.' Museum of Modern Art, New York.

'The World in Color.' Union Carbide Building, New York. Originated and shown in the Netherlands and Prague. Circulated in USA.

'Israel: The Reality.' The Jewish Museum, New York. Circulated.

1970 'The Camera and the Human Facade.' Smithsonian Institution, Washington, D.C.

'Foto-Portret.' A retrospective exhibition of the history of the portrait in photography. Haags Gemeentmuseum, the Netherlands.

1971 'Invitational Exhibition – Paintings, sculpture, prints, photographs.' Provincetown (Mass.) Art Association.

1972 'Portrait of the Artist.' Portraits from the Museum's collection in various media from the Renaissance through the era of photography. Metropolitan Museum of Art, New York.

1974 'The Art of the Portrait Photograph.' Robert Schoelkopf Gallery, New York.

SELECTED BIBLIOGRAPHY

Since the material available is so extensive, only major articles, significant magazine covers, or single photographs are listed. All entries under *Publications* contain written text, statements, or quoted remarks by or about Arnold Newman. The section *Photographs in Published Sources* consists of work executed on commission or existing photographs used to illustrate articles, some self-contained (captioned, but without text).

PUBLICATIONS

BOOKS, ARTICLES, REVIEWS

'Arnold Newman.' *Camera* (Switzerland) (November 1968), pp. 24–33. Article and 9 photographs.

'Arnold Newman, Early Photographs.' *Infinity* (November 1963), cover, pp. 4–9. Article and 6 photographs. (See Rose, Ben.)

'Arnold Newman Photographs the President.' *Popular Photography* (October 1964), pp. 40–41. Article and 8 photographs.

'Arnold Newman "Shoots" Artists.' *U.S. Camera* (February 1946), pp. 24–25. 17 photographs.

'Arnold Newman's 35mm Portraiture.' *Nikon World,* vol. 2, no. 2 (1968). Article and 5 photographs.

'Artists Look Like This.' *New York Times Magazine* (November 4, 1945), pp. 16–17. Article and 10 photographs.

'The Art of the Portrait – as magazine illustration,' and 'The Art of the Portrait – as corporate communication.' *Applied Photography,* no. 44 (1970). Article and 8 photographs.

Barr, Alfred H., Jr. (ed.). *Master of Modern Art* (New York: Museum of Modern Art, 1954. Distribution by Simon & Schuster). One photograph, p. 197.

Bethers, Ray. *From Eye to Camera* (New York: Pitman Publishing Corporation, 1951). 5 photographs, pp. 99, 120–123.

Bondi, Inge, 'Some Relationships Between Photography and Artists.' *Archives of American Art* (April 1969). In text and 3 photographs.

Cole, Sheila. 'Newman.' *Photo Arts* (December 1950), pp. 34–39. Article and 5 photographs.

'Convention Personality – Arnold Newman.' *The National Photographer* (March 1960), pp. 140–141. Article and 6 photographs.

Craft, Robert. 'Stravinsky, Chronicle of a Friendship 1948–1971.' (New York: Knopf, 1972). In text, pp. 303, 310, 311, 312, 313, 314, 315.

'Creative Camera Men.' *Newsweek* (July 1, 1946), p. 81. In text and one photograph.

Creative Photography (Lexington, Ky.: Lexington Camera Club and Department of Art, University of Kentucky, Lexington, 1956). In text and 2 photographs, pp. 20–21.

DeMare, Eric. *Photography* (Penguin Handbook. Harmondsworth, England: Penguin Books, 1957). 2 photographs, pp. 44–45.

Deschin, Jacob. *Say It With Your Camera* (New York: Whittlesey House, McGraw-Hill, 1950). In text and one photograph, pp. 14, 51–53, 83. Completely revised edition (New York: Ziff-Davis, 1960). In text, pp. 14, 60–62, 91.

————. 'Portraits on Display.' *New York Times* (February 20, 1955). Review of Newman's one-man exhibition, Limelight Photo Gallery, New York.

————. 'Portraits of Artists.' *New York Times* (June 16, 1957). Review of Metropolitan Museum's exhibition 'Faces in American Art.' Newman in text.

Downes, Bruce. 'Angle of View.' *Popular Photography* (August 1948), pp. 10, 194. In text and one photograph.

————. 'Let's Talk Photography.' *Popular Photography* (April 1951), pp. 18, 100. In text and one photograph.

The Editors of Time-Life Books. *Life Library of Photography* (New York: Time-Life Books, 1970). 'The Camera,' pp. 40–41, in text and one photograph. 'The Great Themes,' pp. 112–113, in text and 2 photographs. 'Light and Film,' pp. 63–64, in text and 2 photographs.

————. 'Photography Year, 1974 Edition,' p. 146, in text and one photograph.

————. (1971) 'The Studio,' pp. 20–21, 88–91, in text and 4 photographs. 'Great Photographers,' pp. 193, 228–229, in text and 3 photographs.

Encyclopedia Judaica. (New York: Macmillan, 1971). Vol. 12, p. 1035. Biography.

'The Face of the Artist.' *Harper's Bazaar* (October 1946), pp. 166, 247–251. Article and 15 photographs.

Finch, Christopher. 'Images of Friendship: The Collection of Mr. and Mrs. Arnold Newman.' *Auction Magazine* (June 1971), pp. 29–33. Article on the Newmans' art collection, 6 photographs.

'Foto-Portret.' *Haags Gemeentemuseum* (The Hague, Netherlands: 1970), p. 61. Published with their exhibit. One photograph.

Freedman, Richard. 'The Private Life of a Magician.' Review of *Bravo Stravinsky. Book World* (December 31, 1967), pp. 4–5. 3 photographs.

Gelb, Arthur and Barbara. *O'Neill* (New York: Harper, 1960). In text regarding Newman doing O'Neill's portrait, pp. 872–873.

Genauer, Emily. 'Photos of Artists in New Museum Show.' *New York Herald Tribune* (June 16, 1957). Review of Metropolitan Museum's exhibition, 'Faces in American Art.' In text.

Goldsmith, Arthur. 'On Assignment with Arnold Newman'; 'A *Popular Photography* Tape Interview: Arnold Newman on Portraiture.' *Popular Photography* (May 1957), pp. 80–85, 86–87, 113–116, 122–127. Article and taped interview, 15 photographs of Newman on assignment, 12 Newman photographs.

————. 'Arnold Newman: The Portrait as Record and Interpretation.' *Popular Photography* (November 1973), pp. 122–131, 172, 198, 201. Article and portfolio of 11 photographs.

Grierson, Samuel. 'Grierson's Word in Edgewise.' *American Photographer* (May 1951), pp. 314, 317. Review of Newman's one-man exhibition at the Camera Club, New York.

Gruber, L. Fritz. *Famous Portraits* (New York: Ziff-Davis, 1960). 5 photographs, pp. 7, 31, 83, 93, 95. In text, pp. 14, 131, 136, 146–147, 148–149, 158. Also published as *Fame* (London: Focal Press, 1960).

'Half a Century of U.S. Photography.' *Time* (November 2, 1953), pp. 64–65. One photograph.

'How Arnold Newman Uses His Light Meter.' *Modern Photography* (July 1959), pp. 87, 118. Article and 3 photographs.

'Inside 9 Studios.' *Popular Photography* (November 1956), pp. 74, 76. In text and one photograph.

Judge, Jacquelyn. 'Arnold Newman Looks Back.' *Modern Photography* (April 1951), pp. 54–59, 94–96. Article and 8 photographs.

Kinzer, H. M. 'Ideas in Images.' *Popular Photography* (March 1963), pp. 68–69. Article on the exhibit at the Chicago Art Institute. In text and one photograph.

————. 'Arnold Newman Biography.' *The Encyclopedia of Photography* (New York: Greystone Press, 1964). Biography and 3 photographs, pp. 2502–2506.

Knight, John Adam. 'Camera Club Shows Work of Arnold Newman at Exhibition.' *New York Post* (January 25, 1951), p. 17. Review of Newman's one-man exhibition.

Kramer, Hilton. 'Portrait Photographs – A Historical Collision.' *New York Times* (September 4, 1969), p. D27. Review of portrait photographers' exhibition. In text.

'Les Peintures/Arnold Newman.' *American Society of Magazine Photographers, ASMP Picture* (New York: The Ridge Press, Inc., 1959). Statement by Arnold Newman and 7 photographs, pp 150–155.

Lipman, Lillian. *And Music at the Close: Stravinsky's Last Years* (New York: Norton, 1972). In text, pp. 297, 298, 311. 6 photographs, pp. 208–209.

Lyons, Nathan. *Photography in the Twentieth Century* (New York: Horizon Press, 1967). In collaboration with George Eastman House, Rochester, N.Y. One photograph, p. 38.

Mackland, Ray. 'How *Life* Picks a Cover.' *Photography Magazine* (September 1952), pp. 62, 63, 120–121. in text and one photograph.

'Magazine Camera Show.' *Life* (December 13, 1948), pp. 122–123. One photograph.

Mahoney, Tom (ed.). *U.S. Camera Annual, 1949* (New York: U.S. Camera Publishing Corporation, 1949). 7 photographs of 'In and Out of Focus' exhibit, Museum of Modern Art, pp. 28–29.

Mailer, Norman. *Marilyn* (New York: Grosset & Dunlap, 1973), pp. 212, 214, 217. 3 photographs.

McCarthy, Joe. *The Remarkable Kennedys* (New York: The Dial Press, 1960). In text on the making of John F. Kennedy's portrait in relation to his running for Vice President, pp. 163–164.

'Men at Work.' *New York Times Magazine* (January 28, 1951), pp. 12–13. Article and 10 photographs.

Morgan, Willard D. 'Ways and Means.' *Photography Magazine* (Fall 1947), pp. 16, 148. In text and one photograph.

'Museum Honors Symbolic Portraits by Arnold Newman.' *Life* (December 7, 1953), pp. 18–20. Article and 5 photographs.

Neubauer, John. 'The Camera and JFK.' *Popular Photography* (November 1967), pp. 88–103, 144–145. In text and 4 photographs.

Neugass, Fritz. 'Arnold Newman.' *Camera* (Switzerland) June 1953), pp. 254–258. Article and 7 photographs.

Newhall, Beaumont. *The History of Photography from 1839 to the Present Day* (New York: Museum of Modern Art, 1949). In text and one photograph, pp. 239–240. Revised and enlarged edition (1964). In text and one photograph, pp. 188, 190.

Newman, Arnold, and Craft, Robert. *Bravo Stravinsky* (Cleveland, Ohio: World, 1967). 164 photographs by Arnold Newman; foreword by Francis Steegmuller; art director, Frank Zachary.

Newman, Arnold, and Tremblay, Laurence. *Happytown Tales* (Coral Gables, Fla.: Parker Art Printing Association, 1944). Drawings by Arnold Newman.

Newman, Arnold. 'Portrait of an Artist.' *Minicam Photography* (November 1945), pp. 40–44, 126–128. Article and 6 photographs.

———. 'Portrait Assignment.' *Photo Arts* (Spring 1948), pp. 70–73, 106–110. Article and 12 photographs.

———. 'Speaking of Portraits . . .' *Universal Photo Almanac* (1952), pp. 19–26. Article and 11 photographs.

———. 'Arnold Newman's Europe.' *Popular Photography* (March 1964), pp. 50–55, 112–115. Article and 18 photographs.

Newman, Julia. 'Photographic Style.' *U.S. Camera* (March 1961), pp. 57, 59. In text and 2 photographs.

'Perceptive Photographer.' *Newsweek* (February 12, 1951), p. 46. Article and 5 photographs.

Photo (French edition). 'Les Têtes Couronées d'Arnold Newman.' (June 1973), pp. 108–117, 132, 142. Interview and 6 photographs.

Photo World. 'Arnold Newman.' (February 1974), pp. 30–41, 100. Interview and 7 photographs.

'. . . Photographer Catches Spirit of Modern Artists.' *Life* (February 4, 1946), pp. 10–12. Article and 7 photographs.

'Photographic Greats.' *New York Times Magazine* (November 11, 1962), p. 86. One photograph.

'Photography at the Museum of Modern Art.' *Museum of Modern Art Bulletin*, vol. 19, no. 4 (1952). 6 photographs.

'Photography in the Fine Arts.' *Saturday Review* (May 28, 1960), p. 42. One photograph.

'Photography Mid-Century.' *Los Angeles County Museum* (1950). Published with their exhibit, 'Photography Mid-Century.' In text and one photograph, pp. 10, 18; plate 107.

Photography of the World (Tokyo: Heibonsha Publishers, 1958). 4 photographs, 1970 edition. Two photographs, pp. 19–20.

Pollack, Peter. 'The Unshackled Vision.' *Art Photography* (July 1955), pp. 5–7. In text and 2 photographs.

———. *Ideas in Images*. Worcester (Massachusetts) Art Museum, 1962. Published with their exhibit, 'Ideas in Images.' 3 photographs.

———. *The Picture History of Photography*, revised and enlarged edition (New York: Harry N. Abrams, 1969). Chapter 50, entitled 'Arnold Newman,' pp. 646–657. 11 photographs.

'Portraits by the Great American Photographer Arnold Newman.' *Camera* (August 1960), pp. 18–26. 11 photographs.

'Portraits That Break the Rules.' *U.S. Camera* (April 1951), pp. 36–37, 93. Article and 5 photographs.

Reedy, William A. 'Conversation With Arnold Newman.' *Kodak Studio Light*, no. 1 (1971), pp. 13–20. Interview and 5 photographs.

———. 'Portfolio – Portraits for Publication.' *Impact – Photography for Advertising* (Rochester, N.Y.: Eastman Kodak Co., 1973), pp. 313–323. 10 photographs.

Reynolds, Charles R. '3 Who Switched.' *35mm Photography* (New York; Ziff-Davis, Winter 1973), cover and pp. 50–52, 55, 57, 58, 120, 122. In text and 7 photographs.

Rose, Ben. 'Early Newman.' *Infinity* (November 1963), pp. 10–11. Article and 2 photographs. (*See* 'Arnold Newman, Early Photographs.')

Rosenthal, Nan. 'American Artists Photographed by Arnold Newman.' *Art in America* (June 1965), pp. 106–113. Article and 9 photographs.

Scully, Julia. 'Picasso and the Portraitists.' *Modern Photography* (August 1974), pp. 102–107. In text and 1 photograph.

Stagg, Mildred. 'The Work of Arnold Newman.' *The Camera* (May 1951), pp. 48–54, 118. Article and 11 photographs.

Steichen, Edward. 'Problems of Portraiture.' *Art in America*, vol. 51, no. 4 (August 1963), p. 129. One photograph.

———. *Sandburg. Photographers View Carl Sandburg* (New York: Harcourt, Brace & World, 1966). 7 photographs, pp. 94–95.

Steiner, Ralph. 'Challenge to Portrait Photographers.' *Modern Photography* (January 1950), pp. 22, 29, 133–135. In text and 2 photographs.

Szarkowski, John. *The Photographer's Eye* (New York: Museum of Modern Art, 1966). One photograph, p. 86.

———. *Looking at Photographs: 100 Pictures from the Collection of the Museum of Modern Art* (New York: Museum of Modern Art, 1973), pp. 140–141. Text and one photograph.

'This Is Commercial Photography,' *Commercial Camera, Applied Photography Supplement*, no. 4 (1955). Article and 3 photographs.

'Thru Newman's Lens.' *The Art Digest* (December 15, 1945), pp. 12–13. Article and 10 photographs.

Tremblay, Laurence. *Happytown Tales* (Coral Gables, Fla.: Parker Art Printing Association, 1944). Drawings by Arnold Newman.

'25 Great American Photographs.' *U.S. Camera* (January 1960), p. 66. One photograph.

'Vanguard Photography by Two Young Americans.' *A-D Magazine* (December–January, 1941–1942). Article and 9 photographs.

Veit, Ivan. 'Advertising – Those Who Write the News That's Fit.' *Applied Photography*, no. 4 (1955), pp. 6–11. 4 photographs.

Weiss, Margaret R. 'Trends in Transition.' *Saturday Review* (August 29, 1964), p. 136. One photograph.

'What Makes a Good Portrait?' *Popular Photography* (February 1956), pp. 58–61. In text and one photograph.

'World's Greatest Pictures: Stravinsky by Newman.' *Modern Photography* (May 1967), pp. 70–71, 94. Article and 5 photographs.

Yerxa, Fendall. 'Photography: Portraiture Background.' *New York Herald Tribune* (February 4, 1951). Review of Newman's one-man exhibition at the Camera Club, New York. One photograph.

PHOTOGRAPHS IN PUBLISHED SOURCES

BOOKS

Armitage, Merle. *Stravinsky* (New York: Duell, Sloan & Pearce, 1949). One photograph.

Burchell, Samuel, and the Editors of Time-Life Books. *The Age of Progress* (New York: Time-Life, 1966). 7 photographs, pp. 149–157.

Chipp, Herschel B. *Theories of Modern Art* (Berkeley, Calif.: University of California Press, 1969). 2 photographs, pp. 269, 609.

Coughlan, Robert, and the Editors of Time-Life Books. *The World of Michelangelo* (New York: Time-Life, 1966). 10 photographs, pp. 75–81.

The Editors of *Life*. *American Arts and Skills*. Part II: 'The Look of Liberty in Craftsmanship'; Part III: 'The Sturdy Age of Homespun' (New York: E. P. Dutton for Time-Life Books, 1957). Revised edition (1968). Part II, 27 photographs, pp. 38–54; Part III, 29 photographs, pp. 56–68.

Furnas, Clifford C., McCarthy, Joe, and the Editors of Time-Life Books. *The Engineer* (New York: Time-Life Books, 1966). 14 photographs, pp. 40–53.

Grunfeld, Frederic V., and the Editors of Time-Life Records. *The Story of Great Music – The Early Twentieth Century* (New York: Time-Life, 1967). 12 photographs, 'Stravinsky at 84,' pp. 38–44.

The Holy Bible. Illustrated. (Pleasantville, N.Y.: Reader's Digest, 1971). 23 photographs.

Manchester, William. *The Arms of Krupp* (Boston: Little, Brown, 1968). Book jacket photograph of Alfried Krupp.

Moholy-Nagy, Laszlo. *Vision in Motion* (Chicago: Paul Theobald, 1947). One photograph, p. 140.

The Smithsonian Institution (Washington, D.C.: The Smithsonian Institution in association with *American Heritage* magazine, 1965). 46 photographs (as credited).

Stever, H. Guyford, Haggerty, James, and the Editors of Time-Life Books. *Flight* (New York: Time-Life, 1965). 13 photographs, pp. 17–29.

Wertenbaker, Lael, and the Editors of Time-Life Books. *The World of Picasso* (New York: Time-Life, 1967). 2 photographs, pp. 144, 166.

HOLIDAY MAGAZINE

February 1954. 'The U.S. Senate.' 12 photographs, pp. 56–63.

June 1954. 'The Man Who Killed Lincoln.' One photograph, p. 102.

September 1954. 'The Clans of Scotland.' 8 photographs, pp. 38–45.

March 1955. 'British Parliament.' 7 photographs, pp. 56–61.

February 1956. 'The American Indian.' 8 photographs, pp. 25, 26–39.

March 1956. 'What Do You Collect?' One photograph, pp. 64–65.

April 1957. 'French Issue – The Arts of France.' 8 photographs, pp. 64–71.

August 1957. 'Pompeii.' 5 photographs, pp. 46–51.

November 1957. 'The U.S. Marines.' 3 photographs, pp. 70–75.

———. 'Georges Duhamel.' One photograph, p. 75.

April 1958. 'The Pageant of England.' 4 photographs, pp. 56–63.

May 1958. 'The Vatican.' Cover, and 19 photographs, pp. 50–63.

October 1958. 'The United States Navy.' 3 photographs, pp. 54–59.

April 1959. 'African Issue – A Gallery of Leaders.' Photographs, pp. 45, 49, 64–73, 74, 143, 146, 152.

October 1959. 'New York Issue – A First Look at New York' 10 photographs, pp. 50–63, 90–95.

December 1959. 'Discover Israel.' Cover and 22 photographs, pp. 66–77.

March 1960. 'The United States Air Force.' 3 photographs, pp. 82–87.

April 1960. 'Rome: A Pontifical Splendor.' 5 photographs, pp. 82–91.

September 1960. 'The United States Army.' 3 photographs, pp. 54–59.

May 1961. 'The Congo River.' 21 photographs, pp. 74–79.

September 1961. 'The House of Rothschild, Part I." 6 photographs, pp. 32–41.

October 1961. 'Japan: The Big and Little Arts.' 4 photographs, pp. 84–87.

November 1961. 'The House of Rothschild, Part II." 4 photographs, pp. 74–78.

December 1961. 'The House of Rothschild, Part III" 2 photographs, pp. 94–95.

April 1962. 'Washington D.C. Issue – The City of Our Time.' 5 photographs, pp. 52–57, 119,141.

December 1962. 'The House of Rothschild, Part IV.' One photograph, pp. 62–63.

March 1963. 'MIT.' Cover and 8 photographs, pp. 66–75.

July 1963. 'The Americans in My Mind.' 9 photographs, pp. 28–39.

September 1963. 'The Merchant Marine.' 3 photographs, pp. 64–69.

January 1964. 'The Louvre: Halls of Grandeur.' 6 photographs, pp. 70–77.

September 1964. 'The Rockefeller Institute.' 5 photographs, pp. 52–57.

October 1964. 'The German Tradition.' 9 photographs, pp. 66–73.

November 1964. 'Velvet New York.' Cover and one photograph.

April 1965. 'The Leader and Some Notable Spanish Faces.' 9 photographs, pp. 70–77.

May 1965. 'The Ivyless Halls of Yale.' 6 photographs, pp. 76–81.

December 1967. 'Religions of a Devout Land: The Meaning of Israel.' 5 photographs, pp. 58–63, 139–140.

September 1968. 'Lincoln Center.' 5 photographs, pp. 36–45.

(Issue A), March 1969. 'Our Men in Paris.' 11 photographs, pp. 34–39.

(Issue B), March 1969. 'The Invisible Celebrities of Switzerland.' 6 photographs, pp. 34–39.

March 1969. 'Balanchine + Girls = Ballet.' 5 photographs, pp. 54–57.

December 1969. ('Florence Issue.') 'Florence.' Cover and 9 photographs, pp. 28–33.

———. 'Chianti.' One photograph, pp. 62–63.

———. 'Florentine Hill Towns.' 3 photographs, pp. 42–43.

———. 'The Great Craftsmen of the New Renaissance.' 6 photographs, pp. 28–33.

January 1970. 'Most Famous, Yes. But Is the Paris Ritz the World's Greatest Hotel? Probably.' 6 photographs, pp. 38–39.

March 1970. ('San Francisco Issue.') 'Who's in Charge Here?' 6 photographs, pp. 48–51.

———. 'Culture, Counter-Culture . . ." 5 photographs, pp. 56–59.

———. 'The Small Restaurant . . ." One photograph, pp. 68–69.

———. 'Copenhagen.' 6 photographs, pp. 56–59.

November 1970 'The Four Seas of Israel.' 4 photographs, pp. 54–67.

February 1971. 'Nazaré.' 4 photographs, pp. 50–54.

LIFE MAGAZINE

October 7, 1946. 'Eugene O'Neill.' One photograph, p. 102.

August 25, 1947. 'College Fashions: The Gibson Girl Look.' Cover and 8 photographs, pp. 114–116.

May 17, 1948. 'Andrew Wyeth.' One photograph. p. 102.

November 15, 1948. 'New Furniture.' 4 photographs, pp. 115–118.

April 4, 1949. 'Art in Ithica.' 7 photographs, pp. 68–70.

August 8, 1949. 'Jackson Pollock, Is He the Greatest Living Painter in the United States?' 3 photographs, pp. 42–43.

September 26, 1949. 'Philip Johnson's Glass House.' 4 photographs, pp. 94–96.

———. 'How to Make Four Outfits Into One.' Cover and 10 photographs, pp. 89–91.

January 2, 1950. 'Life Visits the Vanderbilt Mansions, Part I.' 7 photographs, pp. 89–92.

July 31, 1950. 'What Do. U.S. Museums Buy?' 7 photographs, pp. 40–47.

January 1, 1950. 'America's Assets.' Cover and 9 photographs, pp. 60, 66–68, 86.

July 2, 1951. 'The Capitol.' 15 photographs, pp. 48–57.

July 23, 1951. 'Life Visits the Vanderbilt Mansions, Part II: Newport House (The Breakers).' 9 photographs, pp. 46–52.

September 3, 1951. 'The Philadelphia Museum.' 9 photographs, pp. 66–74.

February 4, 1952. 'O'Neill Shines Again: Two Old Plays are Hits.' 9 photographs, pp. 82–84, 86.

May 5, 1952. 'Portrait Backgrounds.' 5 photographs, pp. 149–153.

July 7, 1952. 'The White House Redecorated.' 9 photographs, pp. 47–53.

October 27, 1952. 'Chicago's Fabulous Collectors.' 30 photographs, pp. 90–100.

March 22, 1954. 'Sporting Goods.' 12 photographs, pp. 114–123.

August 9, 1954. 'Family [Lehman] Collection.' 10 photographs, pp. 63–67.

May 4, 1955. 'American Arts and Skills, Part II: The Look of Liberty in Craftsmanship.' Cover and 27 photographs, pp. 56–71.

July 18, 1955. 'American Arts and Skills, Part III: The Sturdy Age of Homespun.' 30 photographs, pp. 54–65, 67–68.

May 18, 1959, 'The Ageless Story of Job's Ordeals in the Year's Prize Play.' 7 photographs, pp. 124–134.

December 24, 1965. 'A City's Future Takes Shape.' 10 photographs, pp. 168–174.

LOOK MAGAZINE

October 25, 1960. 'Detroit's Big Wheels.' 10 photographs, pp. 56–65.

———. 'Inside Detroit.' One photograph, pp. 34–35.

September 11, 1962. 'Marilyn Monroe: A Tribute by Carl Sandburg.' 8 photographs, pp. 90–94.

March 26, 1963. 'The Rockefellers.' 5 photographs, pp. 82–85.

March 10, 1964. 'President Johnson's Official Portrait.' Cover.

October 5, 1965. 'The Heritage of Judaism.' 15 photographs, pp. 56–72.

May 16, 1967. 'Philip Johnson's Suburban Museum.' 4 photographs, pp. 69–73.

October 17, 1967. 'The 1968 Cars.' Cover and 44 photographs, pp. 82–95.

December 26, 1967. 'Stravinsky,' 11 photographs, pp. 50–56.

January 9, 1968. 'Gallery '68: High Art and Low Art.' 7 photographs, pp. 14–21.

April 30, 1968. 'Israel: Twenty Years of Siege and Struggle.' 13 photographs, pp. 28–38.

August 6, 1968. 'Krupp.' One photograph, p. 36.

———. 'Galaxy of Stars [cast of Madwoman of Chaillot].' One photograph, pp. 64–65.

December 2, 1969. 'Seven Dobbs Against the Odds.' 13 photographs, pp. 27–33.

PHOTOGRAPHS IN OTHER PUBLICATIONS

Art in America. September–October 1973. 'The Indian Summer of Jack Tworkov.' One photograph, cover.

Art in America. November–December 1973. 'The Nature of Lee Krasner.' One photograph, cover.

Charm. July 1951. '4,500,000 Working Women . . .' 9 photographs, pp. 20–39.

Dance Magazine. January 1957. 'Hanya Holm and Son.' One photograph, cover.

Esquire. November 1965. 'An Historic Picture of the New Frontier.' 14 photographs, pp. 30, 88–95.

Esquire. July 1972. 'Whither Thou Goest.' 4 photographs, pp. 78, 82, 87, 91.

Esquire. July 1973. 'Julia.' One photograph, Miss Lillian Hellman, p. 99.

Fortune. October 1948. 'The Scientists.' 6 photographs, pp. 106–111, 170.

Fortune. March 1972. 'Vincent Learson Didn't Plan It That Way, but I.B.M.'s Toughest Competitor Is – I.B.M.' 4 photographs, pp. 55–58.

Fortune. 'Imports That Dominate Their Markets.' 5 photographs, cover, pp. 124–127.

Fortune. 'RCA After the Battle.' 2 photographs, pp. 122, 124.

Fortune. 'The Ten Highest Ranking Women in Business.' Cover and 11 photographs, pp. 80–89.

Fortune. 'Irving Shapiro Takes Over at DuPont.' 2 photographs, pp. 78, 80.

Horizon. July 1961. 'Cape Cod.' 13 photographs, pp. 10–29.

Horizon. Spring 1974. 'Bohemia Reborn.' 19 photographs, pp. 64–77. In editorial text, 'Progeny,' pp. 2–3.

McCall's. January 1970. 'Follow the Caravan.' 3 photographs, pp. 60–61.

McCall's. February 1970. 'Needlework in Private Hands.' 18 photographs, pp. 68–77.

McCall's. October 1970. 'The Making of a Masterpiece.' One photograph, Julia Child and Simone Beck, p. 84.

McCall's. 'Mastering the Art of French Cooking, Volume Two, by Julia Child and Simone Beck.' 9 photographs, pp. 86–91.

Newsweek. April 8, 1963. 'Pierre Salinger.' One photograph, cover.

Newsweek. December 6, 1965. 'The Power in the Pentagon.' One photograph, cover.

New York Times Magazine. September 5, 1971. One photograph, Edward Hopper, cover.

New York Times Magazine. January 2, 1972. One photograph, Tom O'Horgan, cover.

New York Times Magazine. February 20, 1972, 'The Haute Cuisine Restaurants Here Are UP Against the Kitchen Wall' Cover and 4 photographs, pp. 10, 11, 67, 77.

New York Times Magazine. 'Why Norman and Jason Aren't Talking.' 2 photographs, pp. 34–35.

New York Times Magazine. January 20, 1974. 'Jason Jamie Robards Tyrone.' 3 photographs, pp. 14–15, 68.

Saturday Evening Post. 1958–1960. 'Adventures of the Mind,' an editorial series including portraits of William S. Beck, Vladimir Szworkin, Dr. Fred Whipple, Arthur Schlesinger, Jr., Dr. Hans Selye, Lewis Mumford, Aaron Copland, Dr. Gerald Holton, Dr. Laurence Bragg, Dr. Edward Teller, and others.

Saturday Evening Post. December 1, 1961. 'Artist of the Third Eye, Marc Chagall.' 5 photographs, pp. 22–25.

Scientific American. October 1956. One photograph, Oil Refinery, cover.

Sports Illustrated. September 1, 1969. One photograph, Arnold Palmer, cover.

Sports Illustrated. November 8, 1971. One photograph, Norm Bulaich, cover.

Town & Country. March 1973. 'The Indelicate Art: Artmongering.' 5 photographs, pp. 65–69.

Town & Country. April 1973. 'New York Antique Dealers at Home.' 6 photographs, pp. 84–91.

Town & Country. April 1973. 'Did Anita Loos Write the Great American Novel?' One photograph, p. 64.

Town & Country. 'Hardy Andy.' 2 photographs, pp. 72–75.

Town & Country. October 1973. 'New Cars for '74.' 9 photographs, pp. 166–173.

Travel & Leisure. June–July 1971. 'Monticello.' 7 photographs, pp. 65–71, 76.

Travel & Leisure. October–November 1971. 'Surprising Cities.' 5 photographs, pp. 30–39.

Travel & Leisure. December –January 1972. 'Beverly Hills.' 7 photographs, pp. 38–41.

Travel & Leisure. 'Day Outside of Miami.' 2 photographs, pp. 70–71.

Travel & Leisure. Autumn 1972. 'The Poetic Obsession of Dublin.' 7 photographs, pp. 32–37.

Travel & Leisure. February–March 1973. 'Jerusalem.' 8 photographs, pp. 30–37, 82.

Travel & Leisure. April–May 1973. 'Aristotle Contemplating the Bust of Homer.' 2 photographs, pp. 40–41.

Travel & Leisure. 'I've Seen the Future and It Is Texas!' 7 photographs, pp. 24–29.

TELEVISION AND TAPE RECORDINGS ON ARNOLD NEWMAN

Allen, Casey. 'In and Out of Focus.' WNYC, New York. Thirty minutes. First airing, March 24, 1971.

Cummingham, Paul. *Archives of American Art*. Two two-hour taped interviews. New York. July 14, August 23, 1971.

Seckler, Dorothy. *Archives of American Art*. Taped interview. Provincetown, Mass. September 1, 1964.

EVENTS

Projections of Stravinsky photographs from Arnold Newman's *Bravo Stravinsky* during an all-Stravinsky 'Spectrum Concert,' Boston Symphony Orchestra, Boston, Mass., January 7 and 8, 1972. Michael Tilson Thomas, conductor.

INDEX

Camera (and negative) sizes are given following the titles.
*An asterisk indicates that the print was made from a negative converted from color to black and white.

The name of the publication or individual who originally commissioned the photograph also follows the title. In some instances the photograph printed here may be different from the one originally published. Those of Krupp and Stravinsky were not used by the original publications but appeared elsewhere on numerous occasions.

Where no client is indicated, the photograph was taken for Newman's own uses, although most such photographs subsequently appeared in publications and exhibits around the world.

PORTRAITS

OTHER PHOTOGRAPHS

Designed by Lance Hidy and Arnold Newman.
Type set by the Monotype Composition Co., Boston, Massachusetts.
Printed by Eastern Press, New Haven, Connecticut.
Bound by A. Horowitz & Son, Clifton, New Jersey.

Special technical work by Berkey K+L Custom Services Inc., New York City.

In some instances dates in the original edition were
incorrect; they have been corrected in this edition.